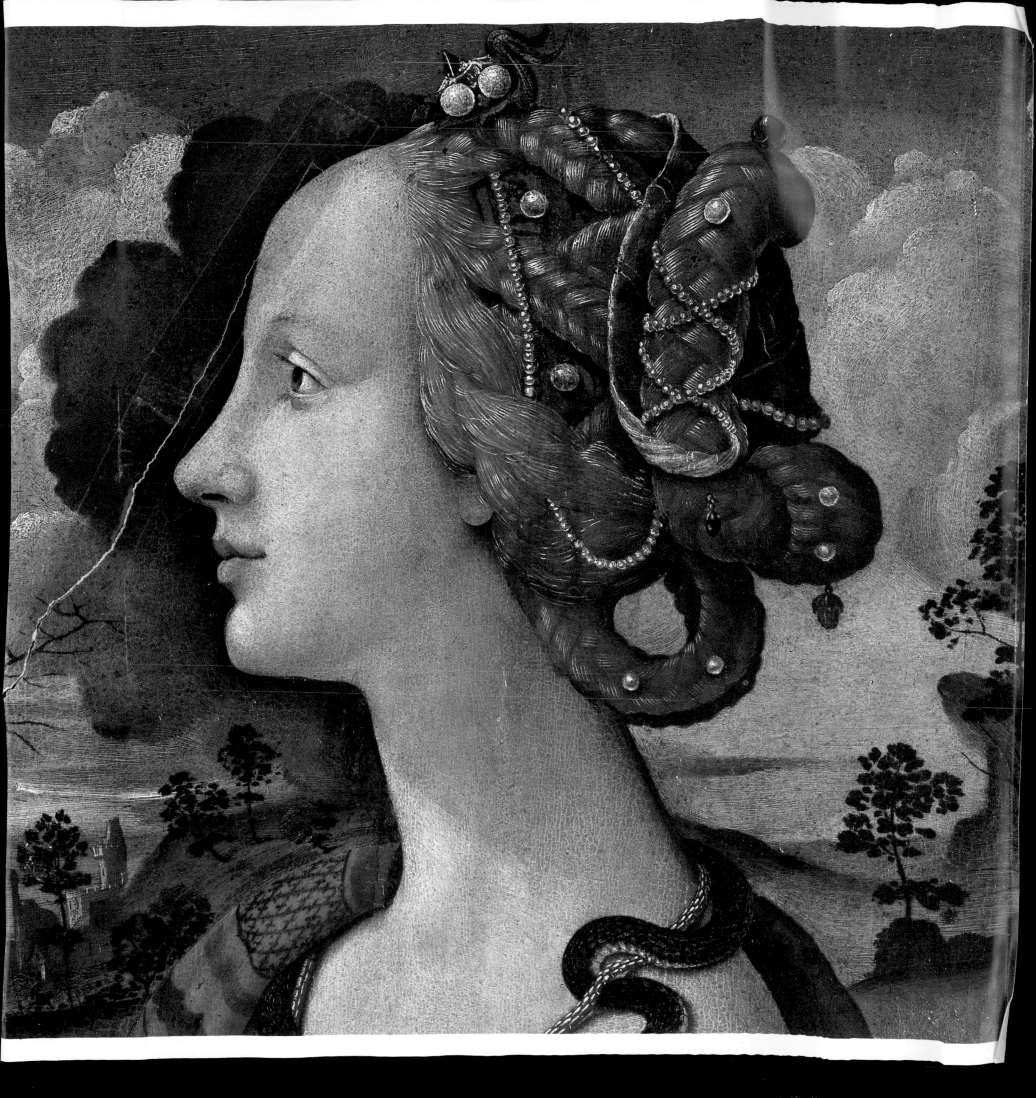

PEARLS

Ornament & Obsession

KRISTIN JOYCE &
SHELLEI ADDISON

Introduction by Sumiko Mikimoto

Piero di Cosimo,
Portrait of
Simonetta Vespucci,
15th century, oil.

SIMON & SCHUSTER
New York London Toronto Sydney Tokyo Singapore

SIMON & SCHUSTER
Simon & Schuster Building
Rockefeller Center
1230 Avenue of the Americas
New York, New York 10020

DESIGNED BY BARBARA MARKS
PICTURE CONSULTANTS: CAROUSEL RESEARCH, INC.
Printed in Japan

10 9 8 7 6 5 4 3 2 1

Library of Congress Cataloging-in-Publication Data is
available.

ISBN: 0-671-75928-0

More precious than
any pearl.
For our children,
Lily and Addison.

Contents

21

By the Divine Dew

ANCIENT ENCHANTMENT WITH A
LODESTONE OF MYTH, LEGEND & BELIEF

Mythology, Symbology & Folklore

Astrology, Alchemy & Dreams

Potions, Cosmetics & Medicinal Remedies

Sacred Pearls & World Religions

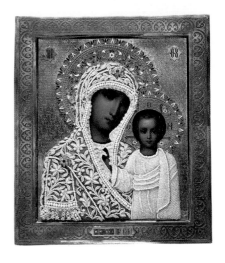

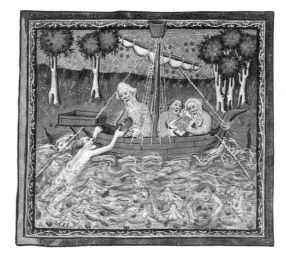

53

Learn from Yon Orient Shell

SCIENTIFIC FASCINATION WITH THE
CREATION OF A NATURAL GEM

The Shell & the Creature Within

The Phenomena of Orient & Color

Paragons to Poppyseeds, Blisters to Baroques

Imitation Pearls & the Proliferation of Fabulous Faux

75

Seeking Goodly Pearls

HISTORIC PREOCCUPATION WITH AN
EMBLEM OF POWER & PRESTIGE

India's Oldest Fisheries & Persia's Royal Vaults

The Dynasties of Asia & the South Seas

Pillage & Plunder in the Mediterranean

Royal Mania & European Expansion into the Americas

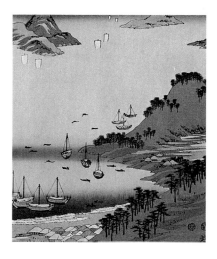

Acknowledgments

WE ARE GRATEFUL to many people for their contributions and encouragement over the three years it took to write *Pearls: Ornament and Obsession*. A few previous authors, from whose work our own so greatly profited, merit special attention. Gemologists George Frederick Kunz and Charles Hugh Stevenson left us an invaluable resource in the form of their massive 1908 work, *The Book of the Pearl*. Edwin Streeter's 1886 volume, *Pearls and Pearling Life*, greatly expanded our understanding as well. And an obscure 1927 doctoral dissertation found in the library of the University of California at Berkeley, Sanford Mosk's *Spanish Voyages and Pearl Fisheries in the Gulf of California*, brought history to life for us.

We would like to express our profound appreciation and thanks to K. Mikimoto and Co., Ltd., beginning with Marcella A. George of Mikimoto America in New York. Her enthusiasm for the book and her spirited campaign to place it in the right hands secured us the financing we needed to finish. Also at Mikimoto America, we are indebted to Minoru Tabata for his commitment to the project early on. At Mikimoto in Japan, we thank Ryo Yamaguchi for sharing his inside knowledge of the pearl business as well as Yoshinori Kokunuo and Takehiko Iimori for their graciousness during our visit, for their ongoing gestures of goodwill, and for their tireless pursuit of artwork and information. Our gratitude extends to the Mikimoto Pearl Museum staff in Toba, especially to curator Kiyoo Matsuzuki for putting his impressive photographic skills to work. We also wish to recognize the assistance of an inspired and highly respected expert, Shigeru Akamatsu, manager of the Mikimoto Pearl Research Laboratory.

Other sources who deserve our appreciation include Cecile Thiery, former research librarian of the Musée Oceanographique de Monaco, and the rest of her colleagues. Ms. Thiery's quick wit, research acumen, and invitation to participate in the museum's private world pearl conference were invaluable. We are indebted to Arianna Galli of Paris for the five-hour interview during which she magically described the pearly tales and treasures of the Middle East. Thanks also to Diana Epstein of Tender Buttons in New York; Alma Gruppo and Manolo Blahnik in New York; Rosebud Cakes in Los Angeles; and Ralph Esmerian, Mary P. Proddow, Christopher Walling, James Arpad, Eric Valdieu, Germaine Juneau, Susan Eisgrau, and Bill Hayes. We offer special gratitude to Birgit Kelley and her Tokyo counterpart, Setsuko Okura, for making our stay at the Esprit House in Shibura district, Tokyo, so wonderful.

We believe our first editor, Mary Hall Mayer, Executive Editor of Simon & Schus-

ter's Prentice-Hall Editions, deserves special kudos. Her enthusiasm for the book was contagious, and her help immeasurably valuable. After her departure, we were fortunate to be "adopted" by Linda Raglan Cunningham, Vice President and Director of Illustrated Books in Simon & Schuster's Trade Division, who devoted tremendous energy to the project despite her already full plate, and Senior Editor Patty Leasure, whose publishing acumen and good cheer made our job so much easier. Linda and Patty introduced us to Constance Jones, our skillful contributing writer and editor, who shared with us her unique talent for digesting mounds of information and generating text at the speed of light.

We reserve special admiration for Laurie Platt Winfrey, owner of Carousel Research, Inc., in New York, for her professional abilities, her gentle support, and her warm friendship. The tenacity of Laurie and her colleagues Fay Torresyap and Robin Sand over two long years of research, cataloging, permissions work, returns, and recataloging proved essential to the success of this project. Later in the project, designer Barbara Marks successfully met the daunting challenge of turning thousands of words and scores of images into 256 beautiful pages.

Applause goes to our left- and right-hand men and women, especially to Tony Kieffer for his fundamental contributions as scholar, chief researcher, and "Chinese chef" and for his work with Sino scholar Xie You Tien on locating and translating rare and ancient works. Our gratitude also goes to Evan Scott Orensten, Jeffrey Lance Johnson, Kendra Lawrence, Bill Craddock, Kate Warne, and Jennifer Kaikinger. Thanks to Penny Greene of the Sausalito Public Library in California; to Dona Dirlam, Elise Misiorowski, Archie Curtis, Rose Tozer, and Robert Weldon of the Gemological Institute of America research library in Los Angeles; to Jacques Constans, Vice President of the Cousteau Society in Paris; to Dr. Jim Brown of the Department of Anthropology at Northwestern University; to Larry Banks of the U.S. Army Corps of Engineers in Texas; to Director of Undergraduate Resources Laura Selznick of Stanford University; and to the Stanford Library, the U.C. Berkeley Library, L'Institute de Monde Arabe in Paris, and the Gemology Institute of France.

Among friends and family, we thank Don Guy for his unending enthusiasm for the project, for his passion for beautiful books, and especially for his love of his wife, Kristin; Michael Rex for embodying perfectionism, hard work, and the pursuit of high ideals; and David Dear for challenging Shellei with his remark, "You appear to be

slowing down." We are indebted to our army of child-care experts: Jimena Barreto, Winnie Gwathmey, Paisley Knudsen, Christine Mota Rex, and Jessica Mihaly; to our exceptional lawyer and business manager, Brad Bunnin; to Shellei's mentor, Susan Klee, for her advice to "assume your international citizenship and pass it along"; to Kristin's mother, Ann, for always believing the world is your oyster when you express grace and use the good that God bestows; and to our close friends, creative souls one and all, Molly Chappellet, Abbie Simon, Toshiko Mori, Brahna Stone, Maryjo Koch, Isabelle Dehais and family, Anne M. Alioto, and Fritha Knudsen.

It is only through the generosity and patience of so many that this project has come to fruition. Our heartfelt thanks extend to them all.

Preface

WHEN WE BEGAN discussing the possibility of collaborating on a book, we sought a subject that would encompass the notions of natural beauty and classic style. Our background in fashion—as costume designers and stylists—had instilled in us an abiding curiosity about human habits of ornament, about why people decorate themselves as they do. This preoccupation with ornament became the frame of reference for our search for a topic. We wanted to avoid the typically superficial trends of fashion, but we could not deny the aesthetic and anthropological allure of costume and adornment. Fascinated by the symbolism of style, we hoped to decipher the messages transmitted by personal dress and discern the meanings of wearable obsessions and tastes displayed by kings, coquettes, rock stars, and ordinary folk.

To us, every fashion choice, whether deliberate or unconscious, is telling. And nothing seems more revealing of the human impulse for adornment than the purely decorative baubles and accessories with which people embellish themselves: vampy pumps rather than clunky sandals, club ties versus bow ties, pearls instead of gold.

Ah, pearls! What more classically captivating ornament is there, we asked ourselves, than the pearl? We love pearls as natural works of art, just as millions of others love them for many delightfully different reasons. Here, no doubt, was the rich and elegant subject we were looking for.

The prospects excited us, but little did we suspect that we had happened on a perfect gem of an idea. We had only a faint notion that the pearl was humankind's oldest gemstone, an object venerated for thousands of years in almost every culture. Still, the book we envisioned—a multifaceted exploration of this iridescent jewel—would be the first of its kind in nearly a century. Trusting our visual instincts and our expertise in journalism and research, we dove in. The passionate pursuit of pearls had begun.

Because the relationship between humanity and the pearl is so ancient and universal, the available information on pearls is tremendously diverse, far-flung, and abundant. Any attempt to cover the subject, even if each chapter in this book comprised a separate volume, can do no more, therefore, than offer a sampling of the data. As a result, our work stands as a narrative compendium meant to provide readers with an intellectual point of departure. It is the first book to tell the story of pearls in each of the various realms of myth, science, history, commerce, design, and the arts, from prehistory through the 20th century. From here, ambitious readers can launch their

own, deeper explorations of any aspect of the pearl that captures their imagination. It has been our intention to pose as many questions as we answer.

Perhaps the first use human beings found for the pearl was as a spiritual totem or religious emblem. The gem's natural perfection—unlike the diamond or emerald, it requires no cutting or polishing—astounded and impressed the ancients. People of many cultures instantly attributed celestial origins, powers, and meanings to the pearl and gave it a prominent place in their varied systems of worship. Astrologers and alchemists studied the pearl's mystical influence on human affairs; healers used the gem in their potions and remedies. Hindus, Buddhists, Jews, Christians, and Muslims alike decorated their temples, shrines, and icons with pearls, hoping to harness the pearl's divine force.

Fascination with the mysteries of the pearl prompted scientists to study its origins and structure. They examined pearl-bearing oysters and mussels to detect the mechanics of pearl formation and experimented with the lustrous beads to decipher the enigma of their milky iridescence. They learned what causes pearls to grow and contemplated the multilayered makeup of the fragile gems and the mother-of-pearl that lines the shells of mollusks. Yet, the more scientists discovered about the natural jewel, the more astonished they became. Science can describe but never define the pearl's enchanting essence.

The rarity and allure of the pearl made it a coveted possession among queens, sultans, and the merely wealthy. As humankind's original and most beguiling gem, the pearl inspired royal passion and launched countless expeditions of trade and conquest. The ancient Romans were so inflamed by lust for pearls that they drained their national treasury to buy the glistening beads. During the Renaissance, European aristocrats hungered so for the gem that historians have called the era the Pearl Age. European appetites led to the cruel exploitation of pearl beds in Central America, newly discovered by Chistopher Columbus. Later, the American robber barons of the industrial revolution made the pearl their gem of choice. The passion for pearls, it seems, transcends the bounds of time and place.

Demand for pearls was long met by the rich pearl fisheries of the Persian Gulf, the Red Sea, and Sri Lanka (formerly Ceylon), as well as numerous other sources in the South Pacific, Central America, and the rivers and lakes of Asia, Europe, and North America. Vast trade routes and prosperous business enterprises thrived on the

commerce in natural pearls, until overfishing all but obliterated the wild oyster banks. Fortunately for pearl lovers, the visionary Japanese entrepreneur Kokichi Mikimoto learned how to culture pearls in oysters raised in captivity. After two decades of tireless effort, Mikimoto perfected the spherical cultured pearl early in the 20th century. His marketing genius and his commitment to a high-quality product won the world over to cultured pearls, which now set the standard in pearl fashion.

People have found an incredible variety of decorative uses for pearls, mother-of-pearl, and faux pearls—whether cultured, natural, or artificial. In ancient times, mother-of-pearl sparkled in mosaic and inlay patterns, while pearl jewelry adorned royalty in Asia and the Middle East. Tribal peoples from the South Pacific to South America ornamented weapons, musical instruments, and clothing with pearls and pearl shell. Particularly elaborate pearl jewelry came from India and Byzantium, as well as from Europe, once the Pearl Age took hold. Russian headdresses, French furniture, Syrian chessboards, and the famous Easter eggs of Peter Carl Fabergé showed lavish use of pearls and mother-of-pearl. Today, the traditions of pearl adornment live on in private heirloom collections and in the classic strands of cultured and faux pearls preferred by fashionable women.

Treasured both as a jewel and as a symbol, the pearl has appeared time and again in literature and the other arts. The leading artists of the Renaissance, particularly the Dutch masters, employed pearl imagery to convey the gem's contrasting meanings of chastity and carnality. In the 20th century, artists in the United States and Japan have elaborated on the pearl's metaphorical message in prints, paintings, collages, and sculptures. Musicians have written lyrics about pearls and designers have created pearl-studded costumes for stage and screen performers. And from the most ancient Indian poets to the most modern American novelists, writers have found the pearl a particularly potent literary device. In the arts, the pearl comes full cirle, to its earliest significance in myth and legend.

We have chosen the images and ideas in each chapter to support our own thesis: that pearls are a metaphor for human experience. In every field of endeavor—from politics to literature, from science to design—the pearl's impact on human motivation is undeniable. To investigate this phenomenon, we approach our topic as anthropologists. We have touched on such areas as biomechanics, historiography, industrial evolution, and the psychology of adornment. Analysis from these varied perspectives

has not only confirmed but enlarged our thesis. We find it remarkable that human reverence for the pearl as an ornament has, across cultures and through time, repeatedly produced unparalleled passionate excesses and creative accomplishments. The story of the pearl is thus, in many ways, the story of humanity. Indeed, pearls are among the world's most exquisite and treasured jewels and among its most prevalent icons of popular style. But, throughout their 4,000-year history, they have transcended the realm of prosaic materialism, playing a significant role in the beliefs and power structures of many cultures. Today, the value placed upon pearls supports major business enterprises, while the endangerment of pearl-bearing mollusk species drives the efforts of some renowned environmental scientists.

Clearly, this project has been about much more than pearls themselves. It has been about sharing the unnerving thrill of an impending typhoon on Ago Bay in Japan, and about learning some well-kept secrets of the world's foremost pearl experts during a sumptuous luncheon high atop the Musée d'Oceanographique in Monaco. It has been about negotiating art permissions with the French, business deals with the Japanese, and publishing contracts with Americans all in one day. It has been about learning how most natural pearls today are fished from vaults rather than from the sea, and about immersing ourselves in pearly tales told by fascinating people around the world. It has been about formulating a thesis, finding obscure information, and illuminating stacks of research with our own conceptual floodlight.

We trust that our readers will be illuminated as well, and that each will see pearls in a new light after perusing *Pearls: Ornament and Obsession*. Culling the most fascinating elements from a rich milieu, this book opens the multilayered world of the pearl to contemporary readers in a way that no previous publication has done. We hope our readers will come to appreciate, as we have, this jewel that dazzles the mind as well as the eye.

—Kristin Joyce and Shellei Addison
February 1992

Introduction

AT K. MIKIMOTO and Company, Ltd., we marvel each day at the beauty and mystery of the pearl. Even now, on the hundredth anniversary of our founding by Kokichi Mikimoto, a century of research and pearl culturing has inspired in us an awe and respect for nature's perfect gem that only grows greater with the passage of time. Our founder, the Pearl King, spent his life studying pearls and promoting knowledge and appreciation of the iridescent gems throughout the world. Since his death in 1954, we have carried on his tradition of education and enlightenment through ongoing work at the Mikimoto Pearl Research Laboratory and by welcoming hundreds of thousands of visitors to the Mikimoto Pearl Museum each year.

We are pleased when others advance the world's understanding of pearls, and thrilled that the publication of *Pearls: Ornament and Obsession* will now bring the wonder and charm of this unique gem to a wide international audience. By putting together a beautiful book filled with truly original research and insight, the authors have done a great service to the gemological community and to the pearl-loving public at large. They have delved to greater depths than anyone in the past eighty-five years and have explored little-known aspects of pearl history to produce a complete, up-to-date work of substance and elegance. Everyone at the Mikimoto company congratulates them.

As the wife of Kokichi Mikimoto's successor, I have come to understand how the pearl illuminates the human senses. Nacre, the material of which the pearl is made, is a pure and perfect solution to the oyster's need to protect its delicate body from harm. Uniting form and function with unerring economy, nature becomes the ultimate designer each time a pearl is born. I can hold a single flawless pearl in my hand and know there are centuries of wisdom hidden within it.

Pearls: Ornament and Obsession reveals this wisdom and shows how, over the course of five millennia, the lustrous jewel of the sea has become humankind's premier ornament and one of its great obsessions. This chronicle of the pearl unfolds as a six-part moral, natural, social, economic, decorative, and artistic history. From the many layers of the pearl's ancient past, dynamic present, and uncertain future emerges a keen awareness that the gem is a consummate metaphor for the ever-evolving human condition. The relationship between people and pearls has always reflected the social and spiritual realities of the world.

As we near the end of the 20th century, the pearl faces a tenuous future because

of the ongoing destruction of the earth's marine resources. Natural pearls are already a part of history, for very few are now found in wild oysters. If subsequent generations are to enjoy the radiance and wonder of pearls, it thus falls to concerned pearl farmers to safeguard the world's captive population of pearl-bearing oysters. We are proud to take up the fight, to pursue the secrets of biotechnology in order to breed stronger, more productive oysters, and to work toward halting the pollution of the seas. Part of this effort involves educating the public, for understanding is the first prerequisite for action. We are therefore pleased to endorse *Pearls: Ornament and Obsession*, a book that will do much to heighten appreciation and awareness of the pearl throughout the world.

Sumiko Mikimoto

PEARLS

By the Divine Dew

ANCIENT

ENCHANTMENT

WITH A LODESTONE

OF MYTH,

LEGEND & BELIEF

This ancient wall piece portrays a meditating bodhisattva, a being worshiped by some Buddhists for its efforts on behalf of souls struggling toward nirvana.

The ancients believed the pearl connected them to the gods and cherished it as a point of contact between themselves and the natural world. Here was an object that captured all the majesty of nature; someone who owned or wore a pearl possessed an object that held the essence of nature's wonder. Requiring no human refinement to reveal its splendor, one of the world's most dazzling treasures was a pure and perfect product of nature alone, all the more precious for its simplicity. Without people to appreciate nature's gift, would the pearl be worthless? From antiquity to the present, humankind as well as nature has lent the pearl its tremendous appeal.

No one knows when people discovered the pearl. Perhaps tens of thousands of years ago some hunter-gatherer, an early migrant from humankind's original home in east Africa, came upon an oyster on the shores of the Persian Gulf or the Indian Ocean. This wanderer must have been startled upon cracking open the muddy, gnarled shell and finding a perfect gem inside. Pristine and lustrous, radiating all the colors of the rainbow from its milky surface, that pearl no doubt astonished, and maybe even frightened, its discoverer. The pearl freely offered all its iridescent beauty and mystery for the taking, a marvel in a dangerous world defined by the harsh facts of brute survival. Plucked whole and brilliant from its briny hiding place, the pearl became one of humanity's first gemstones.

Ancient historical records and sacred texts show that, from the start, people ascribed supernatural attributes to the natural gem. Whether as spiritual symbol or source of esoteric powers, the pearl for millennia figured in myth, religion, folklore, healing, and magic. Countless theories about its origins, legends of its associations with heroes and gods, attempts to harness its potency, and exploitations of its charms to exalt deities attested to the pearl's unique status as an object of wonder. Through the ages, every culture familiar with the gem elevated it far above the rank of mere bauble, reserving for it a special reverence. Indeed, the roots of humankind's long-standing obsession with pearls reach far deeper than prosaic materialism.

MYTHOLOGY, SYMBOLOGY & FOLKLORE

Humanity has long struggled to define and understand its place in relation to such miracles of nature as the pearl. How and why nature operates as it does, and what humanity's role in that order should be, are questions that have occupied shamans, priests, philosophers, scientists, and ordinary people since time immemorial. Extraordinary events—birth, death, and the like—and objects—pearls and other gems, for instance—have served as focal points for that speculation. In these things, people have discerned the unity and harmony of nature; around them, people have created elaborate systems of belief. These belief systems, whether religious or secular, share certain constructs no matter where on the globe they appear. One such construct— mythology—represents humankind's attempt to explain the mysteries of life; another —symbology—offers concrete representations of spiritual truths; and a third—folk- lore—codifies cultural mores.

In his 1990 book, *Transformations of Myths Through Time*, Joseph Campbell, the great scholar of mythology, described two sides of the human psyche: "There is the animal human being who is practical and there is the human human being who is susceptible to the allure of beauty, which is divinely superfluous. This is the distinc- tion. This is the first little germ of spiritual concern and need, of which animals know nothing." If the awareness of beauty marks the difference between humans and ani- mals, human spiritual life logically begins there. Beauty was humankind's first link with the world beyond; hence, objects of beauty, such as pearls, became spiritually powerful—or at least spiritually evocative.

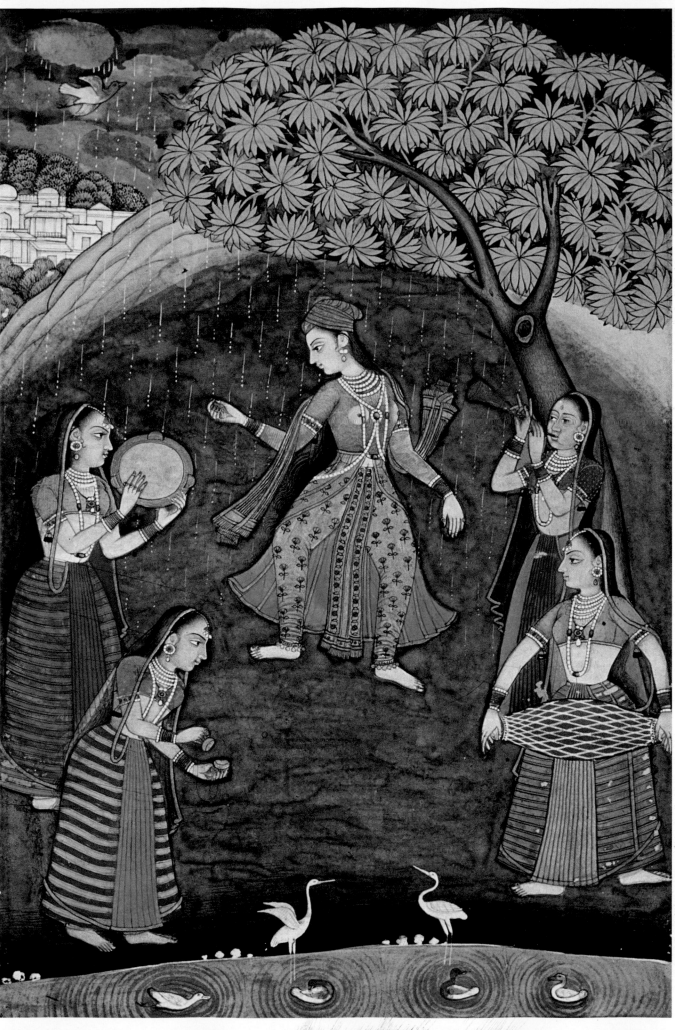

This 18th-century
Indian miniature
depicts a rain
dance in which
the power of
pearls is invoked.

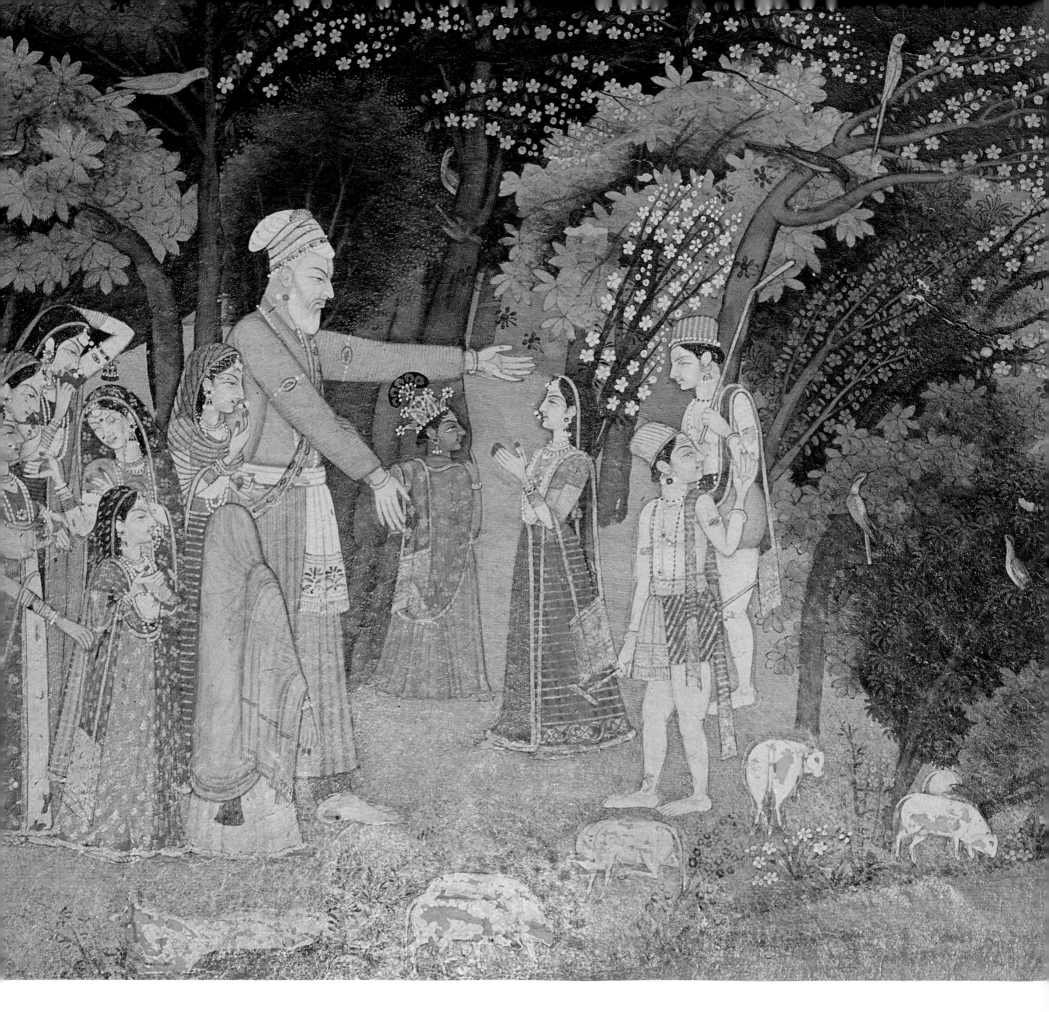

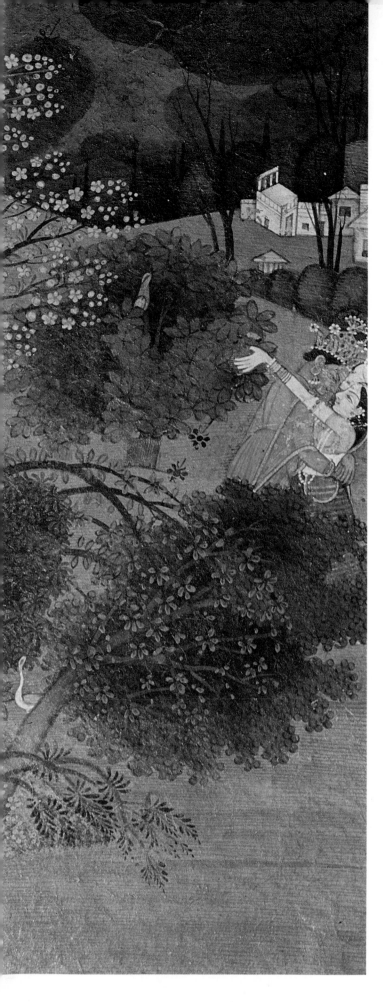

In many cultures, the pearl thus placed human beings firmly at the center of creation. Below humanity, and potentially subservient to it, was nature, of which humanity was of course a part. Above was the realm of the divine, with which people craved contact. But because, as every ancient culture posited, people had souls, they were also a part of the empyreal world. The pearl was both an offering to humankind from nature and the embodiment of sacred principles that were to guide human behavior. As trade and migration dispersed knowledge of the pearl throughout the world, basic beliefs concerning its significance spread also. The far-flung societies that cherished the gem altered their interpretations to fit local customs and devised their own mythologies to explain the gem's origins. Many of these myths shared remarkable similarities.

An Indian text entitled *Mani-Mála*, written in 1881 by Rajah Sourindro Mohun Tagore, records the ancient Indian belief that pearls originated in the foreheads, brains, and stomachs of elephants, as well as in clouds, boars, conch shells, fish, serpents, oysters, and bamboo plants. Each source, the oyster being the most abundant among them, produced gems with different characteristics. Cloud pearls, for instance, were said to attain the size of a hen's egg and could not generally be obtained by ordinary mortals. Owned almost exclusively by gods, cloud pearls radiated good fortune over the regions where they resided. Serpent pearls, meanwhile, supposedly had glowing blue halos and were borne by snakes descended from Va'suki, sovereign of the snakes. Humans rarely saw such pearls; those who did were persons of extraordinary merit.

Another ancient Indian belief took hold throughout the world and became a common pearl-origin myth. One kind of pearl, it was claimed, formed in the forehead of

Eighteenth-century illustration of a Krishna cult episode from the Indian text Bhagavat Purana.

the toad. This belief became so widespread that, centuries later, even Shakespeare referred to it in *As You Like It:*

> *Sweet are the uses of adversity,*
> *Which, like the toad, ugly and venomous,*
> *Wears yet a precious jewel in his head.*

Lesser-known myths gave other peculiar sources for pearls. In Malaysia, pearls were believed to form in coconuts, while in China, freshwater pearls supposedly grew in the chu-pick fish, probably a kind of squid. Some ancient Chinese also claimed a small, wild piglike animal as a source of pearls, while certain Chinese scholars asserted the gems originated in the brain of a dragon.

But by far the most common pearl-origin myths centered on drops of water falling from some heavenly source into the sea. According to Indian belief, both cloud pearls and oyster pearls originated in celestial water droplets. The seeds of moisture stayed in the sky to form cloud pearls, but fell into open oyster shells to become oyster pearls. According to popular Indian wisdom, oyster pearls formed during the season "when the sun rests upon the Swa'ti star" and grew as large as a nutmeg. Across the Indian Ocean, along the shores of Ethiopia, Benjamin of Tudela, a Spanish rabbi of the 12th century, observed local beliefs very similar to those of India. His notes appear in *Pearls and Pearling Life,* an 1886 volume by the British naturalist Edwin W. Streeter:

> On the twenty-fourth day of the month Nisan, a certain dew falleth down into the waters . . . and in the middle of the month Tisri, two men being let down by ropes unto the bottom, bring up certain creeping worms, which they have gathered, into the open air, out of which—being broken and cleft—these stones are taken.

Among the ancient Chinese, common wisdom held that the "mussel becomes pregnant by reason of thunder, and the pearl grows by moonlight." The Chinese and Japanese rain god, embodied as the sky dragon, released liquid droplets from its mouth during storms. Some of the raindrops settled in oyster or mussel shells that lay open near the surface of the rivers and ocean where they lived. Closing tightly around the rain god's precious seeds, the mollusks returned to their homes beneath the water. There, pearls grew from the solidified raindrops, nourished by the moonlight.

A Persian bowl and jar fragment dating from the 10th century employ a prominent pearl motif.

Ancient tile fragment with pearl imagery.

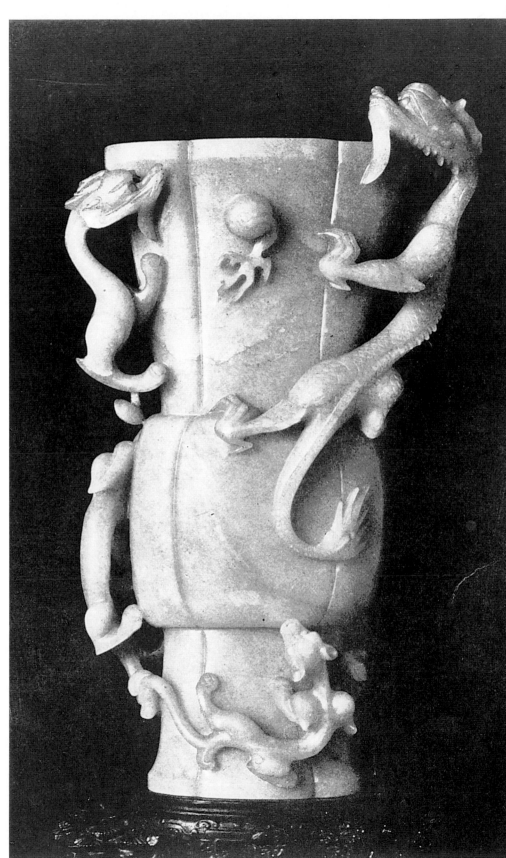

Jade vase on the theme of the Japanese legend of the dragon and the pearl.

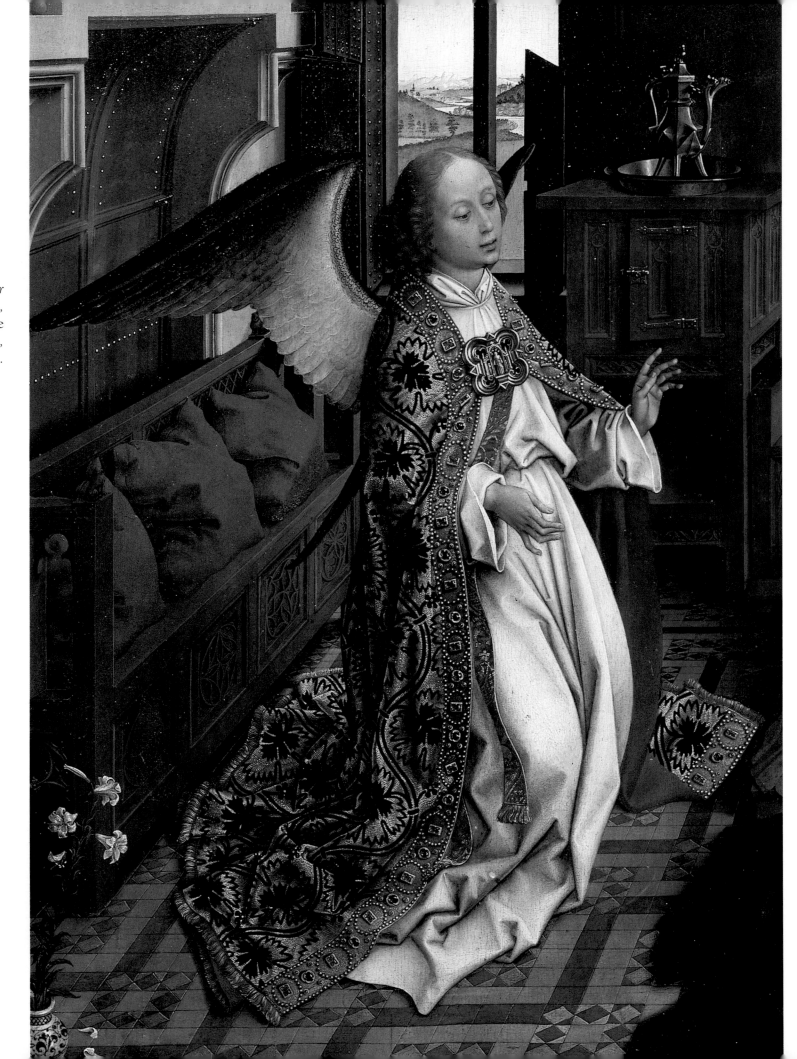

Detail from Rogier van der Weyden, L'Annunciazione (Annunciation), 15th century, oil.

Many peoples of the ancient Middle East also attributed pearl formation to droplets of moisture from the heavens. Instead of rain, however, their myths often referred to these droplets as the tears of the gods. On certain sunny days in spring, the typical version went, oysters rose to the ocean's surface and exposed their tender bodies to the light. Into their gaping shells fell the tears of gods weeping in the world above. Absorbing the sun's rays as they fell, the divine droplets offered rich nourishment to the mollusks. The oysters then snapped shut and carried their sacred cargo back to the deep, where the tears became treasures.

Persians who practiced the sun and fire worship of Zoroastrianism considered the sun's role in pearl formation even greater than that of the rain. One piece of evidence is a gold coin from the reign of Shah Akbar, which bears an inscription extolling "the sun from whom the seven seas obtained Pearls." More often, though, pearl myths named the moon as a player in the formation of the iridescent gem, as, for instance, Chinese legend did. But in either case, the conjunction of water with light or fire seemed to offer the key to the mysteries of the pearl. The gem, it was supposed, was the result of celestial power in the form of light combined with the converse element of water, and thus a physical representation of the divine.

Refocusing the notion of the divine origins of pearls to fit with their own mythology, the ancient Greeks associated the shimmering gems with Aphrodite, the goddess of love and beauty. Aphrodite, also known as Cytherea or, by the Romans, as Venus, was said to have risen from the foam of the sea. Bathed in radiant light and beguiling the world with her laughter, the goddess brought joy and sensuality with her wherever she went. When she stepped out of the sea at her birth, Aphrodite shook droplets of water from herself, droplets that hardened into pearls as they fell back into the ocean. To the Greeks, pearls held all the charms of the love goddess.

Greek pearl mythology also compared the gems with divine tears, a notion that would endure for thousands of years. In the 8th or 9th century B.C., the Greek poet Homer wrote in the *Odyssey*,

> The liquid drops of tears that you have shed,
> Shall come again transformed to Orient Pearl,
> Advantaging their loan with interest,
> Of ten times double gain of happiness.

Jean Fouquet,
Virgin and Child,
c. 1450–80,
tempera on panel
(right wing of the
Melun diptych).
Agnès Sorel,
the officially
recognized mistress
of France's
Charles VII, served
as the model for
this depiction of
the Madonna.

Centuries later, the Scottish poet and novelist Sir Walter Scott would recall Homer's image, writing in *The Bridal of Triermain*, "See the Pearls that long have slept./These were tears by Naiades wept."

The Greek understanding of pearl formation passed to the Romans as Rome conquered much of Greece. In the first century A.D., the Roman scholar Pliny the Elder recorded the state of contemporary wisdom concerning the origins of pearls. Passages from his *Historia naturalis* echoed the dew myths of many cultures:

> This shell-fish, which is the mother of Pearle, differeth not much in the manner of breeding and generation from the oysters, for when the season of the yeere requireth that they should engender, seeme to yawne and gape, and so doe open wide; and then (by report) they conceive a certaine moist dew as seed, wherewith they swell and grow bigge; and when time commeth, labour to be delivered hereof; and the fruit of these shell-fishes are the *Pearles*.

Pliny goes on to describe the influence of light on pearl formation, noting:

> Pale (I say) they are, if the weather were close, darke, and threatening raine in the time of their conception. Whereby, no doubt, it is apparent and plaine that they participate more of the aire and skie, than of the water and the sea; for, according as the morning is faire, so are they cleare; otherwise, if it were mistie and cloudie, they also will be thicke and muddie in colour.

The belief that pearls formed from hardened drops of dew suffused with sunlight or moonlight came to dominate European thinking on the origins of the gem. Remarkably, the Caribbean tribes encountered by the explorer Christopher Columbus late in the 15th century had developed an almost identical understanding of the pearls produced by a variety of mollusks that grew on the roots and branches of mangrove trees. That most cultures, no matter how different and distant from one another, considered the creation of pearls a supernatural product of fire and water reflects the mystical, mesmerizing qualities of the natural gem.

Well into the 17th century, and even later, many Europeans accepted the divine origins of the pearl. As late as 1684, for instance, the high-ranking Corraro family of Venice demonstrated its belief on a medal struck in honor of Elena Piscopia, a member

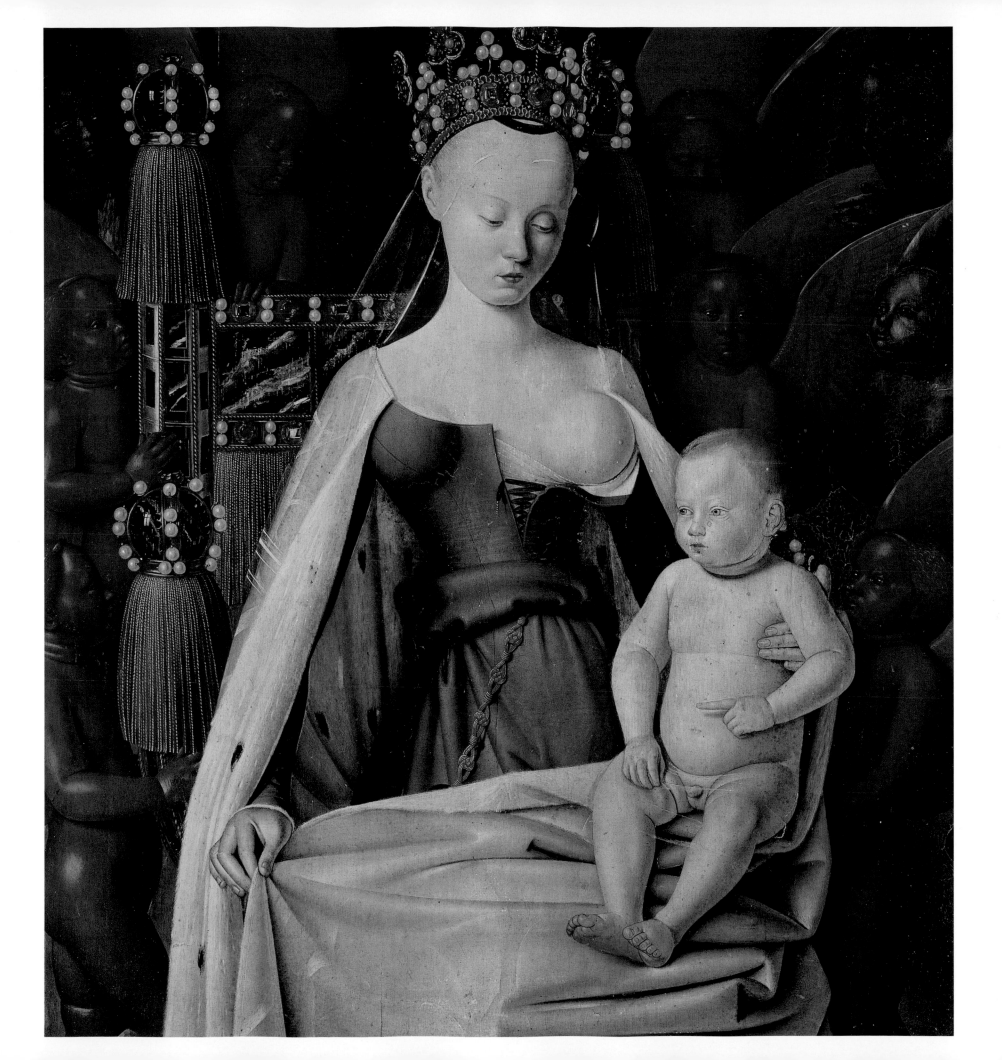

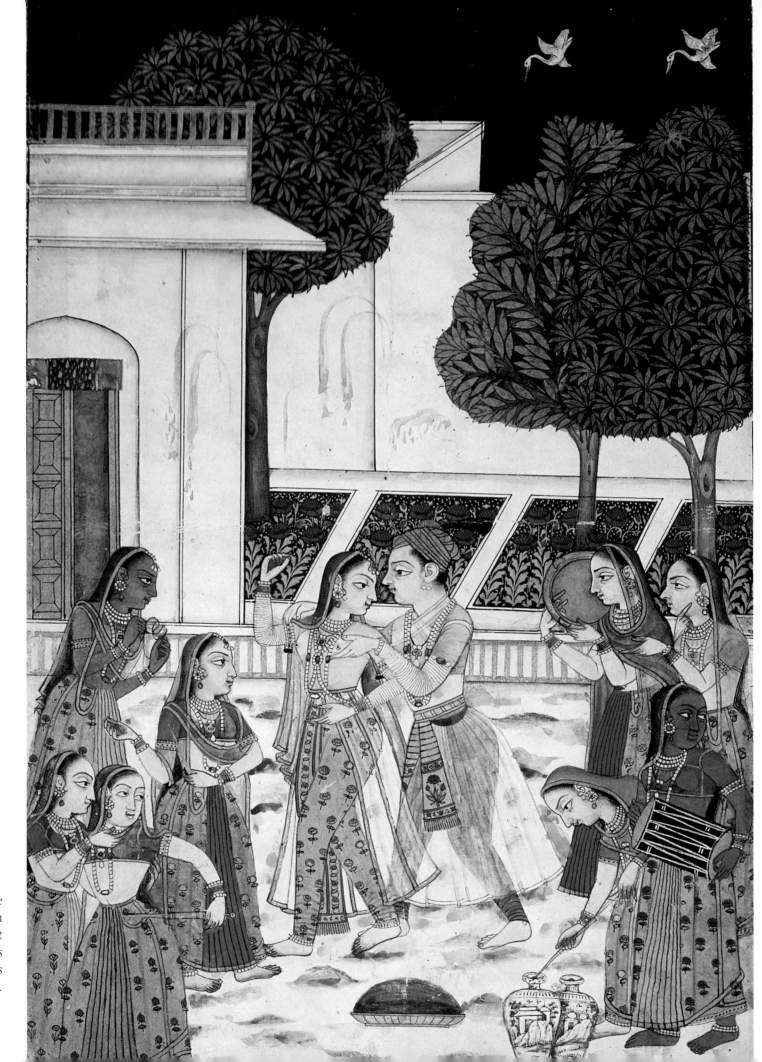

An erotic scene from an Indian manuscript shows dancers and musicians wearing pearls.

of the family. One side of the medal depicted an open oyster shell being sprinkled with water droplets, accompanied by the inscription "Rora Divine," which translates, "by the divine dew."

Of course, after having had for centuries the status of mythical creations, pearls were seen as supernaturally powerful. Indeed, some historians have argued that the human obsession with pearls originally sprang not from a lust for riches but from more spiritual motivations. Humankind long sought pearls not for their monetary value but for their supposed powers. The most commonly held belief concerning the power of pearls was that they conferred great vitality upon their owners. The pearl's association with the fundamental life force also made it a reliable indicator of the health of its wearer: the gem clouded if the wearer fell sick, and lost its luster completely if its owner died.

In Babylonia, the great Middle Eastern civilization that thrived in the 17th and 18th centuries B.C., people attributed to pearls and pearl shell life-giving powers that included the ability to restore youth. Early Chinese scholars assigned similar vital powers to the gems, as well as the power to prevent forest fires. Tales were told of pearls so luminous they could cook rice and could be seen from thousands of yards or even several miles away. Tibetan monks were said to possess a "seduction pearl" that would cause any woman caught in its rays to become ravenous for love. Pearls were also present in abundance in the Chinese version of paradise, a string of five islands whose residents enjoyed eternal youth. Harking back to the myth of pearl formation, the Chinese and Japanese closely associated pearls with dragons, who embodied certain gods and possessed their life-giving powers. Dragons stood watch over the "flaming pearl," a symbol of spiritual perfection.

Even as pearls assumed growing economic significance, they retained their position as coveted talismans. The ancient Romans believed pearls could promote marital bliss, depicting the marital bond between Cupid and Psyche as a strand of pearls whose ends rested in the hands of the god Hymen. In Wales, the Celts credited pearls with tremendous life-giving powers. They used the gems to embellish a sacred vessel known as the Mother-Pot, hoping to impart extra potency to the holy waters contained within. This Mother-Pot later became the Holy Grail of Arthurian legend, the object of the chivalric quest for immortality. In addition to the Holy Grail, ancient mariners sought pearl shell for the life force it contained.

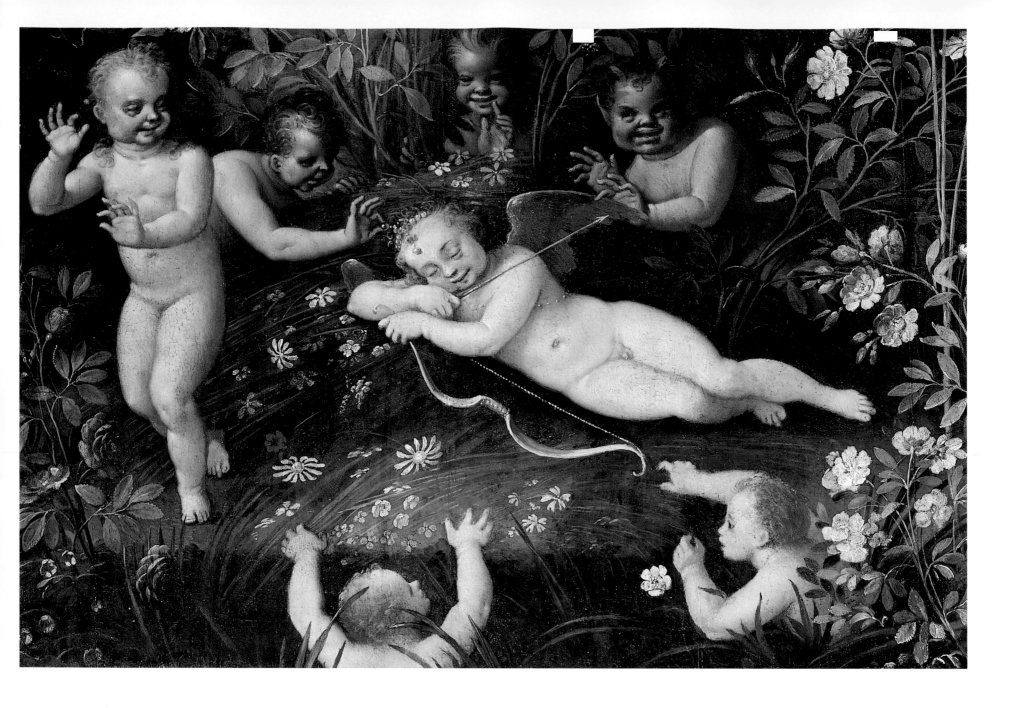

Ecole de Fontainebleau, Allegorie dit allegorie de l'eau (Allegory called allegory of Water), or Allegorie de l'amour (Allegory of Love), 1550–70, oil.

The supposed mythic origins and powers of pearls naturally made the gems potent symbols in every culture where they were valued. Pearls assumed both religious and secular meaning, conveying religious and moral concepts in many different societies. At times they were said to embody sacred beings or principles; at others they merely served as condensed expressions of abstract ideas. Either way, the gems derived their symbolic significance from their supernatural origins and powers. Because of the similarities of pearl-origin myths across cultures, much pearl symbolism is shared by many peoples.

Pearls represented preciousness to the ancient Chinese. Their milky luster symbolized purity, while their secret birth within homely mollusk shells was a metaphor for hidden genius. Lao-tzu, a Taoist philosopher of the 6th century B.C., used this last image when he wrote the proverb "The chosen one wears coarse garments, but in his breast he hides a precious stone." In another reference to the gem's origins, the

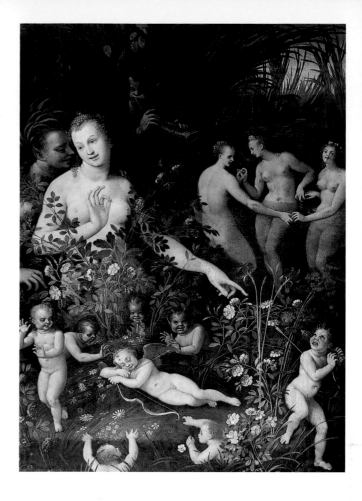

Chinese called their tears "little pearls" and sometimes placed pearls in the mouths of the dead.

In ancient Greece, the home of astrology, pearls assumed specific meaning for practitioners of that art. Astrologers divided the heavens into the twelve houses of the zodiac and assigned significance to the constellations and to the motions of the planets. Because of their appearance as well as their origins in the sea, pearls came to represent the moon, which controls the tides, in astrological symbology. In turn, the moon's association with the concepts of purity and virginity was transferred to the pearl.

Plato, the Greek philosopher, used the pearl to represent his "spherical man," an androgynous union of male and female into a single, essential human being. In Plato's schema, this complete being had perfect knowledge of the divine and was thus a veritable "pearl of wisdom." Ordinary Greeks, however, preferred a less cerebral interpretation of the pearl. The gem's mythological origins as a by-product of Aphrodite's birth translated easily into the symbolism of love and beauty. Aphrodite's followers also called her Pearl, or Pearl-of-the-Sea, and adorned likenesses of her with pearls.

Early Christians transformed the divine dew myth into a metaphor for the virgin birth of Jesus Christ, making the pearl an emblem of both Christ and the Virgin Mary. By extension, the pearl—a perfect gem encased in an unremarkable vessel—came to represent the soul housed within the earthly body. The pearly soul was innocent, pure and filled with faith and wisdom though surrounded by the corruption of the world. Before long, Christian pearl imagery became centered in Saint Margaret of Antioch, whose name was derived from *murawa, murwari,* or *mirwareed,* the Persian word for pearl, which translates "child of light." Saint Margaret, in fact, was closely identified with the goddess Aphrodite. The original legend of Saint Margaret referred to her as a former priestess of Aphrodite, a wealthy sacred prostitute, who converted to Christianity and gave all her possessions to the church. Similarly, the "pearly gates" that came to symbolize the entrance to the kingdom of heaven resembled Aphrodite's own pearly gate—the entrance to her sexual paradise.

The pearl's associations with sexual paradise extended to Islam as well. Islamic iconography employed the pearl as a symbol of heavenly sexual fulfillment. When the faithful died, they were encased in a pearl or surrounded by masses of pearls. There, they lived forever with their *houri,* the beautiful women who in Islamic belief accompany the blessed after death. This identification of the pearl with perfect sexual union

aligns with Plato's "spherical man" construct and parallels another Islamic notion about the gems. Because of their origins, pearls represented the conjunction of fire and water, a symbolic analog of the union of male and female.

Pearl symbology in the modern era includes a wide array of meanings. In heraldry, pearls symbolize high grace, particularly when set in a ring. The ancient associations with the moon still endure, as does the gem's significance as a metaphor for love and beauty. As a signifier of love, the pearl became a euphemism for the clitoris in Victorian times, recalling its place at Aphrodite's pearly gate. Its use in religious imagery, meanwhile, made it a generic symbol of salvation, while its monetary value made it a symbol of wealth. And in the 20th century, psychoanalysts employed the pearl in their work on dreams, interpreting it as a representation of the "mystic center," or soul. Tipping their hats to the scientific explanation of pearl formation, which described pearls as protective coatings around irritants within mollusks' shells, psychoanalysts have also seen the gem as a symbol of the sublimation of abnormal impulses.

Ordinary people throughout history translated the pronouncements of scientists, priests, and philosophers into the everyday lore of the pearl. Legends and other forms of folklore arose in which pearls played a part either as symbols or as objects of value; superstitions evolved concerning the powers of the mysterious gems. These popular fables and practices established the pearl's place in the cosmology of the commonplace, lending importance to the gem for people who could never hope to possess one. Just as important, amusing pearl stories allowed the less-than-wealthy to fantasize about the gem that obsessed the rich and powerful.

The romantic myth of the pearl's origins in divine dew inspired numerous fables that expressed various human virtues. Sa'dī, a 13th-century Persian poet, recorded an example of an early Christian parable in his *Būstān* (Fruit Garden):

> A drop of water fell one day from a cloud into the sea. Ashamed and confounded on finding itself in such an immensity of water, it exclaimed, "What am I in comparison with this vast ocean? My existence is less than nothing in this boundless abyss." Whilst it thus discoursed of itself, a Pearl-shell received it into its bosom, and fortune so favoured it, that it became a magnificent and precious pearl, worthy of adorning the diadem of kings. Thus was its humility the cause of its elevation, and by annihilating itself it merited exaltation.

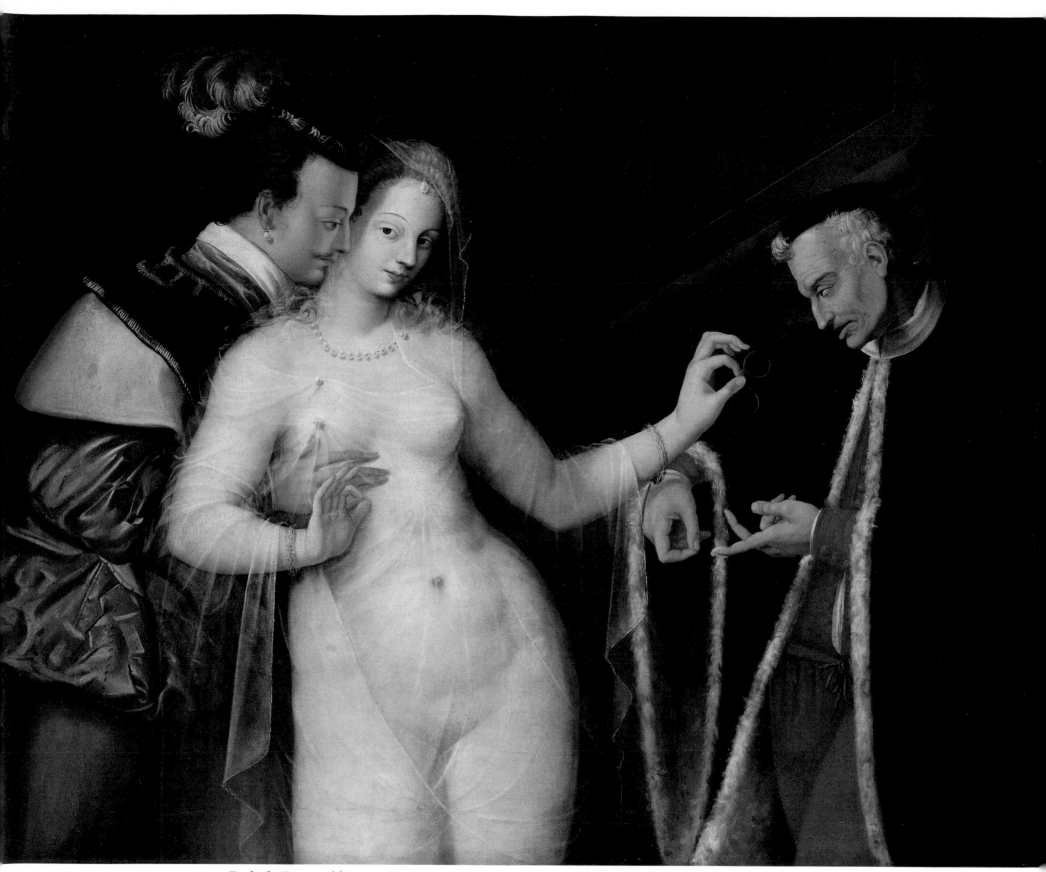

Ecole de Fontainebleau, La Femme entre les deaux âges (Woman Between Two Ages), 1550–70, oil.

Several European fables illustrate such virtues as purity, chastity, patience, and self-lessness in tales of brave oysters and still braver maidens, many of whom happened to be named Margaret.

Around the world, storytellers invented folktales in which the pearl figured as a token of wealth and good fortune. Tales from the Near East, the Far East, Europe, and North America differ in details, but all share a common theme: a person's worth can be measured by the wisdom and generosity—or folly and selfishness—brought out by riches and good luck. From Vietnam, for instance, comes *The Crow's Pearl*, the story of a poor youth who obtains from a crow a pearl that can grant him his wishes. The young man uses the pearl to gain a prosperous rice farm and beautiful wife; when greedy relatives steal the gem, the Lord Buddha helps him get it back so it will not be abused.

India offers *The Calm Brahman*, the fable of a young Brahman who scorns wealth in favor of learning, despite the complaints of his grasping family. A wealthy king who admires the fellow's piety grants him the only reward he will accept: two meager coins the king has earned with honest labor. When the Brahman's wife angrily hurls the coins out the back door of their house, two pearl-bearing trees grow and shower the wise man with riches. By contrast, *The Pearl Necklace*, a tale from Sri Lanka, tells of a mischievous monkey who steals a queen's string of pearls. The monkey's vanity causes him to lose the pearls when the queen's guards spot him showing off his prize and take it from him.

The Geese and the Golden Chain, a Mediterranean folktale, celebrates the virtue of generosity in the persons of Marziella and her brother Pedro. One day Marziella receives a charmed comb that releases showers of pearls whenever she runs it through her hair. She gives away these treasures until a king from a faraway land hears of the miracle and asks Pedro to bring her to him to be his queen. On the ocean voyage, a jealous young woman pushes Marziella overboard and steals her comb, planning to take her place as queen. But the comb draws only thistles from the thief's hair, and the angry king reduces the disgraced Pedro to herding the royal geese. Depressed and lonely, Pedro sleeps in a hut on the beach while his charges grow mysteriously fat. The king discovers that long-lost Marziella, rescued by a merman and held captive beneath the sea on a golden chain, has been visiting the beach and feeding the geese. Brother and sister are reunited, the chain is cut, and Marziella marries the king. In

the end, Marziella's miraculous comb eradicates poverty throughout the kingdom.

Another virtuous queen, this one from Sweden, triumphs over adversity in a tale called *The Queen's Necklace*. Married to a cruel king who has given her a pearl necklace and warned her not to lose it, the queen weeps for the suffering subjects tormented by her husband. One by one, she gives away her pearls to people who ask for her help. When the king discovers that her pearls are gone, he throws her into the dungeon. The queen's loyal subjects hear what has happened and send the pearls back to her in the beaks of small birds, saving her life. Soon afterward, the evil king dies and the queen becomes the beloved ruler of the land.

Folktales like these, as well as folk wisdom about the power and significance of pearls, evolved from ancient myths and beliefs about the gems. The Old World pearl lore eventually traveled to the New World and blended into a distinctly American set of superstitions. Some of these notions echo those of the distant past: in some parts of the United States, pearls worn by a sick person were believed to change color, a belief long held in the Old World. Other American ideas seem purely local: some white women, for example, had their black housekeepers wear their pearls as a means of restoring the luster of the gems.

The most widespread American pearl superstitions, though, have their basis in the ageless identification of pearls with tears. Those who dream of pearls will supposedly cry soon; those who break a strand of pearls will shed a tear for each bead dropped; those whose birthstone is not the pearl will have bad luck if they wear the gem. When it comes to pearls, American folk wisdom clearly sprang from sources thousands of miles and dozens of centuries removed. The world's youngest culture saw truth in the mythology, symbology, and folklore surrounding one of the world's oldest gems.

ASTROLOGY, ALCHEMY & DREAMS

The ancient mythological and metaphorical significance attributed to pearls made the gem an obvious subject of study for alchemists and astrologers, as well as for dream interpreters. Both astrology and alchemy set out to discern the influence of the planets and stars on earthly events. But while astrology resembled pure science in its attempts merely to understand humanity's place in the operations of the universe, alchemy was

Viktor Mikhailovich Vasnetsov, The Three Princesses of the Underground Kingdom, *1884, oil. The Russian folktale celebrates the riches of the earth in the persons of the princesses of gold, iron, and precious stones.*

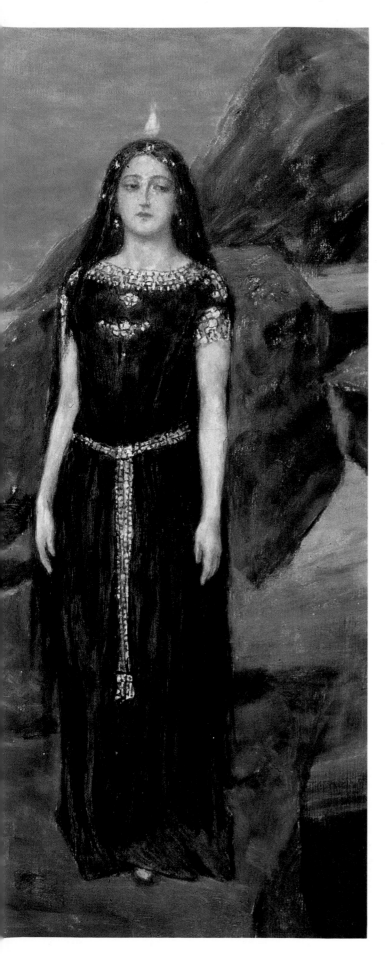

an early form of technology, in that it tried to exploit those operations to benefit people. Dream interpretation, meanwhile, remained an art whose practitioners hoped to relate humans to some kind of higher wisdom and power by analyzing the operations of the mind.

Emerging from humankind's timeless reliance on the heavens for spiritual guidance, astrology originated in Greece in the 3rd century B.C., long after the development of the world's early pearl cosmology. Although many cultures had long found meaning in the movements of celestial bodies, the Greeks were the first to assign specific powers to individual planets and constellations. They developed the familiar twelve-house zodiac system used to foretell the future based on the juxtaposition of the planets and the twelve astrological constellations. Before long, the Greek pursuit spread eastward to the peoples of the Middle East and Asia.

Closely associated in ancient mythology with the moon, the sun, and the heavens in general, pearls naturally assumed significance for astrologers. The pale luster and aquatic origins of pearls identified them most strongly with the moon, a symbol of purity, virginity, and solitude. Sometimes referred to as the "stone of the sea," the pearl was used in lunar rituals; its shimmering radiance also made it the gem of astral visions. Indians wore pearl necklaces and rings because of the gem's astrological power: the pearl was said to propitiate the moon. Because of the pearl's attributes, astrologers eventually connected it with the zodiacal sign of Cancer. In modern times, the gem became the birthstone of those born in the month of June. The birthstone supposedly gives its wearers the power to attract love, overcome annoyances, and cure fevers.

Alchemy developed a bit earlier than astrology, probably in China as an offshoot of that land's complex form of herbalism. Basing their manipulation of powerful substances in part on an evolving knowledge of astral omens, Chinese alchemists sought to create the "elixir of life," a potion that would make the human body immortal. Independently and in response to imported information, alchemists soon labored throughout Asia and the Middle East. Indian and Arab practitioners dabbled with organic and inorganic materials in search of healing remedies and rejuvenating concoctions. It was in Europe—in Greece, to be specific—that alchemy shifted its emphasis to the creation and imitation of precious metals and gems, such as pearls.

Alchemists, whatever their various immediate goals, worked from the basic prin-

ciple of transmutation, the transformation of bad into good. Base metals were to be turned into gold, illness into health, old age into youth, and death into eternal life. The widespread belief in the life-giving powers of pearls, as well as their great value as precious gems, thus attracted the attention of alchemists everywhere. Because of their associations with the vitally important element of water—whether in the form of divine dew or sea foam—pearls were assigned a special place in alchemy. Ancient texts record numerous efforts both to manufacture pearls and to employ them in healing and rejuvenation.

In their attempts to make precious substances, alchemists distinguished between the processes of aurefiction (creating a facsimile of the desired substance) and aurefaction (creating the actual substance wished for). The Chinese text *Tan Ching Yao Chueh* records the following recipe for imitation pearls:

> Take lustrous oyster shells, remove and discard the outer layer, and boil the rest in vinegar until cooked up. Remove from the flame and pull the product into thin filaments. Roll these into pearls of any desired size. Take a carp, lay its stomach open, place the pearls within, and close up the carp again. Steam it until it is extremely well done, and then remove the pearls.
>
> Before steaming the pearls use a pig's bristle to pierce holes for stringing. Then take muscovite and heat it in the milk of a white goat. After the milk has been raised to the boiling point several times, remove the mica. Warm the milk again, immerse the pearls in it, and let them steep overnight. Wash them clean, and they are done.

In Borneo, pearl fishers had their own alchemical formula for making real pearls. They claimed that a pearl would produce more pearls if it was placed with two grains of rice in a bottle that was plugged with a dead man's finger. Another ancient theory, possibly Greek, held that a pearl placed for some time in the womb of a dove would emerge brighter and more iridescent.

Alchemists found many medicinal uses for pearls, which were believed to be effective against everything from teething trouble to insanity. Modern Indian practitioners of *ayurveda*, a traditional form of medicine, still employ some of the old alchemical formulas to promote longevity, virility, and good eyesight and digestion. Much of the ancient Indian alchemy has been discarded, however, for obvious reasons. One recipe for a fever remedy called for such ingredients as mercury, gold,

silver, iron, mica, copper, tin, and pearls. Another case in point is the following cure for digestive problems, fever, diarrhea, and swelling, quoted in a 1984 translation of *Rasa-Jala-Nidhi, or Ocean of Indian Chemistry and Alchemy:*

> One part of mercury, two parts of gold, four parts of pearls, six parts of bell-metal, three parts of sulphur, three parts of burnt cowri shells, and one fourth part of borax are to be rubbed together with the juice of ripe lemon fruits, and confined in a crucible. This is then to be heated by putam, one aratni in length, breadth and height, each, by means of thirty pieces of cowdung cakes, found dried in pasturage. When cooled, the medicine is to be powdered. Dose, four ractis, to be taken with clarified butter, honey, and twenty-nine black peppers.

The alchemist's attempt to tap the supernatural powers of pearls on behalf of the human body corresponded to the dream interpreter's use of pearls in the analysis of the human psyche. For centuries, many Eastern cultures employed pearls in the interpretation of dreams, both as talisman and dream symbol. Pearls also figured prominently in the dreams of certain aboriginal Australians, who considered the dream state closer to reality than the waking state. And the 20th-century psychologist Carl Jung concluded that a pearl-bedecked Queen Elizabeth I, when she appeared in women's dreams, represented power. Thus, in the realm of dreams, as in astrology and alchemy, humankind's obsession with pearls flowered into much more.

POTIONS, COSMETICS & MEDICINAL REMEDIES

Early medicine was closely allied with and, indeed, at times indistinguishable from, astrology and alchemy. Ancient healers in many cultures attributed supernatural origins to diseases and hence sought supernatural remedies for them. The remedies were frequently manufactured and administered according to schedules that corresponded to the phases of the moon or other planetary movements. As a gem assumed to have supernatural qualities, including a strong connection with the moon, the pearl fit easily into the ancient pharmacy. It was, in fact, one of the earliest medicines used. Pearls were also thought to be an aphrodisiac and were first ground up for use in cosmetics by the ancient Egyptians and Chinese.

Long-standing beliefs about the affinity between pearls and their wearers led

people to devise any number of ways to "wear" pearls internally as well as externally. Pearls lent themselves naturally to use in cosmetics, for their mysterious luster remained intact when they were ground into fine powder. Applied to the skin, pearl powder added a seductive sheen to the wearer's appearance, giving him or her some of the allure of the pearl. Beyond enhancing physical beauty, pearl cosmetics supposedly imparted some of the gem's mystical and curative properties to wearers. Health, vitality, and personal character were thought to be bolstered by wearing pearls in this way. Aesthetics, however, lay at the root of the immense popularity of pearl face powder among the aristocratic women of 16th-century France, who were consumed by a pearl craze. Since then, pearl cosmetics have periodically enjoyed episodes of great demand.

Pearls had traditional medicinal uses in India, China, and throughout Asia. The

Pearls for sale at a medicine shop in Hong Kong.

ancient Greeks used pearls as well, even after Aristotle, Plato, and Hippocrates developed the foundations of Western medicine, which discounted ethereal influences on the human body. In China, healers prescribed pearl-based remedies for diseases of the eyes and ears; Japanese physicians treated their patients with pearl ointments and tablets to cure insomnia, gynecological problems, measles, whooping cough, and a number of other ailments. Throughout the East, whole pearls, pearl powder, and burnt pearls were used for heart disease, indigestion, and other problems and taken as stimulating and restorative tonics.

Pearls were used in modern times as well, in both Asia and Europe. Some old European potions that employed pearls probably made patients sicker than they were to start with. The following remedy for epilepsy, which appears in Bolton's *Follies of Science*, must certainly have done so—if, indeed, anyone ever took it:

> Calcine vitriol until it becomes yellow, add mistle-toe, hearts of peonies, elk's hoofs, and the pulverized skull of a malefactor; distill all these dry, rectify the distillate over castoreum and elephant's lice, then mix with salt of peony, spirit of wine, liquor of pearls and corals, oil of anisseed and oil of amber, and digest on a water-bath one month.

In the 17th century, Anselmus de Boot, physician to the Hapsburg emperor Rudolph II, brewed a somewhat less nauseating concoction, which he named "aqua perlata"—pearl water. The mixture of pearls, vinegar, sugar, and several more mysterious ingredients "is most excellent for restoring the strength and almost for resuscitating the dead," he claimed.

Indian practitioners of *ayurveda* used pearl powder—plain, burnt, or mixed with water—to relieve a wide array of bodily and emotional ailments, from poisoning to pain to fear. Taken in water, burnt pearl powder was believed effective against jaundice, heart disease, digestive difficulties, mental illness, bad breath, and the influences of evil spirits. As a cure for headaches, ulcers, cataracts, and other eye disorders, patients inhaled burnt powder through the nose. Pearl powder applied to the skin supposedly cured leprosy; used as toothpaste it strengthened the teeth and gums. Gout, smallpox, and lung diseases were also treated with pearl medicines.

Commonly used in most parts of the world, from the Persian Gulf—as a remedy for malaria and hemorrhaging—to Great Britain—as an antacid and astringent—

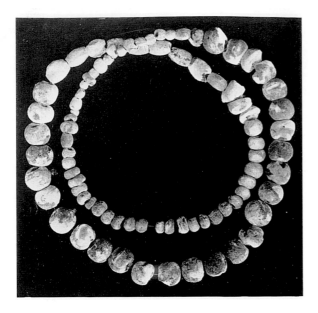

Necklace of freshwater pearls and cut-shell beads, from the Hopewell Indian burial mounds in Ross County, Ohio.

pearls retained a central place in the world's pharmacy until the advent of scientific medicine in the late 19th century. Shunning centuries of knowledge cultivated by folk healers, Western doctors dismissed pearls as having no greater medicinal value than common chalk. Believers in the powers of pearls nevertheless continued using the gems, particularly in the East. Indian healers have preserved many of the old recipes and apply them much as they did in the past. In China, apothecaries still sell whole pearls for use in traditional cures. The Japanese, meanwhile, today treat the common cold with pearl powder and manufacture crushed pearl tablets as a source of calcium. Relying on ancient wisdom, many Japanese take these pills to restore and maintain vitality and to promote longevity. Even in Germany, pearls are made into pep pills. And so the pearl remains a potent potion for those who believe in its metaphysical nature.

SACRED PEARLS & WORLD RELIGIONS

From prehistory, pearls have been a motif and metaphor in virtually all the world's systems of worship. As gems of celestial origin and mystical power, pearls have served as symbols in a diversity of religions; as objects of great beauty, they have decorated ritual objects, clothing, and places of worship around the globe. Pearls employed in a religious context were and are expected to function much as any other ceremonial object, drawing heavenly powers down to earth and elevating the human soul toward heaven. Shrines, temples, and sanctuaries embellished with pearls seemed somehow holier for it, while pearl-studded garments and paraphernalia—incense burners, candle holders, gongs, and the like—somehow promised special efficacy.

The earliest proto-religions included the animistic worship of the sun and the moon. Pearls assumed sacred significance because of their association with both of these heavenly bodies. Indeed, the gems may have first been worn in earrings meant to link the wearer with the moon. Pearls were also used in amulets that protected their owners from danger, illness, and bad luck. In the indigenous cultures of the Americas, pearls were collected in great quantities and used to decorate temples. The mounds built by the Hopewell Indians in the region that is now Ohio, which are some of the most ancient human artifacts in North America, contain large caches of pearls.

Generally regarded to be the world's oldest organized religion, Hinduism used

pearl imagery in its holy texts, or Vedas, dating from as early as 1000 B.C. The oldest of the Vedas, the *Rig-Veda*, employs the term *krisana* several times to refer to pearls. The *Atharva-Veda*, written about 500 B.C., records a hymn to be sung when bestowing a pearl amulet upon a Brahman youth:

> Born of the wind, the atmosphere, the lightning, and the light, may this pearl shell, born of gold, protect us from straits! . . . With the shell [we conquer] disease and poverty; with the shell, too, the Sadanvas. The shell is our universal remedy; the pearl shall protect us from straits! . . . The bone of the gods turned into pearl; that, animated, dwells in the waters. That do I fasten upon thee unto life, luster, strength, longevity, unto a life lasting a hundred autumns. May the amulet of pearl protect thee!

The ancient Indian epics *Rāmāyana* and *Mahābhārata* make several references to pearls, including a description of the pearl as the sea's gift to the gods. Throughout Hindu literature, pearls appear frequently in tales of Krishna, the eighth incarnation of the god Vishnu. In one story Krishna dives into the sea to retrieve a pearl as a wedding gift to his daughter; in another, he wins a pearl as a trophy for vanquishing a monster. Hindu art underscores the significance of the pearl in that faith, depicting gods and practitioners wearing the gem.

Probably because of strictures against graven images, Judaism employs pearls far more sparingly in its decorative arts. The Old Testament, however, does include some pearl imagery. In its description of the land around Eden, Genesis 2:12 mentions the presence of bdellium, generally understood to be pearls. Numbers 11:7 also refers to bdellium, comparing it to the manna with which God fed the Jews journeying through the wilderness with Moses. Both references establish the high value the ancient Jews assigned to pearls, as does a rabbinical story about the patriarch Abraham and his wife, Sarah. Sent by God to Egypt, Abraham hid the beautiful Sarah in a chest to protect her from foreigners. At the Egyptian border the customs collectors asked Abraham to pay duty on the chest. Hoping to keep them from opening the chest, Abraham agreed to pay whatever price they asked. When he consented to pay the highest duty, as if the chest were filled with pearls, the startled collectors opened the chest to find out what item of such great value it could contain. Sarah's dazzling beauty shone forth, brightening the entire land.

Late 17th-century Russian Orthodox clergy stole.

КАЗАНСКІЯ ПР. БЦЫ.

Left: Aleksandra Makhalova, Our Lady of Kazan, 19th century, mixed-media icon.

This Russian icon depicts the Madonna and Child. As was typical, the holy painting is almost entirely covered with pearls, gold, and other precious metals and stones.

Chinese Buddhism included pearls among the eight "jewels," also known as the eight "precious things" or "common emblems," of its iconography. The gem's association with paradise and its supposed power to confer immortality heightened its sacred significance. During the third century, the scholar Yang Xuan Zhi reported that pagodas in western China were often draped with nets of pearls.

The mystery cults of Greco-Roman times, which reached their zenith in the third century, also found special meaning in pearls. These cults were devoted to such concerns as the creation of the world, the human soul's original purity, its fall from grace, and its means of redemption. Among the Manichaeans of Persia, the pearl represented the perfect combination of reason and religious feeling, a state of consciousness that made one invulnerable to the evils of the world. At least one example survives of the pearl's metaphorical significance in the mystery religions. The "Hymn of the Soul" recalls the ancient Chinese and Japanese legend of the dragon and the pearl. In the story, the hero—who represents the human soul—makes a pilgrimage to the sea (the world) to take a pearl from the mouth of a dragon. Once he leaves his parents' home (heaven), he forgets his mission and becomes enamored of worldly things. A letter from his parents reminds him of his task, and he obtains the pearl before heading back. As he travels, he is joined by his brother (the redeemer), who guides him home.

Prayer book owned by Charles the Bald, who ruled France as Charles I in A.D. 840–877 and, as Charles II, was Holy Roman emperor in A.D. 875–877. Photo courtesy of Fred Ward.

The early Christians considered the pearl a powerful symbol of purity, faith, and the virgin birth of Christ. Named for the sacred gem, Saint Margaret of Antioch, the "virgin martyr," was often depicted wearing a string of pearls. The writers of the New Testament, notably the apostle Matthew, used pearl imagery to illuminate their ideas. Matthew recorded the famous "Sermon on the Mount," in which Christ warns his followers, "Neither cast ye your pearls before swine, lest they trample them under their feet, and turn again and rend you" (Matthew 7 : 6). Later in his gospel Matthew records Christ's parables, including this one: "Again, the kingdom of heaven is like unto a merchant man, seeking goodly pearls: Who, when he had found one pearl of great price, went and sold all he had, and bought it" (Matthew 13 : 45–46). The book of Revelation, attributed to John, describes the kingdom of heaven, a place of supreme

beauty. In Paul's vision, heaven's walls were adorned with jewels, "and the twelve gates were twelve pearls, each of the gates made of a single pearl" (Revelation 21 : 21). Elsewhere, the kingdom of heaven is compared to a "pearl of great price."

As Christianity developed into a world religion comprising numerous sects and encompassing diverse rituals and practices, pearls assumed a decorative as well as symbolic significance in the church. The Catholic and Russian Orthodox churches were especially lavish in the use of the gem, encrusting vestments, crucifixes, reliquaries, and missals with them. To the greater glory of God, the saints, or the church, artisans crafted elaborate pearl-studded icons portraying holy figures and episodes. Some worshipers even prayed with rosaries made from pearls or mother-of-pearl. Wealthy and royal church members strove to outdo each other with gifts to the church, including vast quantities of jewels and pearls. In fact, according to *The Book of the Pearl*, written in 1908 by the gemologists George Frederick Kunz and Charles Hugh Stevenson, "For several centuries . . . the greatest treasures of jewels seem to have been collected in the churches." Even during the difficult and impoverished Dark Ages, Kunz and Stevenson wrote,

> the churches of western Europe received many gems from penitent and fear-stricken subjects. The heart of man, filled with the love of God, laid its earthly treasure upon the altar in exchange for heavenly consolation. Pious faith dedicated pearls to the glorification of the ritual; altars, statues, and images of the saints, priestly vestments, and sacred vessels, were surcharged with them.

The lengths to which the Christian church went in its pearly efforts to awe believers and honor God reflect the gem's unique and enduring ability to captivate humankind. Whether as a religious appurtenance, a healing agent, a mythical symbol, or an object of wonder, the pearl has always been a metaphor for humanity's fascination with the mysteries of the universe and the miracles of nature. From the moment of its discovery, hidden somewhere in the mists of time, this natural gem—both quintessential ornament and ultimate obsession—has had a powerful effect on human consciousness and history.

Czar Ivan IV, known as Ivan the Terrible, ordered this altar cross from the Kremlin workshops in 1562 and donated it to the Solovetskiye monastery.

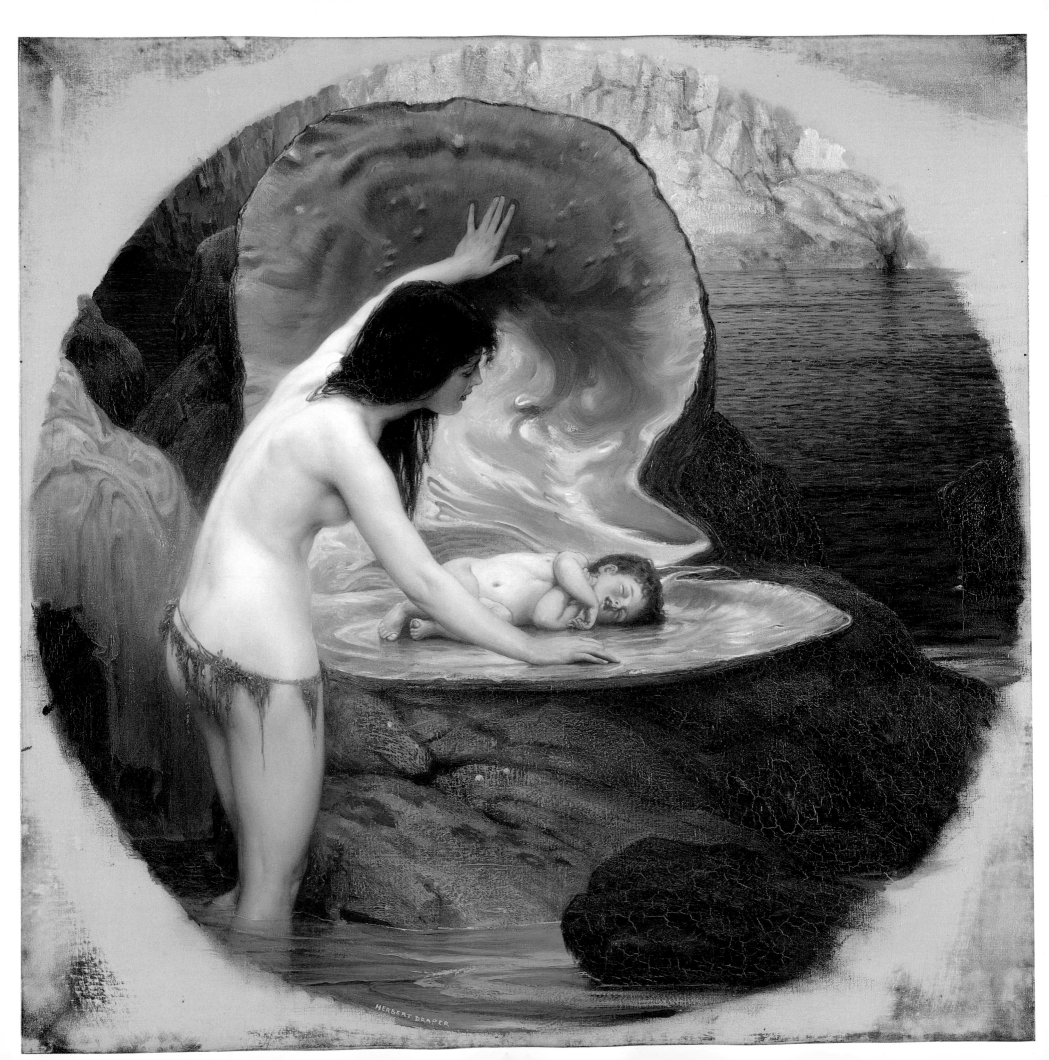

HERBERT DRAPER

Learn from Yon Orient Shell

SCIENTIFIC FASCINATION WITH THE CREATION OF A NATURAL GEM

Herbert Draper,
A Water Baby,
1890, oil.

Human wonder at the mystery of the pearl long inspired all manner of speculation on the gem's origins and nature. The conjecturing assumed mythological, alchemical, and religious form during the millennia in which those modes of thought served to explain the workings of heaven and earth. As modern scientific thinking evolved, however, pearl theorists applied a new kind of logic to their endeavors. Whereas allegory and symbolism had provided the ancient framework for understanding pearls, the budding disciplines of biology, chemistry, zoology, and physics gradually replaced poetry with the scientific method. But even as scientists revealed many of the pearl's secrets, the gem retained its enigmatic appeal.

Somehow, the more people knew about the pearl, the more extraordinary nature's perfect gem seemed. Pearly essentials that remained unexplained drew succeeding generations of researchers into the exploration, even as the iridescent jewel enjoyed incessant international popularity. Yet, with each new fact gemologists uncovered, the pearl grew ever more amazing and enchanting. Science could illuminate but never capture the gem's charms; the experts merely added their numbers to those who had long been obsessed with the pearl.

Until the 16th century, the overwhelming majority of scientists who studied pearls

corroborated the generally accepted belief that pearls were solidified drops of rain or dew. The ancient Greeks, among whom appeared the earliest forerunners of modern scientists, held to the dew theory, as did the Roman scholars who helped initiate the scientific tradition. In 1st-century Rome, for example, Pliny the Elder wrote in his *Historia naturalis* of pearl-bearing oysters that "conceive a certaine moist dew as seed." Marbodus, another naturalist of the period, described the origins of pearls in his *Lapidarium* (literally, "on stones"):

> *At certain seasons do the oysters lie*
> *With valves wide gaping t'ward the teeming sky*
> *And seize the falling dews, and pregnant breed*
> *The shining globules of th'Ethereal seed.*

Before the scientists of Greco-Roman civilization started to study pearls, a few Chinese thinkers familiar with the gem had expressed doubt about the dew theory. The unattributed book *Huai Nan Tzu*, written in the 2nd century B.C., states that "though luminous pearls are an advantage to us, they are a disease for the oyster." Judging by early attempts at pearl culturing—none of which involved dew or raindrops—we see that the dew theory was at least partially discounted in China long before it was disproved in Europe. Recent research by scholars at Stanford University has shown that knowledge of how to stimulate pearl production was widespread in China by the 5th century, not the 12th century, as was previously believed. The Chinese used their insight to produce pearlized Buddha figurines. Practitioners of that art placed tiny carved Buddhas inside the shells of freshwater mussels, removing them after sufficient time had passed for a pearl coating to form. These were the first cultured blister pearls.

Meanwhile, it took Europeans until the middle of the 16th century before they began to rethink their notions of pearl formation. The relative scarcity of pearl-bearing mollusks in Europe may have slowed European study of the creatures. In 1554, the French naturalist Guillaume Rondelet became the first to advance an alternative theory of pearl origins, suggesting that pearls might be cysts or other accretions that build up in response to the intrusion of disease or irritants in the oyster's shell. The move-

ment away from the dew theory took another direction in 1578, when Girolamo Benzoni's *Historia del Mondo Nuovo* proposed that "it is the germ and the most noble part of the eggs of the oyster which are converted into pearls."

Whatever the actual source of pearls, learned Europeans had widely acknowledged the implausibility of the dew theory by the end of the 16th century. A book entitled *Voyage to the South Sea in 1593*, by the ship's captain Sir Richard Hawkins, summed up the general opinion of the ancient theory, calling it "some old philosopher's conceit, for it can not be made probable how the dew should come into the oyster." The study of the pearl now proceeded along two lines, which had as their starting points the original theories of Rondelet and Benzoni. Before long, a scientist interested in Rondelet's disease theory made a breakthrough in the understanding not only of the origins but of the composition of pearls.

In his 1600 work *Gemmarum et lapidum historia*, Anselmus de Boot observed that pearls

> are generated in the body of the creature of the same humour of which the shell is formed . . . for whenever the little creature is ill and hath not strength enough to belch up or expel this humour which sticketh in the body, it becometh the rudiments of the pearl; to which new humour, being added and assimilated into the same nature, begets a new skin, the continued addition of which generates a pearl.

Although de Boot did not quite hit upon the stimulus for pearl formation, he knew it had something to do with disease. He was also the first to establish that pearls are made of the same substance as the smooth mother-of-pearl linings of oyster shells.

Eight years later, the Portuguese adventurer Pedro Teixeira confirmed de Boot's findings in his volume *The Travels of Pedro Teixeira*. "I hold it for certain that pearls are born and formed of the very matter of the shell," he wrote. Adding his voice to the growing chorus of disease theorists, Teixeira went on to note, "Whatever oyster contains pearls has the flesh unsound and almost rotten in the parts where the pearls are produced, and those oysters that have no pearls are sound and clean fleshed."

Notwithstanding Teixeira's observations, the egg theory of pearl formation remained popular. Numerous naturalists working in the 17th century echoed the notions expressed by Benzoni, which in fact had their roots in the 15th century. In 1674, for

instance, a scholar by the name of Christopher Sandius recorded in a letter the hypothesis of "Henricus Arnoldi, an ingenious and veracious Dane." According to Arnoldi, a certain freshwater mollusk of Norway

> produces clusters of eggs; these, when ripe, are cast out and become like those that cast them; but sometimes it appears that one or two of these eggs stick fast to the side of the matrix, and are not voided with the rest. These are fed by the oyster against her will and they do grow, according to the length of time, into pearls of different bigness.

More theory than observation was at work in Arnoldi's assertions, as became apparent with the increasing refinement of scientific technique in the 18th century. Soon after Sandius sent his letter, the egg theory of pearl formation lost most of its adherents, but in some quarters the idea persisted into the early 1800s.

In the first half of the 18th century, the French naturalist and physicist René-Antoine Ferchault de Réaumur concluded that pearls are dislocated bits of shell lining, formed when the organ that manufactures that substance malfunctions in response to some irritation. Réaumur further made the observation that concentric layers of shell-lining material make up pearls. In 1761, the great Swedish botanist Carolus Linnaeus applied the knowledge of the disease theorists to the first European attempt to culture pearls. He placed small fragments of foreign matter inside the shells of living mollusks in an effort to verify whether such intrusions in fact caused pearls to form. The experiment was a success, though the pearls produced were of very poor quality.

Pearl science progressed steadily in the 19th century, as naturalists all over the world struggled to solve the riddle of pearl formation. In the mid-1800s, major advances in biology and scientific technique, such as the methods originated by the naturalist Charles Darwin, encouraged pearl researchers to try new approaches and move forward rapidly. The Italian naturalist Filippo de Filippi made a significant discovery in 1852, when he found that freshwater mussels produce numerous small pearls in the presence of various parasitic worms that prey on mollusks. His findings were duplicated seven years later by a medical officer named E. F. Kelaart, who observed large quantities of parasites in the famous pearl-producing oysters of Sri Lanka. Both scientists agreed that pearly growths form around pests that penetrate

into mollusk shells, and that these growths seem to protect the creatures' soft bodies against irritation.

During the last decades of the 19th century, many pearl experts focused their attention on the parasite theory, which received confirmation from several sources. Some scientists, however, turned their attention to pearls that do not seem to have parasitic origins. It became apparent that any number of intruders—grains of sand, bits of mud or seaweed, even tiny crabs or fish—can start the formation of a pearl. Occasionally, some naturalists observed, pearls form without the benefit of external stimuli, when natural concretions of shell material (known as calcospherules) form within a mollusk and attract pearly buildup.

By the turn of the 20th century, scientists had come to a fairly accurate understanding of pearl origins. They now knew that pearls form in response to the presence of an irritant—whether parasite, pebble, or calcospherule—within the mollusk's shell. From the scientific point of view, pearl production is the mollusk's reflexive attempt to protect itself against injury and disease. The result of this mundane activity is, of course, far from mundane, demonstrating in lustrous fashion the glory of nature's wisdom. Thus, in plumbing the mysteries of a natural phenomenon, science had proved the truth of a proverb written in the 14th century by the Persian poet Moham-mad Shama od-Din Hafez:

> *Learn from yon orient shell to love thy foe*
> *And store with pearls the wound that brings thee woe.*

THE SHELL & THE CREATURE WITHIN

What is this creature that manufactures one of the earth's most valuable gemstones? With its slippery body and craggy shell, the typical mollusk presents an unassuming countenance to the world, but it is capable of one of nature's most miraculous feats. All 128,000 living species of the phylum Mollusca can—as 35,000 fossil species once could—produce pearls, but only a few of these varieties make the gleaming beauties prized as jewels. The oysters and mussels savored as delicacies by humans do not yield pearls of value, while the pearl-bearing varieties are only barely edible. Whatever

The Jomon pearl of Japan, the oldest known extant pearl, dates back 5,500 years.

the pearl-bearers may lack in flavor, though, they more than make up for in the splendor of their iridescent product.

Dating back to the Cambrian period 530 million years ago, mollusks have found a home in almost every corner of the globe. They live in oceans, salt marshes, lagoons, rivers, lakes, and swamps, and on dry land. The second-largest phylum of creatures in the animal kingdom, mollusks fall into one of two categories: the univalves, or gastropods, and the bivalves. The term "valve" here refers to the shells of these soft-bodied invertebrates—indeed, mollusks produce all the world's seashells. Univalves, like the nautilus or the land snail, have a one-piece shell, while bivalves, like the clam or the scallop, have a hinged, two-piece shell. Among the bivalves are the pearl-bearing oysters and mussels; the productive univalves include the abalone, which makes especially lovely mother-of-pearl, and the great conch, which makes pink pearl-like gems.

The mollusks that produce jewel-quality pearls and mother-of-pearl live in a remarkable range of habitats. Freshwater varieties live in the rivers and lakes of China, Great Britain, the European continent, and North America. Saltwater species can be found throughout the Pacific islands from Japan to Australia, along the Atlantic and Pacific coasts of Central America, in the Gulf of Mexico and the Caribbean, among the islands of the English Channel, and in the waters of the Arabian Sea. Before they were fished out, the most valuable natural pearls came from the Persian Gulf, from Sri Lanka's Gulf of Mannar, from the Gulf of Aden at the mouth of the Red Sea, from Burma, from the Sulu Archipelago in the Philippines, from Fiji, from the Tuamotu Archipelago of French Polynesia, and from the Torres Strait, which separates New Guinea from Australia.

Like all mollusks, pearl-bearers prefer sheltered homes in coastal areas. They live in large groups, clinging to banks called paars. Ideally, pearl oysters locate paars that offer abundant rocky anchorage, known as cultch, below the low-tide line in about 40 feet (12 meters) of water. Although their tough shells provide dependable protection from predators, they are subject to the appetites of starfish, sea urchins, sponges, and other creatures. Pearl oysters, for their part, feed passively, by opening their shells and ingesting whatever plankton comes their way. By contrast, they reproduce feverishly, entire banks releasing great quantities of sperm and ova all at once in late summer. Hundreds of thousands of fertilizations take place simultaneously in the

froth, producing tiny larvae, termed spats. Those spats fortunate enough to avoid the hungry prowling of fish and rays eventually grow into oysters.

Within the shell of the adult oyster lives a simple soft-bodied creature with no spine or skeleton—or even any identifiable head. Its mass of viscera consists of gills for extracting oxygen from the water, a palp or palpus for drawing food into its mouth, a primitive nervous system, and organs for digestion, excretion, circulation, and reproduction. Its two muscles, the adductor and the foot, respectively open and close the shell and propel the oyster through water. The foot also contains a gland that secretes fibers with which the oyster anchors itself to stationary surfaces. Encasing the oyster's body and separating it from the shell is the mantle, a flap of skin also referred to as the epithelium.

It is the mantle that manufactures the materials from which the oyster's shell is formed. As the creature grows, or when its shell is damaged, the mantle releases two calcium-based compounds to enlarge or repair the shell. Near the lip of the shell, where the mantle is thicker, its epithelial cells secrete conchiolin, a protein that cements together the calcium crystals that form the periostracum, the brown or yellow outer shell. Once formed, the periostracum remains the same thickness throughout the life of the oyster, although the shell continues to grow in diameter. The periostracum covers the middle layer of the shell, a thicker stratum made of calcium carbonate hardened into crystalline calcite. Deposited by the portion of the mantle just inside the thick outer edge, the shell's middle layer also maintains a constant thickness after formation.

The innermost layer of the oyster's shell, however, grows continually thicker during the creature's lifetime. This is the mother-of-pearl, or nacre, released by the entire exterior surface of the mantle as a smooth, comfortable lining for the shell's interior. In *The Book of the Pearl* (1908), George Frederick Kunz and Charles Hugh Stevenson describe this layer of nacre in sumptuous terms:

> The pearl-bearing mollusks are luxurious creatures, and for the purpose of protecting their delicate bodies they cover the interior of their shells with a smooth lustrous material, dyed with rainbow hues, and possessing a beautiful but subdued opalescence. No matter how foul, how coral-covered, or overgrown with sponges or seaweeds the exterior may be, all is clean and beautiful within.

Like the shell's middle layer, mother-of-pearl is made of calcium carbonate, but in nacre the compound crystallizes differently, into a substance called aragonite. Instead of calcite's trigonal (hexagonal) crystals, aragonite has orthorhombic crystals with eight triangular faces. The crystals form microscopically thin plates, which are cemented together by conchiolin in an overlapping pattern. The resulting nacre is a translucent film marked with hundreds of serrated ridges. When light plays over the striations on a mother-of-pearl surface and shines through to the layers of nacre below, it creates iridescence. The same principle applies to pearls, which are also composed of nacre.

Just as the nacreous lining of an oyster's shell provides the tender creature with a healthful, pleasant living environment, so do the nacreous growths known as pearls protect the oyster from damage. Irritants such as sand and parasites are bound to enter the mollusk's sanctum when its shell is open; some pests even bore right through the oyster's armor. When such a misfortune befalls the mollusk, its natural defenses spring to action in order to contain the threat. If the intruder lodges between the shell and the mantle, the mantle simply deposits a layer of nacre over it, trapping the offending particle against the shell wall. Invaders that penetrate the oyster's muscles or viscera are soon surrounded by a cyst of epithelium identical to the mantle tissue. The inner walls of this pearl sac secrete nacre to coat the foreign body. As time passes, new layers of nacre are added, transforming the irritant into a pearl.

The pearly shapes that result from the oyster's attempts to defend itself depend on the location of the pearls in the shell. Those that grow against the shell wall resemble buttons, blisters, and hemispheres, while those that grow in muscle tissue take on a variety of irregular forms. Unhindered by the limitations of confining locales, spherical and near-spherical pearls develop in the soft parts of the oyster's viscera, which more easily accommodate their growth. The ideal place for a spherical pearl to grow is a natural pocket between the creature's stomach and kidneys. Pearls formed in the viscera are often more lustrous as well, because they lie far from the mantle's edge, where nacre of poorer quality is produced.

Cultured pearl cultivators use their knowledge of oyster biology to induce pearl formation under controlled conditions. Since the late 19th century, when Japanese inventors, most notably Kokichi Mikimoto, defined the principles of modern pearl culturing, ongoing experimentation has yielded cultured pearls of increasingly fine

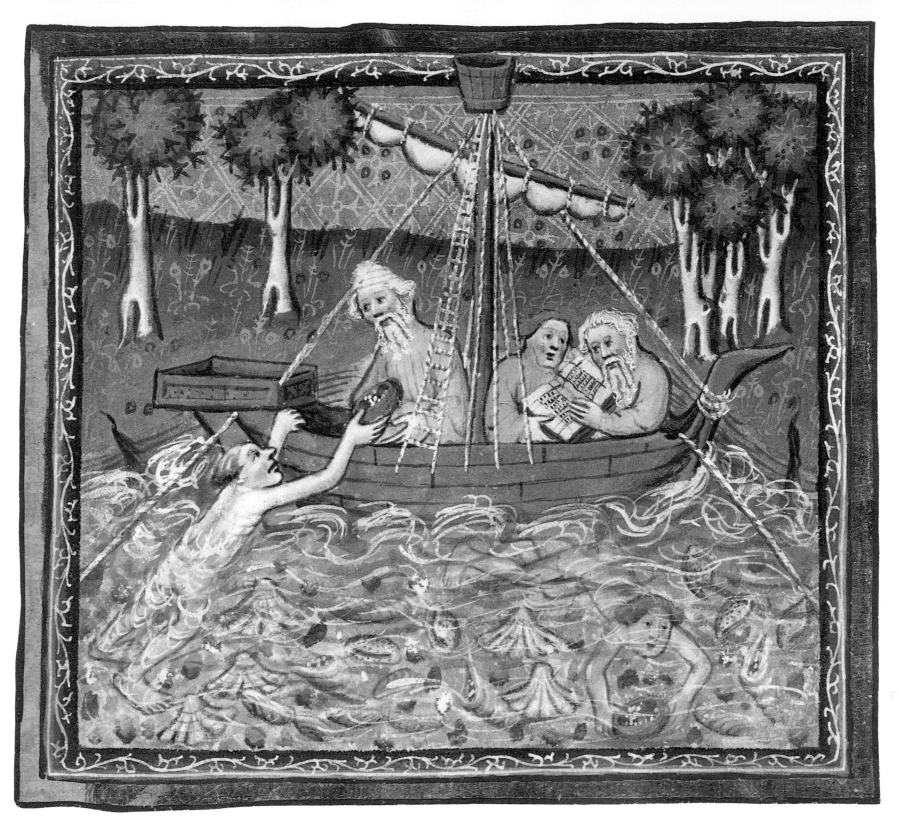

quality. Today's technique involves harvesting tiny bits of nacre and mantle tissue from mollusks raised specifically for this purpose, crafting the nacre into a bead called a nucleus, attaching a piece of mantle tissue to the nucleus, and implanting the package in the viscera of a host oyster. The seed is generally placed in the host's gonad (reproductive organ), but in some species it is placed nearby, to avoid harm to the host. Usually left to develop for one to two years, approximately half of all implantations succeed in producing pearls; the remainder are either ejected from the shell or

This illustration of Chinese pearl diving appeared in a 1338 manuscript from Les Livres du Graunt Caam.

kill the host. Forty percent of the pearls produced in this manner are marketable, although only one in eight of these attains gem quality.

In its lifetime, a single oyster can grow any number of pearls within its shell, for it will use nacre to neutralize as many irritants or implantations as violate it. Nor is there any limit to the possible size of a pearl, for an oyster will add new layers of nacre as long as a pearl remains in the shell. Pearl divers have found natural spherical specimens as large as 300 grains (nearly two-thirds of an ounce) in old oysters, although luster seems best in pearls weighing less than 100 grains. But at every stage of growth, the pearl is a complete gem, as noted by Kunz and Stevenson:

> The humble mollusks, like the five wise virgins with prepared lamps, keep their gems perfect in beauty and luster at all times. It matters not whether the pearl be removed when it is only the size of a pin-head or not until it reaches that of a marble, it is at all times a complete, a ripe, a perfect pearl, and the largest surpasses the smallest only in the characteristics and properties which are incidental to size.

Every mollusk produces nacre, but only a few species make the brilliantly lustrous type found in valuable pearls and mother-of-pearl. Some of these varieties are sought for their pearls alone, others for their mother-of-pearl only, and a few for both. The *Haliotis*, or abalone, manufactures colorful mother-of-pearl and irregularly shaped pearls. Large but less lustrous pearls come from *Tridacna*, the giant clam, while the Mediterranean *Pinna* yields attractive specimens that tend to deteriorate rapidly. The freshwater *Unio* manufactures small, irregular pearls with a charming iridescence. Inaccurately referred to as pearls, the non-nacreous pink and brown beads produced by *Strombus giga*, the great conch, are valued for their porcelaneous beauty.

The world's most highly prized pearls, those spheres that all but glow with opalescence, come from a few species of oysters. *Pinctada mazatlanica*, the La Paz oyster, and *Pinctada margaritifera*, the Tahitian oyster, offer the mysterious black pearls of the Pacific, while *Pinctada maxima*, the South Seas oyster, and *Pinctada fucata* (also known as martensii), the Akoya oyster, host the cultured pearls of Japan. Pearl aficionados agree that the finest natural pearl producer is the *Pinctada radiata*, the so-called Oriental oyster of Sri Lanka, the Persian Gulf, and the Red Sea. Because of a greatly diminished population, *Pinctada radiata* today yield very few pearls; most pearls now on the market are cultured.

Humankind's insatiable demand for pearls has seriously endangered pearl-bearing oysters in the wild. In search of priceless gems, pearl fishers throughout history harvested too many oysters, and took them younger and younger, until the world's oyster banks were severely depleted. Marine pollution from spilled oil, fertilizer runoff, acid rain, and detergents has taken its toll in more recent years. At the same time, increasing human exploitation of coastal resources—for housing, recreation, oil drilling, fish farming, and so on—has destroyed important mollusk habitats. Culturing is now both the source of the overwhelming majority of pearls and the best hope for the future of pearl-bearing bivalves. People who work in the field are exploring the potential of genetic engineering, artificial spawning, laboratory-controlled habitats, and innovative nutrition to improve the oyster's lot. Hand in hand with ecology and conservation efforts, biotechnology may be the answer to safeguarding the world's pearl supply.

THE PHENOMENA OF ORIENT & COLOR

Whether natural or cultured, all pearls are judged for quality and value on the basis of the same criteria. Two of the key factors that determine the value of a pearl are orient and color. As companions in the creation of the pearl's lustrous hues, color and orient are closely related, but each plays a distinct and separate role. Thanks to the natural beauty imparted by orient and color, the pearl requires no cutting or polishing to bring out its radiant sheen. With perfection as its birthright, the pearl seems to stand alone among gems.

By far the most important variable in the pearly equation, orient is the gem's famous iridescence, the miraculous characteristic that sets it apart from all other jewels. Orient defines the essence of pearliness—the uniquely captivating play of light over the translucent surface of the gem, the rich luminosity that has enthralled the world for millennia. The greater the orient, the more beautiful and valuable a pearl is judged.

A mechanical phenomenon with mystical results, orient arises from the nacreous structure of the pearl. Layer upon layer of nacre, each one composed of overlapping plates of translucent aragonite glued together with conchiolin, make up the gem. Kunz

Both the smooth mother-of-pearl shell lining and the pearls produced by mollusks protect their soft bodies from harm.

Examples of various fine pearl shapes.

and Stevenson compared the pearl's structure to that of a cabbage, with layers of overlapping leaves. Orient occurs at the serrated edges of the leaves—the aragonite plates—where light diffracts and scatters. As the rays of light pass through the microscopic layers of aragonite and conchiolin, they reflect off the surfaces of these two substances in a different manner, producing different wavelengths. Waves of light reflecting outward from the pearl interfere with waves of light entering the pearl, amplifying some wavelengths and canceling others out. This interference produces the rainbow of iridescence that seems to swirl over the surface of a pearl.

The curved surface of a pearl enhances orient, since the plates of aragonite are arranged so the jagged edges of overlapping layers lie especially close together. Accordingly, curved pearls possess more orient than flat mother-of-pearl. And because orient depends on the ability of light to penetrate numerous layers of nacre, pearls with thinner, more transparent layers display greater orient. A pearl with a thicker coating of nacre will have more orient than one with a thin coating if it is composed of many thin layers, for greater iridescence occurs where light has more surfaces on which to play. Essential in this regard is the thickness of the pearl's outermost layers, which should be as thin as possible. For this reason, pearl farmers harvest oysters in cold weather, when the mollusks deposit nacre in thinner layers.

Whereas orient is light reflected, the body color of a pearl is light absorbed. Orient creates the iridescent surface tints of the pearl, while body color provides the canvas on which orient works its lustrous art. Chemical rather than mechanical properties determine a pearl's color, which can fall almost anywhere on the spectrum. White, pink, yellow, gold, green, and blue tint the pearl's characteristic creamy color; silver-gray, aubergine, and black represent the range of shades offered by so-called black pearls. Today, pearl aficionados prefer the pink, white, gold, and black varieties.

Because a mollusk manufactures its pearls from the same material as its shell lining, the gems from a given mollusk have the same basic color as its mother-of-pearl. Black-lipped oysters, whose shell lining becomes whiter toward the center, can make

both black and white pearls; white-lipped oysters make white pearls only. Within a single mollusk, different pearls can have different tints, and within single pearls the layers of nacre can vary in color. For this reason, the color of a cultured pearl depends on the location from which the mantle tissue is taken. Each of the world's great pearling regions produces a range of colors, though not all regions produce all colors. For instance, black pearls come primarily from the South Pacific and on rare occasion from the waters of Baja California and rivers in the United States, while certain pearls from Sri Lanka and Myanmar (formerly Burma) have a distinctive golden hue found nowhere else. Pearl experts have conducted extensive research in hopes of discovering the source of pearl color and devising ways of boosting production of more desirable gems.

During the centuries of study devoted to understanding pearl formation, naturalists have advanced numerous theories of pearl color. One of the first such theories attributed pearl color to weather conditions: pearls formed from dewdrops would have a bright color if they were conceived on a sunny day, a dark color if conceived on a stormy day. Another theory suggested that whiter pearls grew in deep water, protected from the sun's burning rays, while darker ones grew in shallow water. As pearl science evolved, one naturalist speculated that the black mud in which certain black-pearl oysters lived was responsible for the duskiness of those gems. Elsewhere, an investigator conjectured that yellowish pearls came from oysters in which the flesh had rotted severely.

Modern gemologists cite several factors as possible sources of pearl color. The color of a pearl's nucleus may influence hue as it shows through the translucent layers of nacre. Alternately, the conchiolin that bonds a pearl's aragonite layers together apparently has some color of its own that can affect the gem's appearance. Jean Taburiaux, the author of *Pearls: Their Origin, Treatment and Identification* (1986), has identified pigment-bearing "cells," termed chromatophores, as a tinting agent in pearl strata. He suggests that chromatophores produce yellow, salmon, black, and

Freshwater pearls display a wide range of shapes and colors. Photo courtesy of Fred Ward.

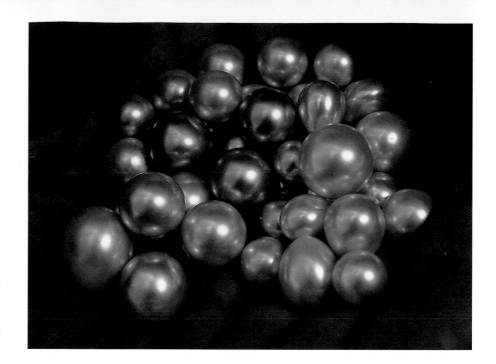

blue shades, while white, pink, and silver-gray shades arise from the reflection and interference of light within the pearl. Taburiaux also notes the impact of water chemistry on pearl color: mineral salts and other water-borne substances in the oyster's habitat, he claims, have subtle effects on nacre production. Australia's greenish pearls, for instance, grow in a plankton-rich environment, and the creamy pearls of the Persian Gulf and the Red Sea grow in highly saline waters. As illuminating as they may be, pearl scientists do not, however, consider any one theory conclusive, so the search for the secret of pearl color continues.

PARAGONS TO POPPYSEEDS, BLISTERS TO BAROQUES

Beyond orient and color, a pearl draws its appeal and monetary value from its shape and size. The perfectly spherical pearls so prized for classic strand necklaces come in a wide range of sizes, from the almost invisible dust pearls to the half-grain seed pearls to the paragons, which weigh 100 grains or more (there are 480 grains in an ounce). But spheres represent only one small category of decorative pearls. Rivaling and at times surpassing them in value is a whole range of delightful pearl shapes, many of which can grow much larger than the spheres do.

Pear-shaped pearls, referred to as eggs when squat and drops when elongated, come closest to the spheres in shape. Three-quarter pearls resemble spheres but have one flat surface, much like the hemispherical mabe pearls. Departing further from the spherical form are hollow blister pearls known as *chicot* and flat button pearls termed *bouton*. Cylindrical, conical, and grooved varieties proliferate, as well as any number of odd shapes with evocative names: butterflies, dragonflies, crosses, bird's-eyes, strawberries, bridges, and so on. In some cases, multiple pearls fuse to form twins, triplets, or larger pearl concretions. Assorted large specimens of peculiar shape qualify as baroques, many of which are hollow. Freshwater mollusks, meanwhile, offer smaller, irregular pearls, such as the dog-tooth, the flower petal, and the rice krispie.

The first determining factor of a pearl's shape is the growing gem's location within the shell of the mollusk. More regular specimens tend to form in the soft viscera of the oyster; baroques generally develop in the muscles; and blisters, buttons, and mabes grow against the shell wall. In addition, the shape of the pearl nucleus influ-

Most commonly described as greenish in tone, cultured Australian pearls display a range of hues. Some experts believe the warm waters of the South Pacific may contribute to the golden tones of certain pearls. Photo courtesy of David Doubilet.

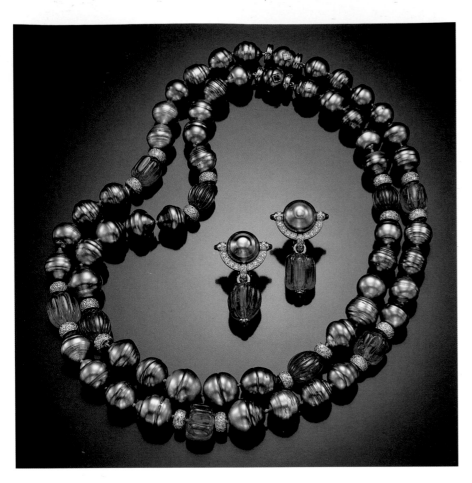

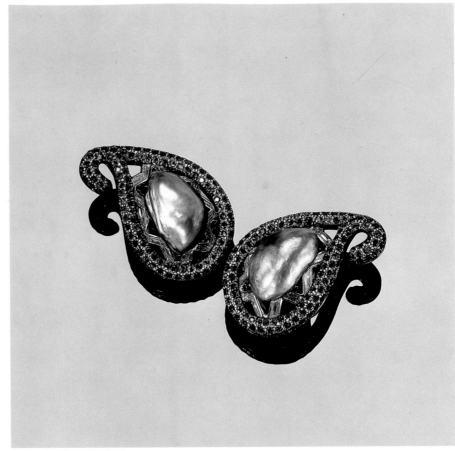

Above: Necklace and earrings of black Tahitian pearls, diamonds, emeralds, and sapphires, by Christopher Walling.

Above right: The pearls set in these earrings designed by Christopher Walling have the characteristically colorful luster of pearls produced by the abalone.

ences that of the finished pearl if the nucleus is a large object like a crab or a fish. Pearls that move within the shell during their growth can take on unusual shapes if they lodge between the mantle and the shell or if they fuse with a new irritant or another pearl. When a mobile pearl comes to rest against the shell wall, layers of nacre may coat it to create a rounded button or a hollow blister with a whole pearl inside. Pearl harvesters can sometimes break these formations open to retrieve hidden gems. As an example, Kunz and Stevenson cite the experience of a pearl hunter off the coast of Australia:

> We came across an old worm-eaten shell containing a large blister. . . . For many weeks it was untouched, no one caring to risk opening it, for if filled with black ooze, which is frequently the case, it would be of little value. At last, baffled in his attempt to solve the problem, and emboldened by an overdose of "square face," the skipper gave it a smart blow with a hammer, which cracked it open, and out rolled a huge pearl, nearly perfect, and weighing eighty grains.

Whether as blisters that adhere to the shell wall or as baroques that develop within the oyster's soft body, hollow pearls originate with an organic nucleus—the source of the "black ooze" mentioned by Kunz and Stevenson. According to Taburiaux, a tiny sea creature, a parasite, or a piece of seaweed can serve this purpose, stimulating the oyster to enclose it in a protective layer of nacre. As the plant or

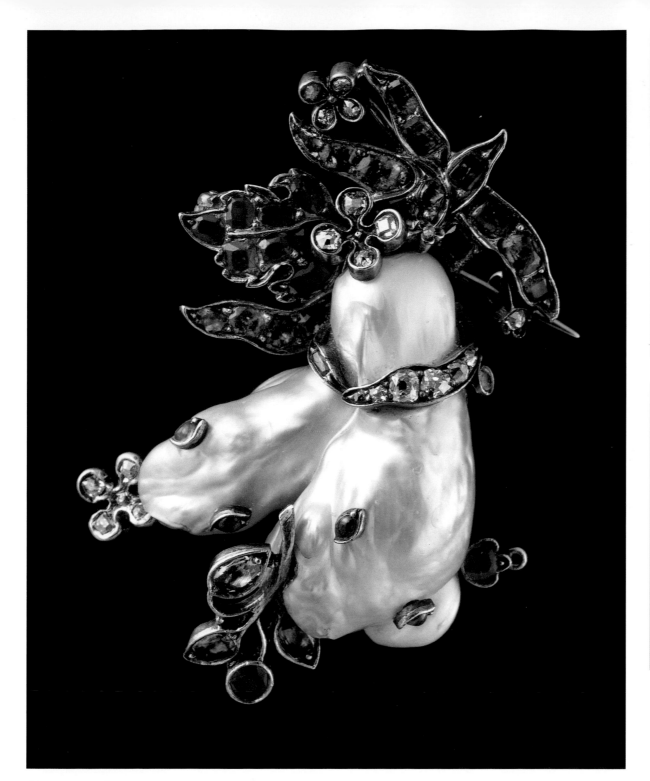

*Baroque pearl set in
a brooch with diamonds,
rubies, and emeralds.*

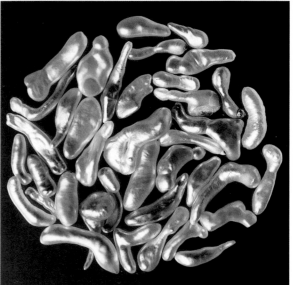

*The combination
of color, shape,
and size produces
an infinite array
of pearl forms.*

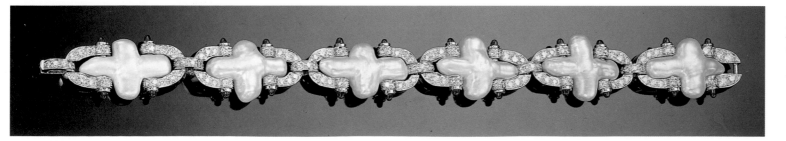

*Bracelet of X-shaped
freshwater pearls,
diamonds, and rubies,
by Christopher
Walling.*

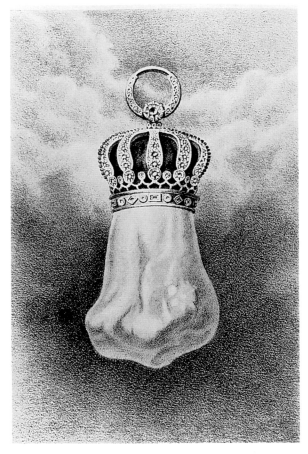

The Hope pearl is a large baroque specimen weighing 1,800 grains (4 ounces).

Examples of various cultured pearl shapes.

animal matter dies and decomposes within its pearly prison, it releases gases that inflate the nacreous coating before it hardens. This process can produce very large, hollow formations (the French call them *soufflures,* or "puffballs") with fascinating contours. If subsequent layers of nacre are deposited unevenly on the surface, the varying thickness of the pearl's wall can make the gem's shape even more bizarre.

Although these oversize oddities can attain weights of up to three ounces, their luster is seldom as fine as that of smaller, and especially spherical, pearls. Still, collectors treasure them as curiosities, often discerning recognizable figures or objects in them, much as children see faces or animals in the clouds. Jewelers design lavish pieces around baroques that resemble fruits, body parts, or entire human figures. These creations are among the world's most valuable examples of pearl jewelry. Indeed, the human imagination has room for every kind of pearl, no matter how peculiar, for the shimmering gems seem to have unlimited powers of seduction.

IMITATION PEARLS & THE PROLIFERATION OF FABULOUS FAUX

Not content simply to enjoy nature's iridescent bounty, people have long sought to

reproduce the miracle of the pearl by artificial means. As with so many earthly phenomena it has found pleasing, humankind desires an endless supply of pearls. Pearl culturing arose in response to this impulse, as did the faux pearl industry. The first imitation pearls were probably produced in China before the first century. In an A.D. 83 volume entitled *Lun Heng*, Wang Chhung wrote of the practice, stating that "by following the proper timing (i.e. when to begin heating and how long to go on) pearls can be made from chemicals, just as brilliant as genuine ones. This is the climax of Taoist learning and a triumph of their skill."

However, faux pearl production remained almost unknown until the 16th century, when Venetians learned how to manufacture iridescent glass. They blew bubbles of this material and filled them with wax to make fake pearls. Imitation pearls of much higher quality appeared in the 17th century, thanks to a discovery made by a Parisian rosary maker named Jacquin. One day, while watching his housekeeper scale a fish over a basin of water, Jacquin noticed that the surface of the water had a pearly appearance. Upon closer inspection, he found that the iridescence occurred when a substance coating the fish scales dissolved in the water. Jacquin filtered the scales out of the water and combined the remaining solution with varnish to create a pearly lacquer he called essence d'orient. Before long, he learned how to coat the insides of glass beads with the substance and fill the beads with wax to produce faux pearls.

Jacquin's technique caught on in pearl-crazed Europe, and scores of inventors set out to duplicate and improve on his formula. Years of experimentation yielded a near-perfect recipe that used the scales of 2,000 fish to produce just one liter of concentrated essence. Demand for the concoction was so strong that manufacturers had to find enormous supplies of fish with the right kind of scales. They learned that bleak, shad, herring, and salmon produce large amounts of the substance isolated by Jacquin, a substance that scientists have since determined to be guanine, an organic waste similar to uric acid.

Today, faux pearl producers employ three different methods. The first closely follows Jacquin's original technique of coating the insides of hollow glass beads and filling them with wax. Another popular technique involves coating solid glass or plastic balls with essence d'orient. Mass producers of these beads repeatedly dip hundreds of balls into vats of the pearly fluid until a sufficiently thick layer of iridescence builds up. Depending on the method used and the manufacturer's standards of workmanship,

An early technique for pearlizing glass or glazed objects like this 7th-century cut-glass jar from Persia involved burying them in the earth for extended periods of time.

Pearlized glass bottle from Rome, 2nd or 3rd century.

faux pearls can be absurdly cheap or moderately expensive, easily damaged or quite durable.

Majorica S.A., a company based on the Spanish island of Majorca, uses the third technique of faux pearl production, which it developed and now guards closely. Founded in 1890 by the German immigrant Eduardo Hugo Heusch, Majorica is universally regarded as the maker of the world's finest imitation pearls. The company's painstaking process and scrupulous quality control annually generate 2.5 million strands of faux pearls that are visually difficult to distinguish from the real thing. Using specialized machinery and delicate hand crafting, expert laborers first make carefully designed nuclei. The nuclei are dipped in the finest essence d'orient and polished when the coating dries. Workers repeat this step several times to create perfect color and luster, after which they apply a final, protective coating. To prevent future discoloration, the beads receive a dose of ultraviolet radiation. Rigorous inspection ensures that no inferior bead leaves the factory.

Not even the highest-quality imitation pearl, however, can duplicate nature perfectly. As with all faux pearls, their smooth surface gives them away. Whereas a genuine pearl rubbed against the teeth will feel slightly gritty, an imitation will not. Fakes of lesser quality will sometimes reveal scratches in their polished surface or cracks in the coating around holes drilled for stringing. Dipped pearls without a protective outer coating may feel soapy to the touch. But even though faux pearls are readily apparent to the educated eye, gem dealers and jewelers around the world have enacted stringent regulations governing the manufacture and sale of the imitations. All fakes must be clearly identified as such when they are sold.

Though they sell a product meant to deceive, faux pearl producers around the world profit greatly from the seemingly endless demand for pearly goods. With the arrival of quality imitations, faux pearls have gained a degree of legitimacy, finding a place in the wardrobes of people as highly placed as the American First Lady Barbara Bush. The enormous size of today's international faux pearl market reflects the burning human desire to possess even a good imitation of the compelling gem. Without a doubt, the world's passion for pearls is insatiable, and has only been heightened by scientific inquiry into the gem. Through culturing and faux pearl techniques, science has opened new avenues for people to nurture this ancient obsession, despite the disappearance of natural pearls.

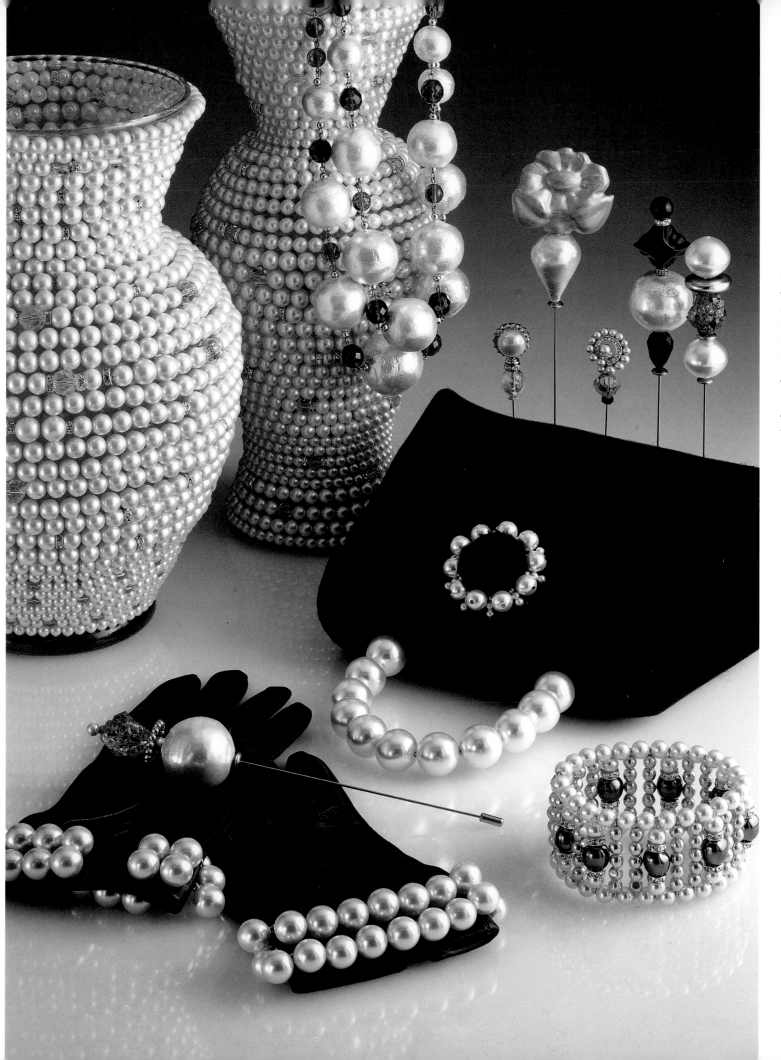

Contemporary
designers from
Showroom Seven
in New York
City re-create
the pop-pearl
aesthetic of the
1960s in an
assortment of objects
made from
imitation pearls.

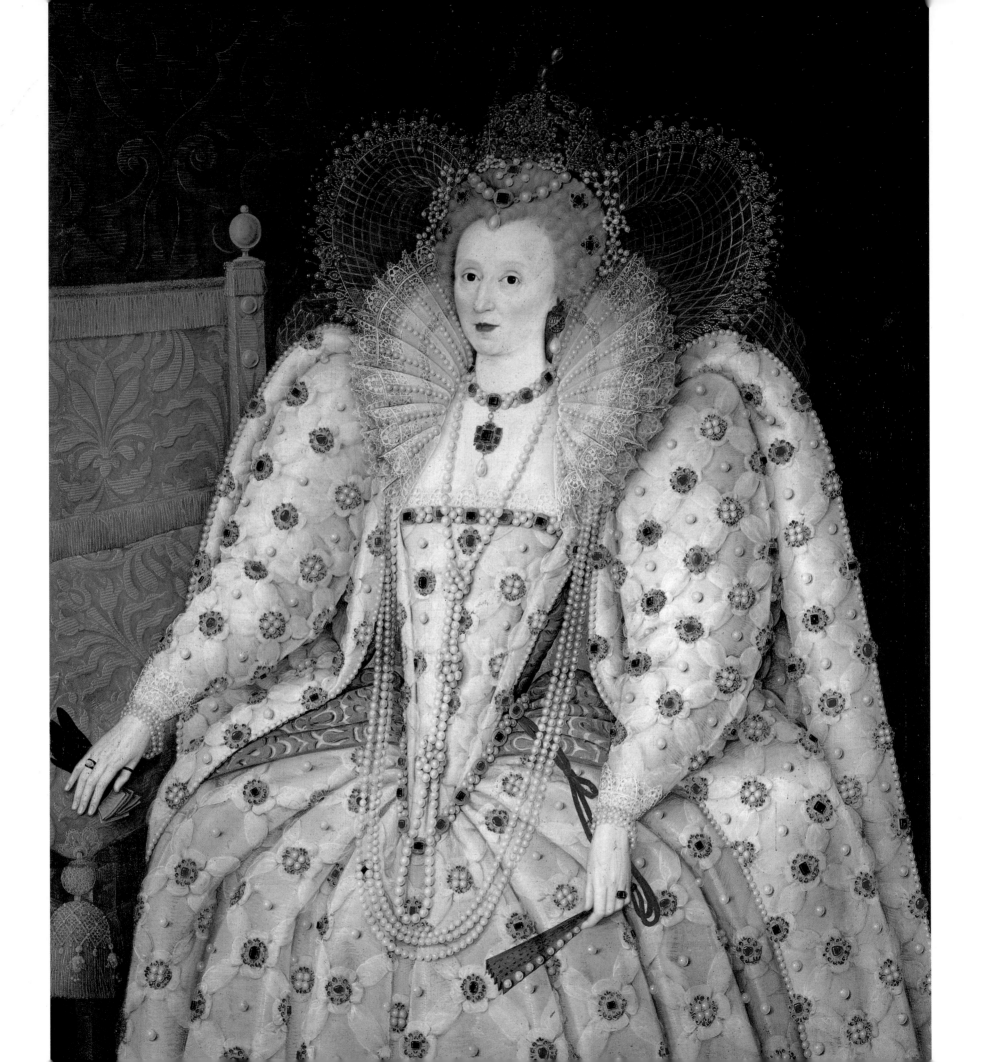

Seeking Goodly Pearls

HISTORIC

PREOCCUPATION

WITH AN

EMBLEM OF POWER

& PRESTIGE

A rare and compelling gem, the pearl early became one of humankind's most precious commodities. Emperors and queens, pontiffs and caliphs, and the aristocratic and the wealthy have harbored singular acquisitive sentiments toward pearls, desiring them above all other goods except, perhaps, gold. Amassing riches and displaying status in the form of pearls, the powerful have made the gem an enduring symbol of prestige. Their quest for pearls has launched expeditions of conquest and discovery and drained the treasuries of some of the world's largest empires. This lust for pearls has left a distinct mark on history.

"It is strange that this little glistening bead, the pearl, should have been the cause of so much movement in the world as it has been," wrote Arthur Helps in *The Spanish Conquest in America*, which is extracted in Sanford Mosk's 1927 doctoral thesis, "Spanish Voyages and Pearl Fisheries in the Gulf of California: A Study in Economic History." He continued:

> So general, indeed, was the love for pearls, that it was expected that whatever country in the wide circuit of the whole world was cursed with an abundance of pearl-producing oysters, would be sure, when the fact was discovered, to become a theatre for displaying the rapacity of the rest of mankind.

That rapacity, it seems, is as ancient as people's knowledge of the pearl.

Archaeological finds have turned up pearl jewelry dating back to 500 B.C., but

Portrait of Queen Elizabeth I, the "Faerie Queen."

An Iranian chest overflowing with pearly treasures evokes the opulence and conquest of empires ancient and modern.

written accounts and works of art reveal human use of pearls long before that. Unfortunately, most ancient pearls have not survived the ravages of time: the fragile gems generally disintegrate when buried for centuries. But lingering evidence shows that pearls spread across the ancient world via commerce, war, and gift-giving, and world history includes countless references to the gems. The rich and powerful, according to these sources, almost universally employed pearls as a form of wearable wealth capable of dazzling rivals and subordinates. Given in trade or tribute, pearls could purchase loyalties and kingdoms. Lavishly employed in religious decoration, they could help secure the faith of believers. Thus, as ornament and obsession, the pearl remained the world's most valuable gemstone into the 20th century; the increasingly rare natural pearl still ranks among the costliest jewels on earth.

INDIA'S OLDEST FISHERIES & PERSIA'S ROYAL VAULTS

That some of the world's most ancient cultures were located near some of the world's richest pearl fisheries invites speculation on the role pearls may have played in the birth of civilization. The waters of the Persian Gulf, the Red Sea, and the Indian Ocean supported enormous oyster banks that had thrived ever since life first appeared on earth. Living undisturbed for millions of years, mollusks kept their pearly secret until humans discovered them perhaps a dozen millennia ago. The Middle Eastern and Asian cultures of antiquity learned how to extract treasures from the oyster banks in the surrounding seas, and as social organization developed, so did exploitation of the pearl fisheries.

In Persia, an empire that peaked in the 6th through the 4th centuries B.C., rulers amassed great fortunes in pearls. Coins and portraits of the period depict queens adorned with earrings and necklaces made of the gems. The oldest known piece of pearl jewelry, in fact, originated in Persia. In 1901, archaeologists found a necklace of 216 pearls in the tomb of an Achaemenid princess buried in the Khuzistan region of Iran. They determined that the strand dated to the 4th century B.C.

When the Parthian and Sassanian kings ruled Persia in the centuries just before and after the birth of Christ, the area now known as Iran came into contact with outsiders via trade. International commerce boosted the value of pearls even further, and local rulers developed an even more avid appetite for the gems. Wealth poured

Mogul emperor Shah Jahan commissioned this portrait of his three younger sons about 1635. At the center is Aurangzeb, who reigned from 1658 to 1707, at the peak of Mogul power.

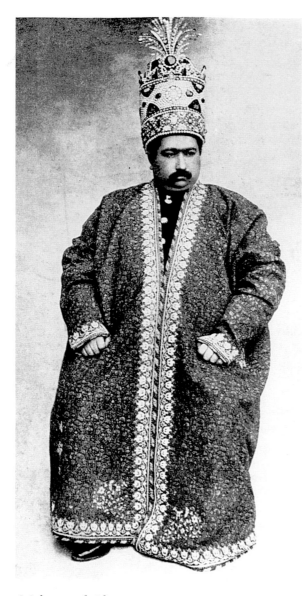

Mohammed Ali,
Shah of Persia,
wearing the Qajar
crown.

Nadir Shah of
Persia, who ruled
from 1736 to 1747,
conquered parts
of the Mogul empire.
Included in the
booty he seized were
jewels that once
belonged to the
great Aurangzeb
and eventually
became part of the
Qajar crown.

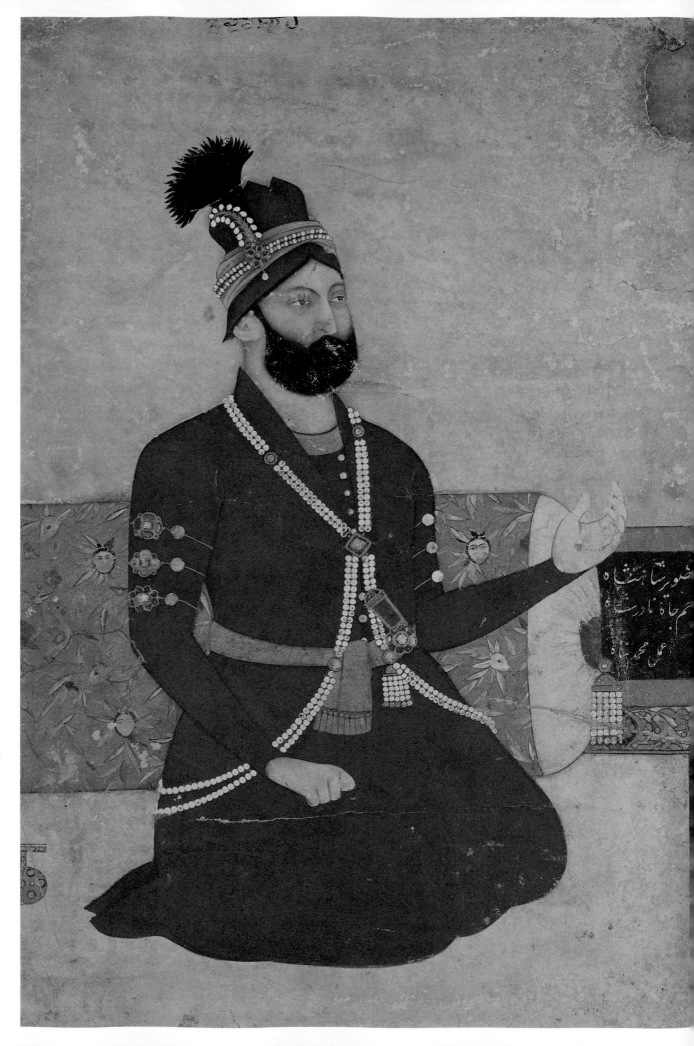

into the region as foreigners demanded the Persian Gulf's pearly fruits in trade. Prosperity and pearls attracted outside marauders, and over the course of centuries the area experienced invasion first by the Greeks under Alexander the Great and then by the Byzantines, the heirs to the Roman empire. After the fall of Rome in A.D. 410, the produce of the Persian Gulf pearl fisheries once again flowed directly into Persian treasuries. By the time Islam appeared, in the 7th century, the Persian court had become perhaps the most opulent on earth.

Under Islam, Persian art and commerce flourished. From A.D. 641 to 1517, Persia was part of the intellectually and culturally rich Islamic empire, which reached from Spain to India and into Africa. The staggering quantities of pearls gathered by the ruling Muslim caliphs during this time were set in elaborate adornments for every part of the body and worn in great numbers. This display of pearly wealth amazed the world and made Persia the stuff of legends. Fabled for its riches, Persia tempted the Ottoman Turks, who spent the 16th through the 18th centuries in an unsuccessful effort to take control of the ancient land.

European influence grew in unstable Persia starting in the 18th century, spelling the decline of Persian wealth and power. The European fascination with Persian pearls reached far back into the Middle Ages. During the Renaissance, the pearl craze in Europe's nobility launched extensive trade in the gems between Persian suppliers and European buyers. But it was the unrivaled luxury of the "oriental" courts that had the most lasting impact on the European imagination. Rumors and fairy tales abounded, intoxicating Europeans with fantasies of pearl-studded wardrobes and gem-filled vaults. *Persian Anecdotes: Or, Secret Memoirs of the Court of Persia*, a 1730 novel written by one Madame De Gomez for the king of England, provides a glimpse of Europe's enchantment with "the East." Numerous passages, including a catalogue of a princess's wedding procession, describe Persian riches in detail:

> Then follow'd the Presents. . . . Bracelets and Necklaces of Pearls and precious Stones of infinite Value . . . large Diamonds and Pearls, and other precious Stones of an inestimable Value . . . and Robes of the richest Eastern Stuffs, set with Pearls and Diamonds. . . . The *Bassa*, who was to be Father to the Princess, [was] richly dress'd, and royally mounted, that is to say, that his Saddle was adorn'd with Diamonds, Pearls, and Rubies. . . . By his Horse's left Ear was a Plume of Feathers surrounded with a Circle of Diamonds and Pearls of infinite Value.

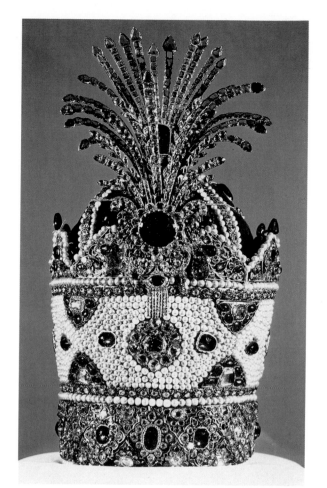

The royal crown of the Qajar house of Persia includes about 1,800 pearls, 300 emeralds, 7 large diamonds, and 1,500 red stones (rubies and spinels).

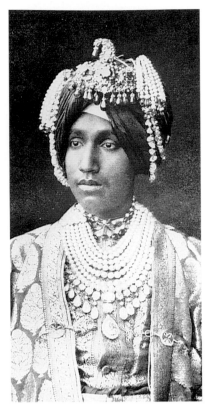

A maharaja of Patiala, in northern India, wearing the crown jewels.

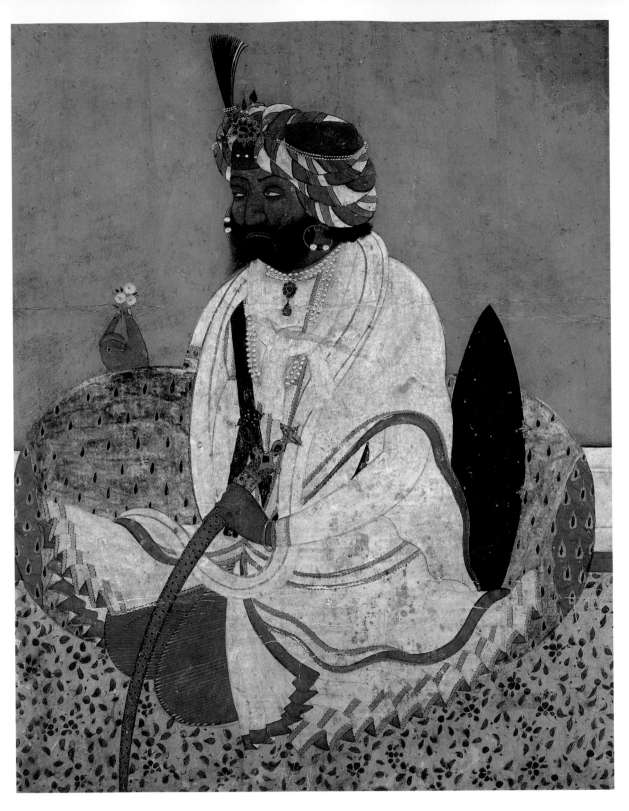

Maharaja Gulab Singh of India wearing examples of Mogul pearl jewelry.

Such displays, whether fictional or factual, were meant to awe all who saw or heard of them. Hardly unique to Persia, this technique of impressing regal might upon subjects and foreigners appeared in virtually every culture. In those societies familiar with pearls, the iridescent jewels invariably played a prominent role in pomp and ceremony. Among those blessed with fine pearl fisheries, India and Sri Lanka (which was called Ceylon during the period of European colonization) reveled in the abundance of the gems. Texts from the 6th century B.C. record the use of pearls as gifts

between Indian kings, while writings from 300 B.C. note that Sri Lanka's ambassador to India brought gifts of pearls to rulers there. Throughout India's history, pearls appear in this way, as a symbol of power.

The pearl fisheries of India and Sri Lanka, particularly those in the Gulf of Mannar, yielded pearls that were long considered the most beautiful on earth. These gems, typically valued at three times their weight in gold, inspired frequent power struggles among the various rulers of southern India and Sri Lanka. The trans-Asian trade routes, meanwhile, distributed the region's pearls across two continents, piquing foreign interest in the area. In the 10th century, after a long period of decentralization, ownership of the pearl fisheries in the Gulf of Mannar passed to Rajaraja the Great, the first ruler of the Chola dynasty. Until the early 13th century the Cholas controlled the harvesting and trade of pearls.

Late in the 13th century, the Italian explorer Marco Polo passed through India on his way to China and observed a king who wore pearl jewelry "worth more than a city's ransom." The king, Polo wrote in his *Travels*, forbade the exportation of large pearls from fisheries under his control, for he "desires to reserve all such to himself, and so the quantity he has is almost incredible." Two Muslim visitors had similar impressions of the Indian leadership's taste. Their notes appear in the 1733 volume *Ancient Accounts of India and China by Two Mohammedan Travelers*, by the French physician and journalist Théophraste Renaudot: "Pearls are what they most esteem, and their value surpasses that of all other jewels; they hoard them up in their treasures with their most precious things."

In the 16th century, the Moors invaded India and established the Mogul Empire, hoping, among other things, to take control of the pearl fisheries. Native pearl fishers suffered terrible oppression and loss of income until they rose against the Moors and, with the help of Portuguese seafarers, retook the fisheries. The Portuguese, however, were not content to leave the immense wealth of the fisheries to the local people. From 1524 to 1658, the years of the Pearl Age in Europe, the Portuguese reaped an untold fortune from the pearl fisheries of India and Sri Lanka. Then the Dutch supplanted them as colonial rulers, followed by the British in the late 18th century.

To Britain's disappointment, the pearl fisheries yielded only small profits during the 1800s, for centuries of overfishing had depleted the oyster banks. Prior colonizers had already scoured the pearl fisheries and claimed the last of the great natural pearls

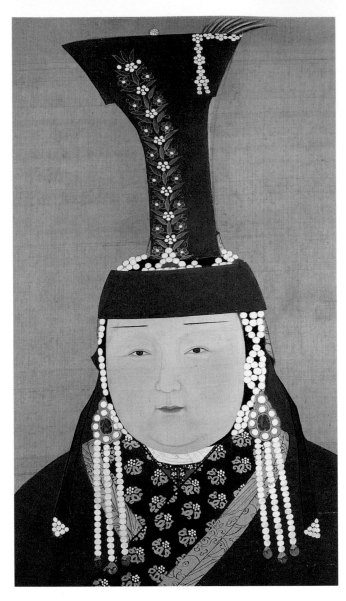

Yüan dynasty (1277–1368) empress of China, wife of the Emperor Shih T'su.

for themselves, either to wear or to sell. But even four hundred years of European appropriation could not produce a single Western pearl collection to match the splendor of the great treasuries of India, Sri Lanka, or Persia.

THE DYNASTIES OF ASIA & THE SOUTH SEAS

Although China never boasted pearl fisheries as renowned as those of Persia, India, and Sri Lanka, that ancient land fell under the pearl's spell as long as four thousand years ago. Until China started trading with outsiders, most of its pearls came from the rivers and lakes of the interior, although the southwestern Chinese exploited some oyster banks in the China Sea. The Japanese also found pearls in the waters surrounding their island nation, as did the various native populations of the South Pacific. Throughout Asia and the South Pacific, people of position and wealth sought pearls for their aesthetic and economic value. From the start, the gems were esteemed as vehicles of status and prosperity.

An ancient Chinese text, the *Shu Jing*, makes note of tribute in the form of pearls paid by lesser potentates to a 23rd-century B.C. emperor. The payment of tribute in the form of pearls became a common practice in China, showing up repeatedly in written historical records. *Rang Wang*, a work by Chuang-tzu, a Taoist philosopher of the late 4th and early 3rd centuries B.C., describes such tribute paid to Shanfu, an important personage during the Zhou dynasty of the 11th through 8th centuries B.C. This use of pearls reveals the extremely high regard in which the Chinese held them. According to Zhao Xi Gou, a writer of the southern Sung period, the ancient Chinese "did not value gold or jade, but valued pearls for they were far brighter."

The volume *Shang Shu* records the use of pearls as adornment and decoration in the 11th through 4th centuries B.C. Noble families during the Warring States period, which preceded China's unification under the Quin dynasty in 221 B.C., accumulated stockpiles of pearls in order to protect their political and economic future. Pearls, however, were more than mere currency and ornament. They served to enhance their owners' image, imparting an air of authority and grace. To that end, the empress Wu Zitian adorned the exterior of her palace with pearls, a practice that became popular among well-to-do Chinese. Warriors sometimes used pearls to intimidate and distract their opponents, carrying resplendent pearl-studded flags into battle.

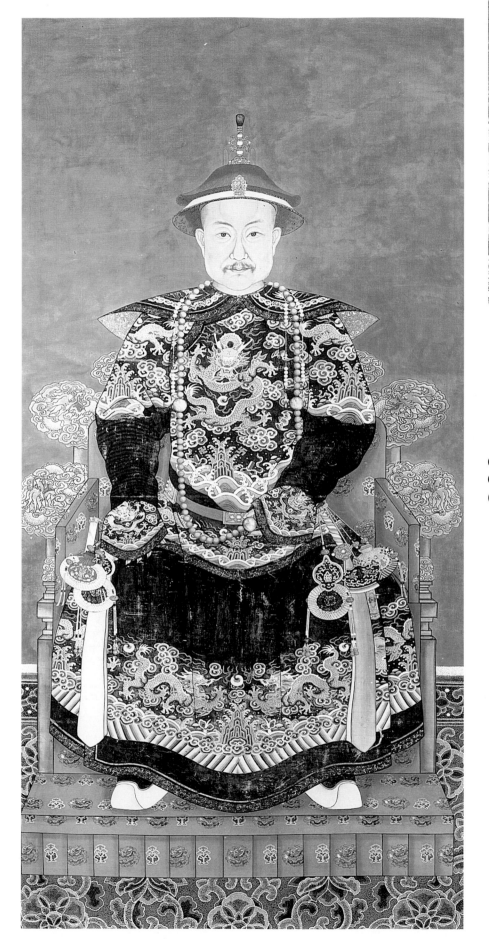

Chinese emperor
Ch'ien Lung
(1736–1795).

Portrait of the
empress dowager
Ts'u Hsi of China,
by Katherine A.
Carl. Younger and
more attractive
than the empress,
one of her ladies in
waiting served as
the artist's model.

Chinese empress
dowager Ts'u
Hsi in the late
19th century. Rebel
leader Chiang
Kai-shek looted
the empress's pearls
in the mid-20th
century.

During the Quin dynasty, China came into contact with the West via the "silk roads" over which traders traveled the breadth of Asia. These routes had grown from the East-West trade corridors established during the reign of Macedonia's Alexander the Great in the fourth century B.C. Western demand for silk, porcelain, jade, and other Chinese luxury goods brought unprecedented prosperity to China, along with Indian and Persian pearls. Reaching its peak under the T'ang dynasty of the 7th and 8th centuries A.D., Chinese affluence, combined with a taste for such foreign luxuries as pearls, spawned extreme opulence in the court. The monarch Mingti, for example, wore so many pearls and was accompanied by such a lavishly encrusted retinue that pearls littered the streets through which he passed. Such extravagance soon spread to the upper classes, ushering in an era of unrestrained spending on the accoutrements of wealth. The drain on the nation's treasuries ultimately contributed to the downfall of the T'ang dynasty in the early 10th century.

Into the 20th century, Chinese history was marked by the rise and fall of successive dynasties, as well as periodic foreign invasions, as rulers struggled for control of the country's wealth and power. Fortunes in pearls changed hands as part of the political ebb and flow, finally ending with the triumph of the Communists under Mao Zedong. During the civil war of the 1940s, Mao battled the Nationalist leader Chiang Kai-shek, eventually forcing him off the mainland and onto the island of Taiwan. But before Chiang was expelled, he looted the imperial tombs in Beijing, taking the empress Tsu-Tzi's burial pearls. Chiang transported these reminders of China's past glory to Taiwan, where he presented them to his wife as a wedding gift. With this gesture, the last chapter of China's ancient pearly history came to a close.

PILLAGE & PLUNDER IN THE MEDITERRANEAN

Because the Mediterranean Sea supported no pearl fisheries in ancient times, pearls came to this region much later than they did to Asia and the Middle East. The Babylonians and Egyptians used mother-of-pearl ornaments thousands of years before the birth of Christ, but pearls do not appear in archaeological evidence or historical records until perhaps 500 B.C. About this time, the Egyptians obtained their first pearls, and the Greeks traded with the Phoenicians for a few of the gems. Not until the 4th century B.C., when Alexander the Great conquered all the lands from Greece

and Egypt in the West to India in the East, did the inhabitants of the Mediterranean region truly discover the pearl.

The iridescent gem achieved instant popularity in Egypt, where the citizens of Alexandria earned renown for their extravagant use of pearls in jewelry and cosmetics. Pearls also poured into Greece, but few Greeks shared the Egyptian taste for showy attire. Instead, the gems filled the treasuries of the wealthy and adorned statues of the gods and goddesses, in particular Aphrodite, known as Pearl of the Sea. In pursuit of further riches, the Greeks conducted Eastern military campaigns meant to secure Greek control of foreign gem and precious metal supplies. These efforts met with only sporadic success, and after the death of Alexander in 323 B.C. the Greeks lost their grip on far-flung territories.

Building on foundations laid as much as two hundred years earlier, Rome in the 1st century B.C. superseded Greece as the Mediterranean's dominant power, plundering Greek treasuries and taking possession of Greek pearls. The military campaigns of Pompey the Great, Julius Caesar, and Augustus Caesar extended and secured Roman control over lands as far north as Britain, as far east as Palestine, and as far south as North Africa. As Roman wealth multiplied, the empire's gentry developed a voracious appetite for pearls.

It started with Pompey's triumphal procession into Rome after the Mithradic Wars of 88 to 63 B.C. The spectacle included the display of thirty-three pearl crowns, a pearl-studded shrine, and dozens of pearl ornaments. A few years later Julius Caesar's conquest of Britain, according to some historians, may have been inspired in part by the reported presence of pearls in that region. Egypt's fall to Rome brought a large influx of pearls into the empire from Alexandria, while expeditions during the reign of Augustus Caesar seized control of Red Sea pearl fisheries. The Romans also captured pearls in Jerusalem when they destroyed that city in A.D. 70.

As decorations for temples and jewelry for statues of Roman deities, and as assets in the imperial treasury, pearls were an important component of the empire's political and economic structure. The gems were assigned such tremendous value that entire military campaigns could be financed by the sale of a single pearl. In fact, the Romans ranked pearls as their most precious commodity.

An anecdote recorded by Pliny the Elder in his *Historia naturalis* illustrates the unequaled value Romans placed on pearls. According to Pliny, Cleopatra, the Egyp-

Portrait of a 4th-century Roman, Ceramus Boonnerius, and his family.

Portrait in wax of a Roman woman wearing pearls.

tian queen who ruled from 51 to 30 B.C., frequently entertained the Roman general Marc Antony with lavish banquets meant to dazzle her guest. One day she wagered with him that she could consume the value of an entire country in a single meal. Certain that even Cleopatra could not achieve such extreme indulgence, Marc Antony accepted the wager and arrived for dinner on the appointed evening. Cleopatra served him a sumptuous banquet indeed, but the meal was far from the most extravagant either had eaten. Certain he had won the bet, Marc Antony was surprised when Cleopatra proceeded to best him. To do so, she removed a large pearl from one of her earrings, crushed it, stirred the powder into her wine, and drank it. Pliny judged the value of that single pearl to be 30 million sesterces, the equivalent of nearly a million ounces of silver.

The Romans had a saying that "a pearl worn by a woman in public is as good as a lictor walking before her," a lictor being an officer who carried the insignia of important personages when they appeared in public. Well aware of the pearl's power to confer status, those who could afford the gems bought as many as possible and wore them everywhere. The sumptuary laws enacted by Julius Caesar in an effort to curb the display in fact enhanced the mystique of pearls, for the laws merely prohibited women below a certain rank from wearing the gems. Thus, any woman who wore pearls in public made her high social standing abundantly clear. Demand for pearls and pearl jewelry during the reign of Augustus Caesar helped fuel the expansion of

the merchant class that imported and traded in pearls, and of the artisan class that designed jewelry featuring the gems.

As Rome ripened into a firmly established, exceedingly prosperous empire, the consumption of luxury goods escalated even further. The emperor Caligula, who ruled from A.D. 37 to 41, when he was assassinated, took opulence to new heights during his reign. He wore slippers encrusted with pearls and bestowed a pearl necklace upon his favorite horse, whom he also elevated to the consulship. Like all visitors to Caligula's court, the Jewish philosopher Philo marveled at its extravagance. Kunz and Stevenson quoted the scholar's musings in *The Book of the Pearl:* "The couches upon which the Romans recline at their repasts," he wrote, "shine with gold and pearls; they are splendid with purple coverings interwoven with pearls and gold." Caligula's wife, Lollia Paulina, caused a stir one day when she appeared at a festival covered from head to foot in emeralds and pearls. To ensure no one would fail to appreciate her wealth, she carried documents that placed the value of her jewelry at 40 million sesterces, or one-and-a-quarter million ounces of silver.

Seneca, the great statesman, philosopher, and dramatist, bemoaned Rome's decadent lust for pearls. Writing of the taste for pearl earrings, he remarked, "Simply one for each ear? No! The lobes of our ladies have attained a special capacity for supporting a great number . . . they wear the value of an inheritance in each ear!" Despite such criticisms, the emperor Nero carried on Caligula's tradition of excess before killing himself in A.D. 68. His scepter and throne were crusted with pearls, as were the masks of the actors who performed before him. Imitating Nero's penchant for pearls, the Roman gentry continued to spend all they could spare on the gems. The poet Martial wrote in disgust of one woman he knew:

> By no gods or goddesses does she swear, but by her pearls. These she embraces and kisses. These she calls her brothers and sisters. She loves them more dearly than her two sons. Should she by some chance lose them, the miserable woman would not survive an hour.

The Roman pearl craze, of course, did not end with Nero's suicide. Writing of his contemporaries at the end of the 1st century, Pliny complained, "It is not sufficient for them to wear pearls, but they must trample and walk over them." The scholar also recorded the appearance of alabaster counterfeit pearls, which "looked almost real

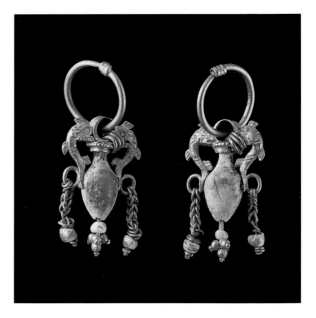

Sixteenth-century pearl earrings with a fish motif, designed by Dutch artisan Hans Collaert.

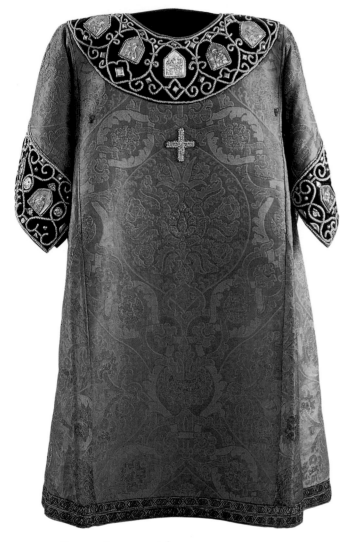

Saccos (ceremonial robe) of Job, enthroned in 1589 as patriarch of the Russian Orthodox Church.

when covered with a coating of silver lacquer." That pearl counterfeiters found a profitable market for their product attests to the remarkable power the pearl had over the Roman imagination. Indeed, the Romans sent so much gold to India in exchange for pearls that a serious trade imbalance developed and the Roman economy weakened significantly. It was only a matter of time before Rome's pearl decadence contributed to the decline of the empire.

In A.D. 330 the capital of the Roman Empire moved east to Constantinople, the site of old Byzantium. By the end of the 4th century the Roman Empire had split in two; the city of Rome fell to the Visigoths in A.D. 410. When the Western empire, subject to repeated attacks by Huns and Vandals, disintegrated completely at the end of the 5th century, Constantinople replaced Rome as the world's leading cultural center. The pearl craze of the 1st century was over, but Constantinople would not forget the pearl. Gems from the East flowed into the city, which lay at the crossroads of the major trading routes linking Europe with Asia. In the 6th century, the city of one million entered a period of luxurious wealth. Skilled Byzantine jewelers created some of the most elaborate pearl jewelry of the Christian era, including the crown of Saint Stephen. That crown was used in Austria-Hungary into the 20th century.

ROYAL MANIA & EUROPEAN EXPANSION INTO THE AMERICAS

When the Goths, the Huns, and the Vandals plundered Rome, they captured booty that included the tremendous stores of pearls so passionately accumulated by the Romans. Many pearls fell into the hands of the Franks when they, in turn, sacked the Goth cities of Gaul, Toulouse, and Narbonne. Meanwhile, the budding civilizations of Europe cultivated trading ties with Byzantine merchants who exported pearls from the East. As Europeans converted from paganism to Christianity in the first millennium A.D., they devoted most of their pearls to the glory of God. Pearls adorned the shrines, reliquaries, vestments, and other sacred objects of the church, rather than wealthy individuals.

After the death of Charlemagne, the Frankish ruler who in A.D. 800 had become the first Holy Roman Emperor, Western Europe (excluding Moorish Spain) was then divided into three nations, which corresponded roughly to France, Italy, and Germany.

Jan van Eyck, panels
from Altarpiece of the
Adoration of the
Mystical Lamb, 1432,
oil. The three vertical
panels show Saint
John the Baptist,
Christ in His Glory
(center), and the Holy
Virgin; the panel at
the bottom depicts the
Holy Eremites,
religious recluses of the
period. An
enlargement for detail
appears on the
following pages.

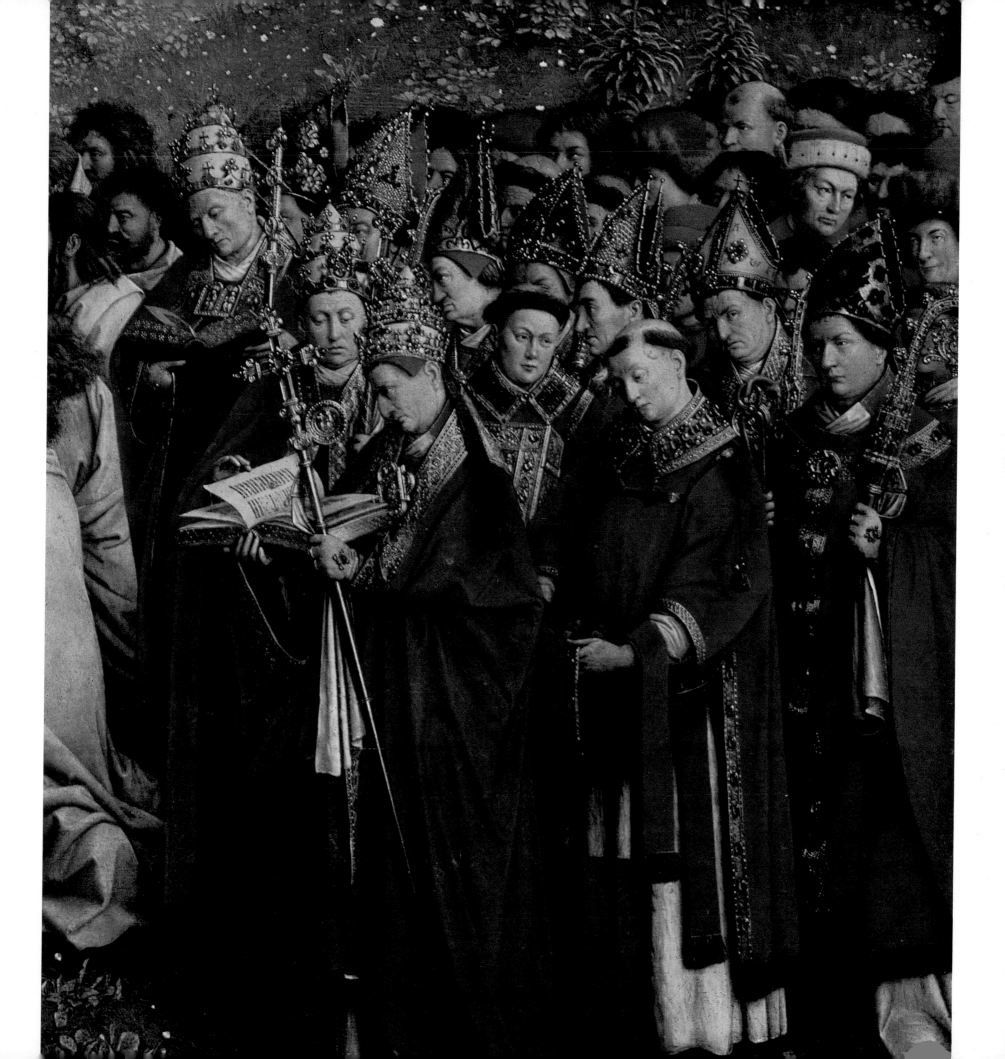

Czar Aleksis I Mikhailovich, father of Peter the Great, in the 1670s. The collar was copied from those worn by Byzantine emperors.

ѠБРАЗ ВЕЛЇКАГО
ГДРА ЦРА ИВЕЛЇКАГО
КНZА · АЛЕѮѢА МІХАЇЛОВІЧА
ВЅЕА ВЕЛІКІА ІМАЛЫА
ІБѢЛЫА РОЅІЇ САМОДЕРЦА.

Depredation by Norman invaders plunged the continent into the Dark Ages, during which the wealthy often donated their pearls to the church in hopes of buying divine assistance in difficult times. Pearls that remained in private possession tended to change hands frequently, because perpetually warring nobles liked to wear their gems into battle. The practice originated as a means of guarding one's wealth by wearing it, but precious stones were also believed to have mystical protective powers.

Finally, during the 12th and 13th centuries, the Crusades lifted Europe out of its social and economic morass. Pearls and other riches poured into the continent from conquered Moorish lands in North Africa and the Middle East; knight and merchant classes arose to exploit Europe's greater contact with the outside world. In the improved economic atmosphere, displays of wealth and status through personal adornment became fashionable. Pearls became a popular gift on special occasions, such as weddings and military victories. Because gem cutting was not practiced until the middle of the 15th century, the naturally perfect pearl was valued above jewels that required faceting and polishing. Royalty of the period showed off their collections at public gatherings and celebrations; in some instances, laws forbade those outside the aristocracy to wear pearls. Certain rulers—including several dukes of Burgundy and James III's Queen Margaret of Scotland—were positively obsessed with the gems, prompting Petrarch, the 14th-century Italian poet, to ridicule nobles "adorned like altars on festival days."

During the Renaissance of the 14th through 17th centuries, a passion for riches and luxury infected the European nobility. Europe's relative economic and political stability encouraged cultural development, ushering in a period of tremendous intellectual and artistic achievement. A taste for elaborate fashions and architecture inspired a flowering of the decorative arts. Pearls, the most expensive gemstone, figured prominently in the ornate and ostentatious jewelry, dress, and interior design of the period. Hungering to accumulate more and more gems, Renaissance rulers sought new wealth via commerce and conquest.

In 1492, Spain's King Ferdinand and Queen Isabella commissioned the Italian explorer Christopher Columbus to seek a direct water route to India, then considered the most desirable trading partner. Not only was India a source of pearls, it was also a supplier of all manner of gems, spices, fabrics, and other exotic products. Columbus, of course, never reached Asia, stumbling upon the Americas instead. Drawn by the

The star of the Order of Saint Catherine, founded by Peter the Great to honor women. Around the center of the medallion is the motto "For Love and Country."

plentiful resources of the New World, he returned two more times, and on his third voyage, in 1498, he located the rich pearl fisheries of Central America. He wrote of local people who "came to our ship in their canoes in countless numbers, many of them wearing pieces of gold on their breasts, and some with bracelets of pearls on their arms; seeing this I was much delighted." The explorer delivered nearly 50 ounces of the American gems to Ferdinand and Isabella when he returned to Spain. The pearl rush was on.

The discovery of an abundant new supply of pearls set off a pearl craze in Europe, inaugurating a period some historians have called the Pearl Age. Wealthy men and women adorned themselves with the extravagant pearl fashions popular at that time, decorating themselves with great quantities of the gem. In *History of England* (1849) Thomas Babington and Lord Macauley recorded a visit by Russian nobles bedecked with pearls: "The ambassador and the grandees who accompanied him were so gorgeous that all London crowded to stare at them, and so filthy that nobody dared to touch them. They came to the court balls dropping pearls and vermin." To satisfy the demand for this most desired of all jewels, hundreds of pounds of pearls crossed the Atlantic from the Americas each year. For decades, pearls were a more coveted American commodity than gold.

All the ruling families, or houses, of Europe—the Hapsburgs of Austria, the Valois of France, the Medicis and Borgias of Italy, the Tudors and Stuarts of England —filled their treasuries with pearls, virtually ignoring other jewels. Some of the most notable collections belonged to the Hapsburgs, to Catherine and Marie de Médicis, to the Valois kings who ruled France from 1515 to 1589, and to England's Charles I and his wife, Henrietta Maria. A contemporary account quoted in Kunz and Stevenson describes a wedding gift from Charles I to Henrietta Maria in 1625 as "a rich suit of purple satin, embroidered all over with rich orient pearls . . . the value whereof will be twenty thousand pounds." Kunz and Stevenson also make note of the legendary moment when Lucrezia Borgia's father, Pope Alexander VI, gave her a large box of pearls as a wedding gift, saying, "All these are for her! I desire that in all Italy she shall be the princess with the most beautiful pearls and with the greatest number."

England's Henry VIII elevated the royal love of pearls to a new level of fetishism. The king, who wore more jewelry than any of his six wives, ascended the throne in 1509. He financed his prodigious wardrobe first with the family inheritance and then

with riches seized from cathedrals and monasteries when he outlawed Catholicism in England. Purchasing pearls in quantity, he used them to decorate his robes, coats, hats, and even his shoes. So fond was he of the natural gem that he encouraged his male courtiers to sport pearl earrings set in gold. But though the portly, vain Henry cut an undeniably impressive figure, his own daughter would rival him as the most recognizable ruler in British history.

Queen Elizabeth I, who ruled England from 1558 to 1603, no doubt acquired her taste for pomp and display from her father. Her wardrobe showed her passion for pearls, and she has survived in history as the most avid pearl lover the world has ever seen. Every gown, crown, wig, and piece of jewelry she owned trumpeted her insatiable appetite for the iridescent gem, with which she adorned herself day and night. Dazzled by their queen's shimmering, bejeweled presence, Elizabeth's courtiers and subjects knew precisely to whom they owed their obedience and loyalty. The imposing monarch was, in the language of modern historians, a master of the politics of spectacle.

"A pale roman nose, a head of hair loaded with crowns and powdered with diamonds, a vast ruff, a vaster farthingale, and a bushel of pearls, are the features by which everyone knows at once the portraits of Queen Elizabeth," noted the 18th-century writer Horace Walpole. If anything, in attributing a mere "bushel of pearls" to the monarch Walpole badly underestimated Elizabeth's holdings. She customarily weighted herself down with seven or more ropes of pearls at a time, "the longest of which extended to her knees . . . the greater part like nutmegs," according to one contemporary observer quoted in L. Twining's *A History of the Crown Jewels of Europe* (1960).

Queen Elizabeth's ever-expanding wardrobe required the attention of a large, full-time staff. More than three thousand pearled gowns, eighty decorated wigs, and numerous chests full of earrings, pendants, stomachers, chokers, rings, and ropes were housed and cared for in special quarters. The catalogue of the Wardrobe of Robes also included an abundance of such accessories as hair nets, gloves, shoes, and even the pearly "dog collar" worn by Elizabeth's pet ermine. Protecting the queen's garments against the ravages of mildew, mice, moths, and dust involved daily airing and continual cleaning. Overseen by the Yeoman of the Robes, the royal wardrobe was tended by dozens of grooms and pages. Seamstresses spent their days meticulously removing

Queen
Elizabeth I
at her
coronation
in 1558.

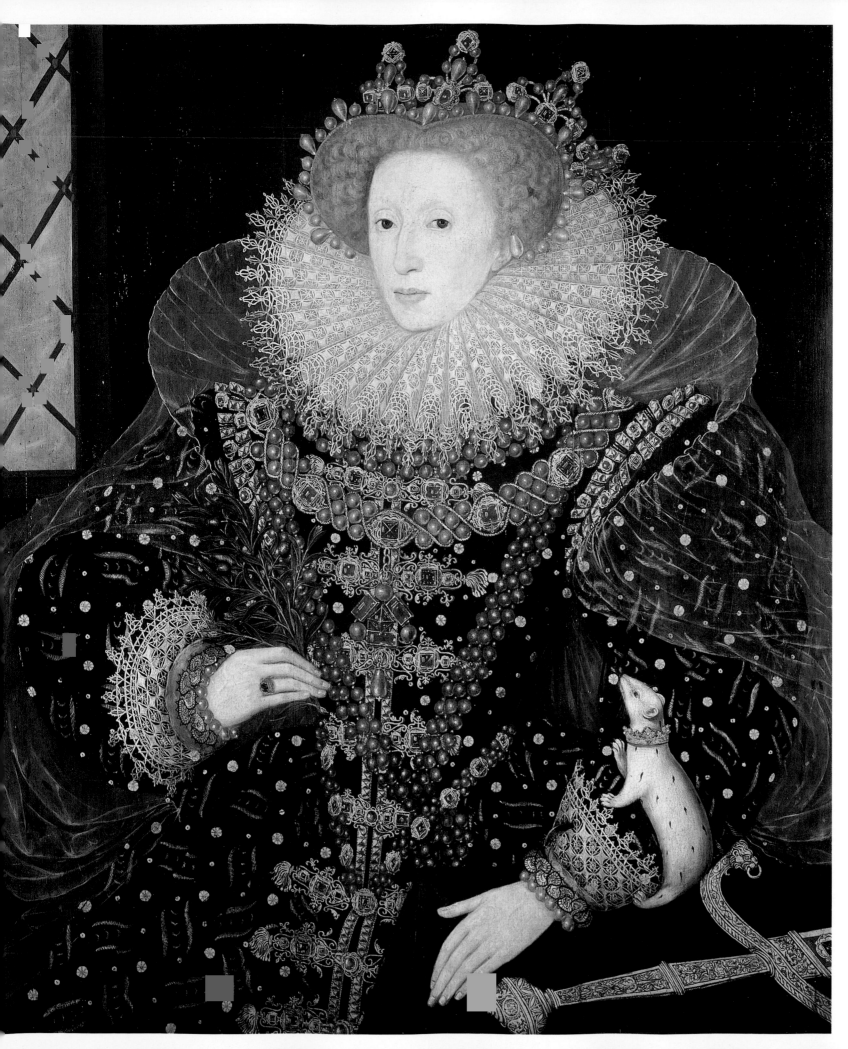

The famous
"ermine" portrait
of Queen
Elizabeth I,
c. 1585,
in which the
queen sits with
a pet ermine
wearing a
pearl collar.

hundreds of hand-sewn pearls from garments slated for cleaning, then carefully replacing each bead afterward.

Encrusted virtually from head to toe with both black and white pearls, the monarch may on occasion have seemed more flamboyant than commanding. What started as a fascination when she was in her twenties became an obsession, driving the queen to acquire and hoard pearls while neglecting some of her other royal interests. Elizabeth's fixation on pearls blurred the line between imperial politics and personal addiction. In her quest for ever greater quantities of the gems, she enlisted Sir Walter Raleigh to exploit the British alliance with the Spanish court of King Ferdinand and Queen Isabella. Spain's control of the American pearl supplies had glutted that kingdom's coffers with the gems, and Elizabeth wanted a share.

One of Elizabeth's most famous acquisitions was a necklace known as the Hanoverian pearls, a piece consisting of six pearl strands and twenty-five large drop pearls. A wedding gift to King Henry II of France and Catherine de Médicis from Pope Clement VII, the necklace passed to Mary Stuart when she married Francis II, Catherine's son. Mary became queen of Scotland after Francis died, and returned to her homeland. Perceiving Mary as a threat to her sovereignty, and perhaps coveting Mary's pearls, Elizabeth had the Queen of Scots beheaded in 1587. The necklace and the Scottish throne passed to Mary's son, James VI, who sold the pearls to Elizabeth for a mere 300 pounds sterling. James got his revenge, however, when the English crown passed to him upon the Virgin Queen's death.

Elizabeth's ruthless search for pearls revealed that she considered the gems more than mere objects of beauty: she found them indispensable in her efforts to fortify her appearance of regal strength. As an unmarried woman governing one of the world's largest empires, Elizabeth used every means at her disposal to create an image of authority and invulnerability. Pearls created an air of power and, through their traditional association with the notions of purity and chastity, reminded the world of the queen's unsullied virtue. The extremes of personal adornment that Elizabeth took pains to cultivate helped to foster an aura of superiority few dared challenge. Central to this effort, pearls became the trademark of Elizabeth's long reign.

In England and on the Continent, the royal mania for pearls spread to the upper classes. Sumptuary laws attempted to curb pearl extravagance in France, England, and Germany, as well as in Italy. Faced with civil unrest and economic instability,

Henry II, king of
France from
1547 to 1559.

Venetian magistrates acted out of desperation in 1599, passing a resolution that stated:

> The use and price of pearls has become so excessive and increases to such an extent from day to day, that if some remedy is not provided, it will cause injury, disorders and notable inconvenience to public and private well-being.

The resolution went on to restrict the public wearing of pearls to women married fifteen years or less.

Sumptuary laws rarely worked, for the compulsion to outdo one's neighbor in the display of wealth and prestige was a powerful motivator. Spain, the major supplier to pearl-obsessed Europeans, dominated trans-Atlantic commerce through the 16th century. Through the brutality of such conquistadores as Pizarro, Cortés, and Balboa, Spain extended its rule over Central and South America. Spanish adventurers found pearl fisheries on the islands off Venezuela, in the Gulf of Panama, and along Baja California, which came to be known as the "pearl coast." Cortés also sent a report to Europe of Amazon islands inhabited only by women wearing the gems. The conquistador, received as a god by the Aztecs, received a stunning pearl-studded robe from the emperor Montezuma before he plundered that ancient Mexican civilization. The riches taken by force from the New World made Spain the world's most powerful empire in the 16th and 17th centuries.

For the Spanish, colonization of the New World and exploitation of its pearl fisheries went hand in hand. Spanish settlers enslaved the native pearl divers and forced them to work long hours under harsh conditions. Shark attacks, hemorrhages, and dysentery killed thousands of divers, who were made to dive too deep for too long in waters they knew to be dangerous. To replace depleted ranks of divers, Spanish settlers simply raided neighboring communities and kidnapped new slaves. The European hunger for the American gems seemed to have no limits.

A combination of factors did, however, bring the Pearl Age to an end in the 17th century. Peasant uprisings protested the excesses of the ruling class and cast European nations into turmoil. Between 1618 and 1648, the Thirty Years' War, a Protestant uprising against Catholic oppression, ravaged Germany and sent shock waves through the rest of Europe. In England, Oliver Cromwell led the anti-royalist Roundheads to victory in a civil war that ended in the beheading of Charles I. Austerity began to

Henry IV, king of
France from
1589 to 1610.

Following pages:
Jacques-Louis David,
The Coronation of
Napoleon, 1805–7,
oil. Opulently attired
in pearls and
Empire-style garb
to assert his imperial
status, Napoleon
took the pearly crown
from the hands of
the pope and placed
it on his own head.

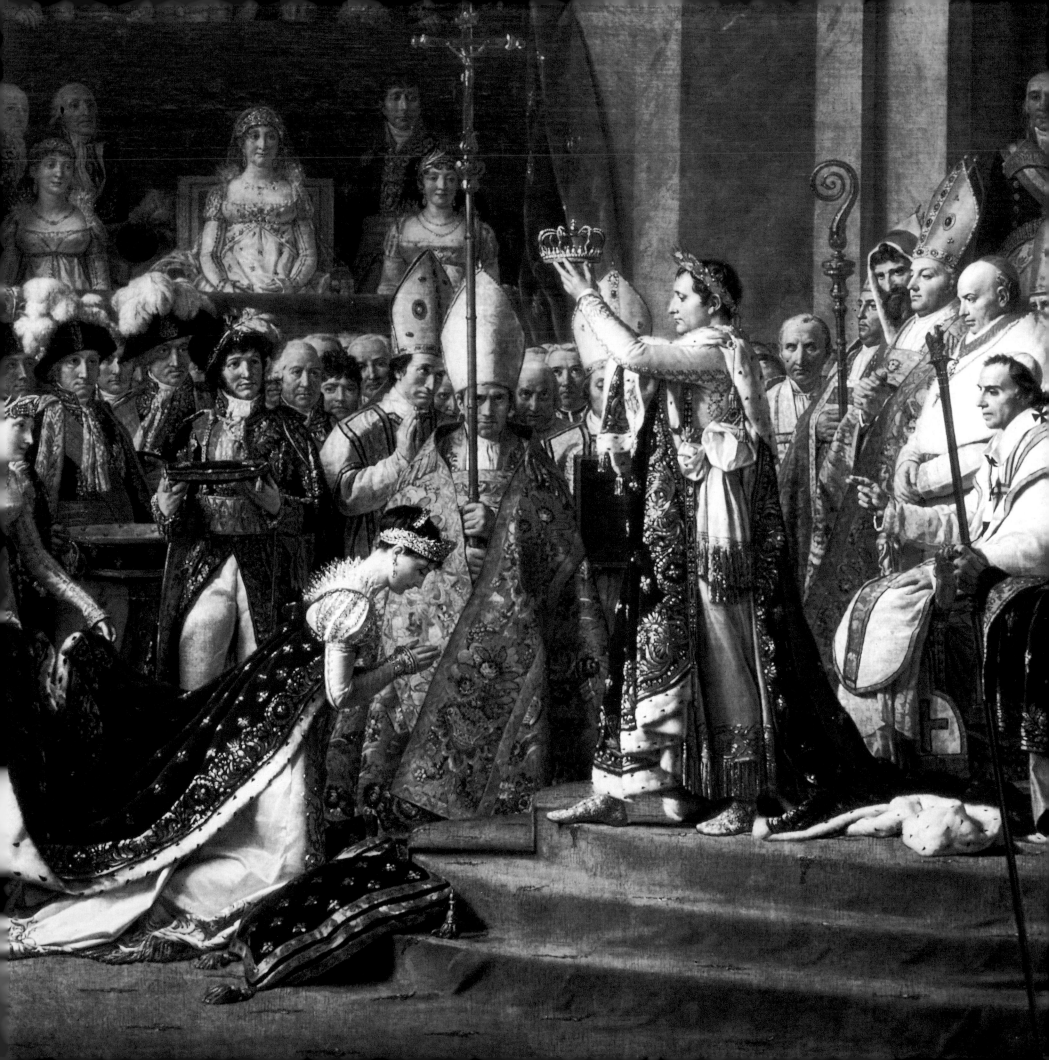

replace extravagance as a necessary, if not welcome, ethic in many European nations. At the same time, the introduction of faux pearls and the refinement of gemstone faceting techniques altered the tastes of the elite.

The end of the pearl craze coincided with the depletion of many of the world's pearl banks, which had been fished to exhaustion to satisfy European demand for the gems. Sri Lanka, the Americas, and the Red Sea, once glorious sources of pearls, had little left to offer, and conditions in the Persian Gulf were only slightly better. Many of the pearl fisheries were abandoned and lay idle for a number of years, serendipitously allowing the oyster populations to regenerate. In the 19th century, various pearl-fishing regions experienced periodic revivals and declines. Then, midway through the 1800s, Europeans learned of the pearl sources around Australia and other islands of the South Pacific. France's Empress Eugénie, wife of Napoleon III, developed a taste for black pearls, starting a trend. Queen Victoria's fondness for white pearls made the gems fashionable again, and pearls reappeared on noblepersons. In the United States, freshwater pearls from the Mississippi River valley allowed the middle class new access to affordable pearl jewelry.

After the Civil War, the industrial revolution brought tremendous wealth to certain Americans. These nouveaux-riche families—the Vanderbilts, the Fricks, the Morgans, the Carnegies, and others like them—sought to bolster their new prestige by purchasing emblems of status and power. Pearls, one of the costliest and most desired gemstones, served the robber barons' purposes well. More refined and less flashy than many jewels, pearls had the historical imprimatur of royalty. The tastes in pearls of Queen Victoria's son Edward, the Prince of Wales, and his wife, Alexandra, burnished the gem's gleaming image in the first decades of the 20th century, making pearls all the more attractive to status seekers. The industrialists had an especially strong appetite for historical pearl pieces—those that had been owned by royalty in the past.

Cartier, Tiffany, and Chaumet, jewelers to the rich and powerful, became the world's leading pearl purveyors. In 1917, Pierre Cartier used a two-strand pearl necklace then valued at one million dollars to pay for the six-story mansion that houses the company on Fifth Avenue in New York City. From these headquarters he sold to wealthy Americans many pearl ornaments with long and colorful pasts in Europe and Asia. On one occasion, Horace Dodge went to Cartier before a Dodge daughter's

wedding to buy a pearl necklace for his wife so the groom's mother would not outshine her. Cartier showed Dodge many necklaces, which the businessman rejected as not spectacular enough. Finally, the jeweler brought out a strand of enormous pearls that had once belonged to Catherine the Great. Dodge reportedly muttered, "Never heard of her," but was impressed enough with the necklace to write a check for one million dollars on the spot.

Although the rising American elite, immensely wealthy but rather raw, loved pearls, they viewed the gems as mere assets and had little reverence for the ancient and noble history of pearls. The heiress Barbara Hutton, for instance, received an exceptionally rare and valuable wedding gift from her father: a string of fifty-three pearls that had once belonged to Marie Antoinette. When a friend visited her one day and asked to see the necklace, Hutton laughed and said she had given it to her goose. She offhandedly explained to her startled friend a superstition she had heard—that if a goose swallows pearls, they will come out with a brighter luster.

The stock market crash of 1929 brought an end to the carefree spending of the robber barons. As the Great Depression shrouded the world, demand for natural pearls plummeted. And the introduction of Japanese cultured pearls in the 1920s temporarily confused pearl buyers, throwing the pearl market into turmoil over the authenticity of these manufactured gems. At first considered fakes, cultured pearls cast doubt on the value of natural pearls, for it was nearly impossible to tell the difference between the two. Status seekers turned to other jewels, but a huge market for pearls opened up among middle-class consumers. Coco Chanel's invention of costume jewelry popularized cultured and faux pearls; before long, every stylish woman seemed to own a strand of iridescent beads.

Destruction of the Japanese cultured-pearl industry during World War II, combined with the extreme scarcity of natural pearls, kept the iridescent gem out of the limelight for many years. As exemplified by the quiet chic of such celebrities as Grace Kelly, pearls remained an essential element of the classic wardrobe in the 1950s, but pearl extravagance was replaced by a preference for simple, understated strands. Pearl values declined: for example, the million-dollar necklace that had paid for Cartier's headquarters in 1917 brought only $157,000 at auction in 1957. The actor Richard Burton took advantage of the dip in pearl prices, buying the famous La Peregrina for Elizabeth Taylor in 1969. Though the perfect, pear-shaped beauty had a regal past—

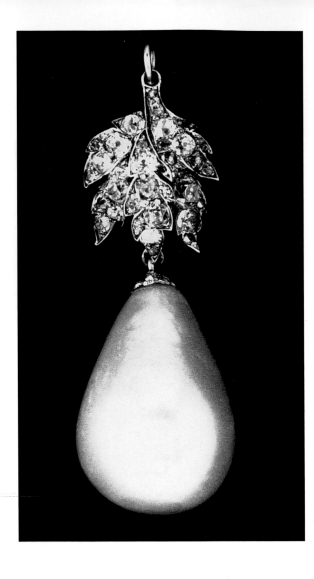

La Peregrina, the fabled 500-year-old pearl that belonged to many European monarchs and is now the property of actress Elizabeth Taylor.

it was found off Panama by a slave in the 16th century and subsequently belonged to such notables as Mary Stuart—it sold for a mere $37,000. Still, the historic gem added another layer of glamour to the actress's image.

In the 1970s, pearls experienced a renaissance as growing numbers of professional women adopted them as the accessory of choice. Pearls enhanced the authoritative air the white-collar woman hoped to convey to her colleagues, both male and female. The rediscovered status symbol enjoyed a rapid rise in popularity during the 1980s, when a return to conservative styles converged with the ascendancy of a wealthy class of new business barons. Pearls were considered a subtle expression of elegance, capable of conferring refinement on their wearers.

Because of the rarity and prohibitive cost of natural pearls, a wide segment of consumers turned to cultured pearls to satisfy their desire for affordable opulence. Only the fantastically rich could afford natural pearls, which had a mystique not associated with cultured pearls. Arab sheiks, among the world's last reigning monarchs, transformed their oil fortunes into natural pearl collections unrivaled anywhere on earth. These closely guarded treasures are seldom, if ever, seen by foreigners. By contrast, American business giants—the contemporary royalty of today's corporate empires—are more than happy to show off their natural pearl acquisitions. The fash-

Jeweler Jacques Cartier with Arab sheikhs during a pearl-buying trip to the Middle East.

ion designer Calvin Klein, for one, acquired a necklace given by Edward, the Duke of Windsor, to his wife, the American divorcée Wallis Warfield Simpson, whom the duke married after abdicating the British throne in 1936. Kelly Klein, the designer's wife, now sports the pearls with jeans and a T-shirt.

Thus, the pearl accurately reflects the preferences, passions, and power structure of every age. Whether religious fervor, artistic expression, political endeavor, or economic achievement, the values and appetites of disparate cultures have been revealed in humanity's enduring relationship with the pearl. At every turn of history's cycle, the human quest for power and prestige has paralleled the ageless pursuit of the treasure of pearls.

Known as one of the best-dressed women of her era, the Duchess of Windsor wore a splendid pearl necklace given to her by her husband. American fashion designer Calvin Klein recently bought the necklace from the Duchess's estate.

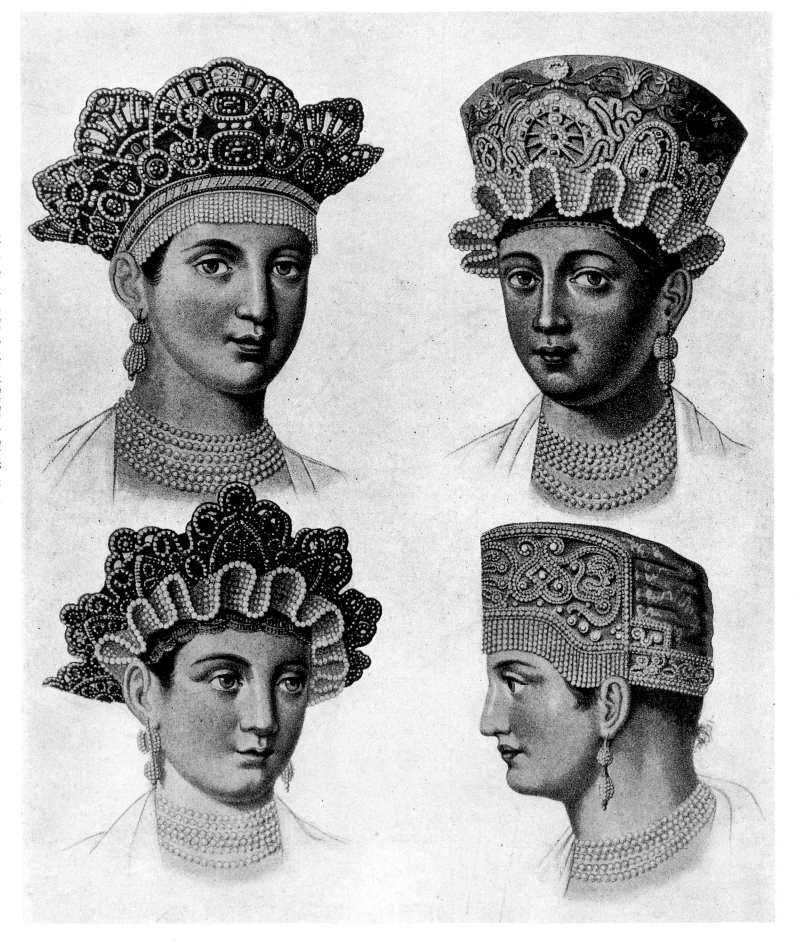

These kokochnik headdresses from the 17th century exemplify a traditional form of Russian pearl work. Worn by women of noble rank, the kokochnik had faceted beadwork, gilded thread, mother-of-pearl, and riverseed pearls interwoven to form lacelike patterns.

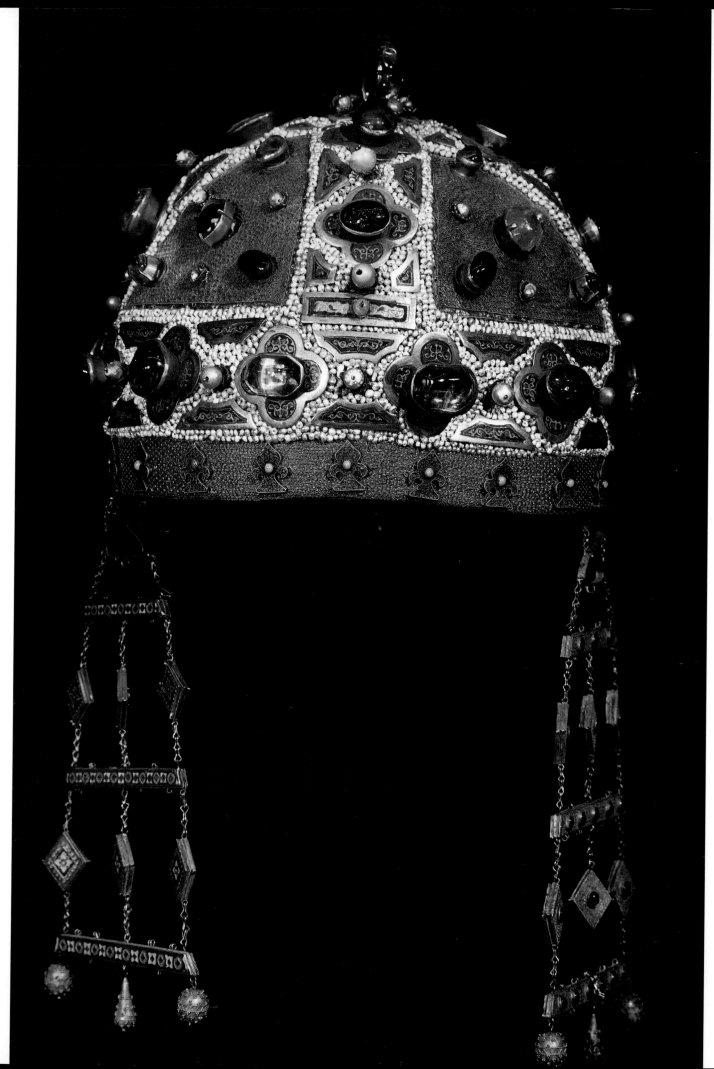

The tiara of
Queen Constance
of Aragon dates
from the late
12th century.

The radiance of the sun and the
moon creates a glowing corona
around each of the celestial
bodies that illuminates the earth.
On this page and those that
follow, the earth's monarchs took
the lead from the rulers of the
day and night and used precious
metals and jewels to create
shimmering crowns that signified
authority. Religion and legend
employed the halo as a symbol of
spiritual purity, while people of
privilege displayed their position
with gleaming tiaras; all such
crowns symbolize the life-giving
power of light. Similarly, the
pearl captures the complexity of
light in its layers and translates
it into the luminescence termed
"orient." The gem evokes
thoughts of wisdom and
goodness, making it a prized
feature of crowns
throughout history.

The Mikimoto
Pearl Crown II was
created in 1977
for international
exhibition. It
contains more than
796 cultured pearls
and 17 diamonds.

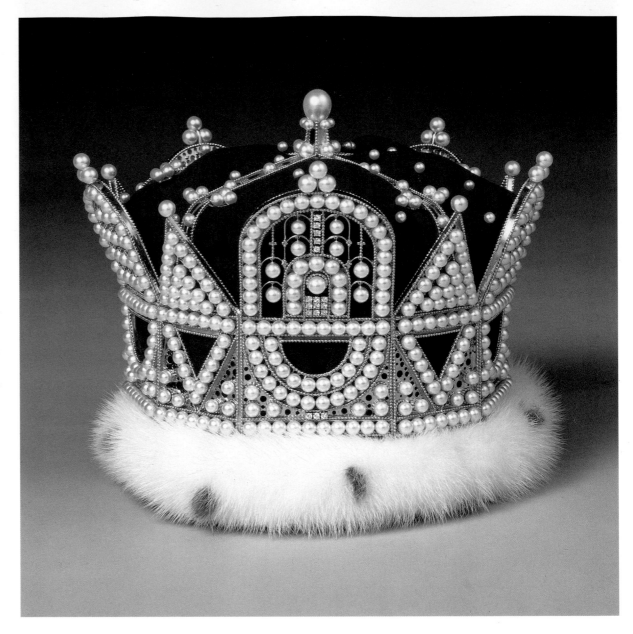

The firm of Van
Cleef & Arpels
created this crown
for Empress Farah
Diba of Iran in
1967. It includes a
150-carat emerald
plus 36 smaller
emeralds, 1,469
diamonds, 36 rubies,
and 105 pearls.

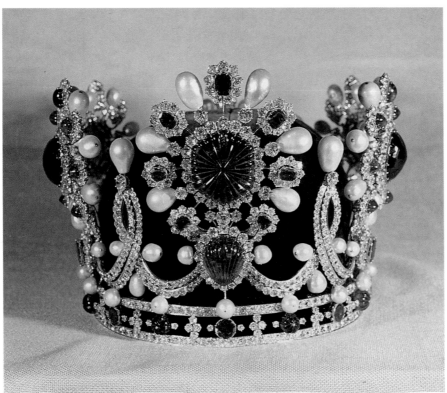

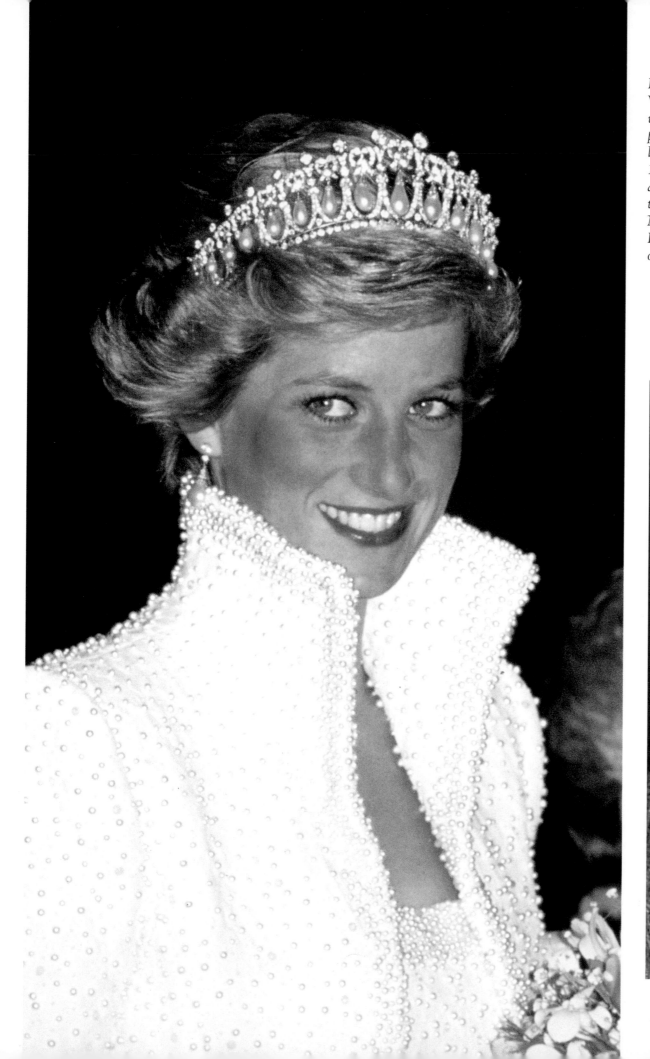

Diana, Princess of Wales, wears a tiara with a mysterious past. It looks much like Queen Mary's 1914 creation, but it also resembles a tiara acquired by Mary from Princess Irina Youssoupov of Russia.

England's Queen Mary had this diamond and pearl tiara designed for her in 1914. It featured two rows of standing pearls in addition to a row of diamond "lover's bow-knots," plus 19 dangling drop pearls.

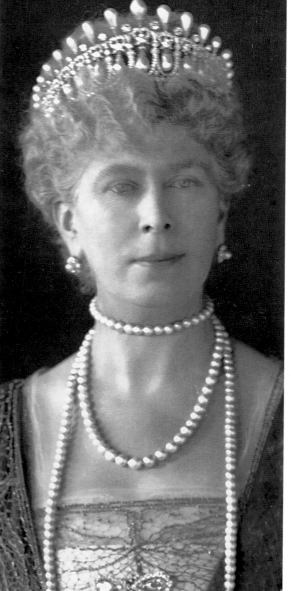

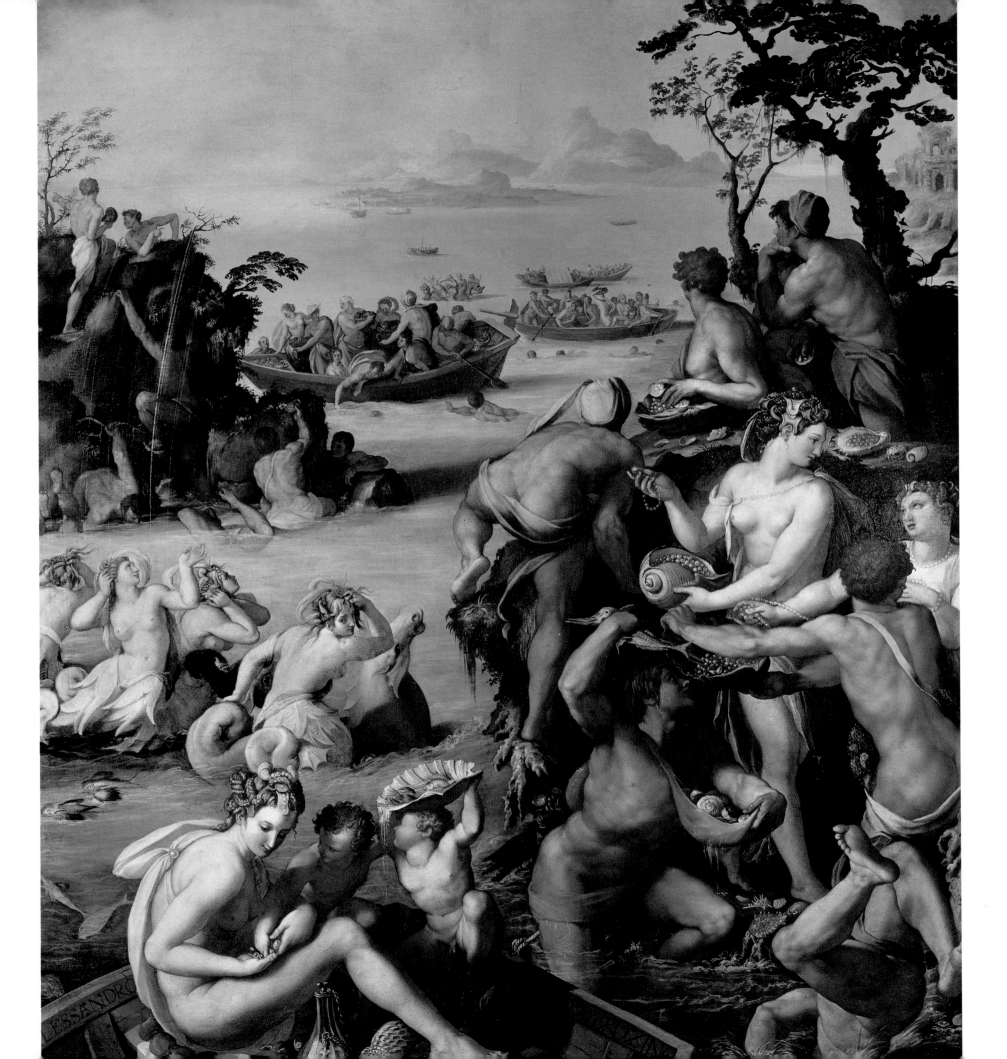

A Most Soveraigne Commoditie

DIVERS,

MERCHANTS &

ENTREPRENEURS

IN PURSUIT

OF A TREASURED

ASSET

Italian Renaissance painter Alessandro Allori captured the romance of pearl diving in Pearl Fishing.

Trade is as old as the human race, and trade in the world's oldest gemstone has a venerable place in the history of business. Gold launched many a conquest in times gone by, and oil sparked scores of political and military battles in the 20th century, but neither these nor any other articles of commerce have the pearl's special mystique: a combination of ancient sacredness, timeless beauty, and extraordinary value. Is it any wonder, then, that some of the world's most prosperous business ventures have had pearls as their sole object of pursuit? Entire industries have arisen to satisfy the luxurious and regal obsession with the lustrous bead.

The international market for pearls was so important in the centuries preceding the birth of Christ that by A.D. 77 the Roman scholar Pliny the Elder had written in his *Historia naturalis*, "The richest merchandise of all, and the most soveraigne com-moditie throughout the whole world, are these pearles." Vast and sophisticated mercantile networks linked pearl lovers with jewelers, jewelers with merchants, and merchants, in turn, with pearl divers and their financial backers. Radiating outward from the pearl fisheries of the Persian Gulf, the Indian Ocean, the Red Sea, and China, the pearl trade reached across Asia, the Middle East, North Africa, Europe, and, eventually, the Americas.

As the market for pearls grew, entrepreneurs sought out new fisheries in the South Pacific, in the British Isles, in the gulfs of Mexico and California, and along the rivers of North America. They stripped bare the world's pearl beds in search of profits, exploiting the labor of divers who dreamed of finding a pearl that would make them rich. By the 19th century, this rapacity had depleted the globe's pearl oyster population and made natural pearls an exceedingly rare commodity. Periods of neglect allowed some pearl banks to revive, but pearls found in the wild became smaller and fewer with each passing year. The glory days of the pearl fisheries were over.

Demand for pearls, however, remained high, boosting pearl prices to astronomical levels. Hoping to carve a niche in this seller's market, a few farsighted innovators started experimenting with ways to encourage pearl formation in oysters, both in the wild and in captivity. In Japan, these efforts centered on pearl culturing—the introduction of artificial irritants in order to stimulate pearl formation. Several inventors working independently experienced success almost simultaneously at the turn of the 20th century, and scientific periculture was born. An ambitious young man named Kokichi Mikimoto soon dominated the industry, aggressively promoting cultured pearls throughout the world. His marketing genius won acceptance for the gems in a matter of decades, earning cultured pearls a permanent place in the jewelry market.

Today, cultured pearls constitute the overwhelming majority of pearls available to consumers. Natural pearls remain a rarity because of the continuing instability of wild oyster populations. Oil drilling in the Persian Gulf and elsewhere has spelled doom for once-great oyster habitats, and pollution has weakened even the most remote pearl banks. Even oysters grown by pearl farmers in protected conditions are suffering from the destruction of the earth's environment. The efforts of scientists and environmentalists now seem to be the only hope for the long-term survival of pearl-bearing oysters. Oceanographers such as Sylvia Earle, the chief scientist of the United States National Oceanic and Atmospheric Administration, work steadily to salvage the marine environment inhabited by oysters and other creatures. In the laboratory, recent advances in biotechnology have greatly benefited the beleaguered mollusks, but the world's pearl supply is still endangered. Perhaps the same human energy and desire that virtually wiped out the great pearl fisheries will one day restore the oyster population. Perhaps humanity's ageless love of pearls will usher in an age of respect for the creatures that create these remarkable gems.

GREAT PEARL DIVERS & THE OLD PEARLING CAMPS

The English poet Robert Browning wrote in *Para Celcus*, "There are two moments in a diver's life:/One, when a beggar, he prepares to plunge;/Then, when a prince, he rises with his prize." For thousands of years, pearl diving did indeed offer such promise to the laborers who dove from the boats owned by pearl merchants. Some were slaves and others freemen, but for all of them the work was exhausting and dangerous, and the pay minuscule. Still, countless dreamers ventured to pearling camps in search of a fortune. Any one of the oysters they received as their cut of the day's catch might hold a perfect, shimmering gem that could instantly lift a slave from bondage to freedom, a common laborer from poverty to wealth.

Among the great pearl fisheries of the world, the Persian Gulf ranked as one of the most magical. That local people engaged in pearl fishing as long ago as the second millennium B.C. was established by archaeologists in the 19th century. A cuneiform inscription from the ancient Assyrian city of Nineveh describes a king's interest in "the sea of the changeable winds," where "his merchants fished for pearls." Until the 16th century, Arab and Persian kings controlled the fisheries, taking a portion of the oysters caught there. Portuguese adventurers took over for nearly a century, but the Persians expelled the foreigners in 1622 and made the gulf the world's leading pearl producer during the 18th century. The region remained autonomous until the 19th century, when a brief period of British rule commenced. Soon after the British left, in 1919, oil replaced pearls as the region's most important export.

The Persian Gulf fisheries thrived on the dreams of those who sought what Pliny described as the world's "most perfect and exquisite" pearls. Pearl fishers worked the gulf's waters yearlong, taking the bulk of their catch in the months of June through September. Centered on the island of Bahrain, pearl fishing dominated the economy of the entire region. Until 1932, when oil was discovered, up to 90 percent of Bahrain's population made a living in the pearl industry. "We are all, from the highest to the lowest, slaves of one master—Pearl," said a Bahrainian to the British writer Francis Turner Palgrave, who recorded the observation in his 1865 volume *Personal Narrative of a Journey Through Arabia*. In service to this master, the pearl fishers of the Persian Gulf used the same methods for generations, rarely changing the techniques or structure of their craft.

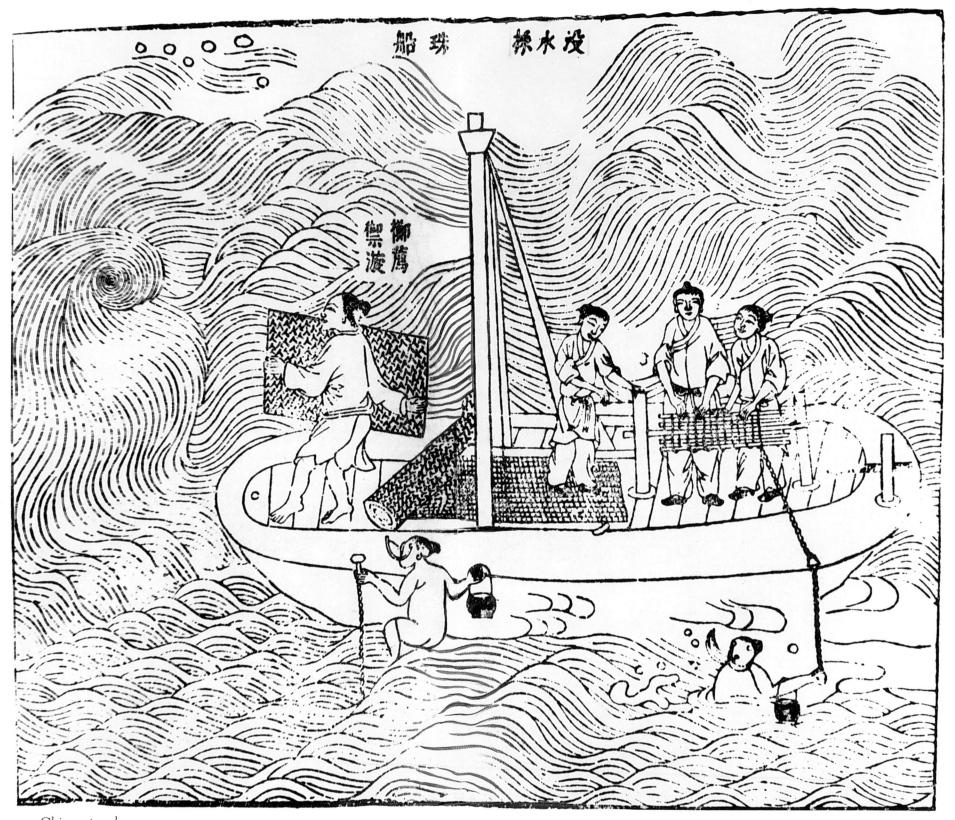

珠船　没水採

獺鵞禦渡

Chinese pearl
divers of the Ming
dynasty.

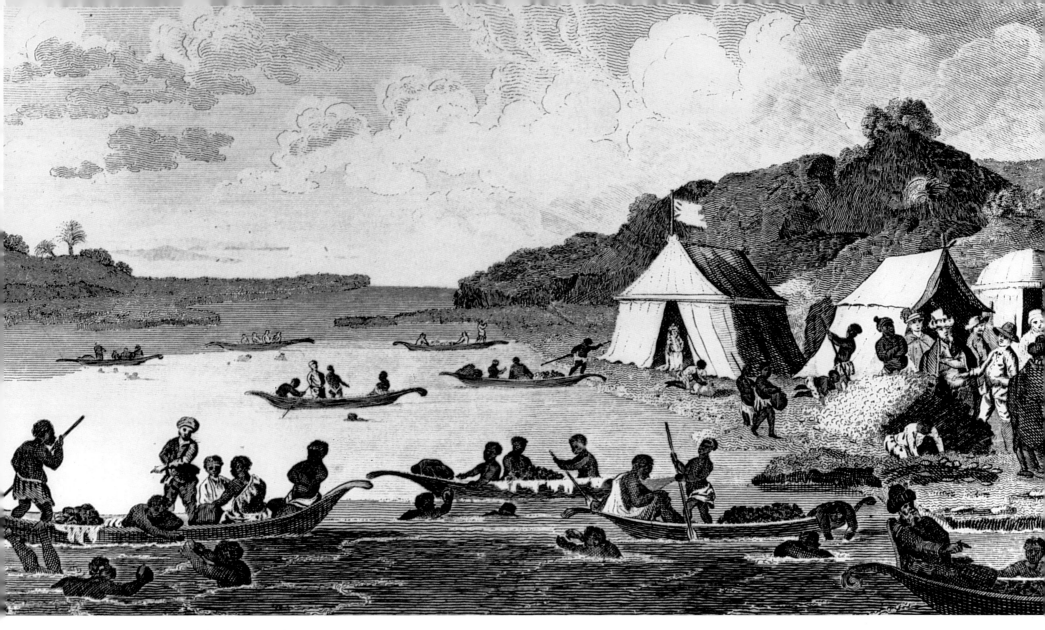

The Pearl Borer,
*a 17th-century
engraving.*

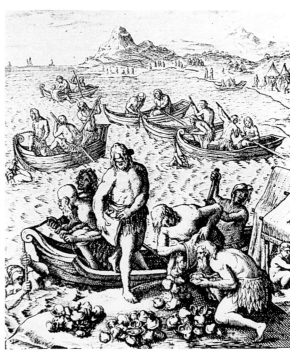

This 1790 engraving,
A View of the
Pearl Fishery, *shows
the exploitation
of indigenous pearl
divers by European
profiteers.*

*Persian Gulf
pearl fishers in
the 1600s.*

Fishing for pearls in the Persian Gulf was a highly organized and hierarchical endeavor. Referred to in Arabic as *bunnias*, the Arab and Indian financiers who bankrolled pearling ventures provided the necessary boats and equipment, as well as the provisions and supplies required by the diving crews. The *bunnias* hired the crews and advanced pay to the crew members' families for the duration of the pearling expeditions. The captain of a pearling vessel was called a *nakhoda*. Also included in the crew was a *serinj*, the *bunnia*'s personal agent; several *ghoas*, or divers; the *sebs* who tended the ropes; and a prayer-man known as *el musully*, responsible for relieving the *sebs* when they said their prayers.

Fleets of boats filled with divers made their way to the pearl beds, where divers sometimes planned their strategy by surveying the scene below the water's surface with glass-bottomed boxes. Clad in a loincloth and perhaps some makeshift gloves, each diver plugged his nose with a hinged clip of animal horn and grasped a pearl sack in one hand. After taking a deep breath he slipped over the side of the boat and disappeared beneath the water's surface. Divers used weighted lines to hasten their descent and pried oysters from their perches with their hands or with small knives. Minutes passed with no clue to a diver's whereabouts other than the line tied to his ankle at one end and to the boat at the other. Finally, at the diver's signal, a rope tender hauled his partner up from below to deposit his haul into the boat. A few moments' rest was followed by another dive.

Pearling crews worked on various types of boats. The earliest divers used small dugout canoes that could transport only two people on day trips close to shore. Because of their efficiency and versatility, canoes were favored by pearl divers for many centuries. The introduction of larger vessels, known as luggers, or *boutre*, eventually allowed for longer pearling ventures, farther out to sea. Driven by a single mainsail, these boats carried crews of fifteen or twenty on expeditions lasting a week or more. The divers plunged into the waters around the boat or launched canoes carried on board to explore shallow or less accessible areas nearby.

At the end of the diving day, the pearl fleets headed back to shore with their catch. Some crews opened oysters on the way home, harvesting any pearls and tossing the debris into the gulf. But because this practice gave divers the opportunity to hide pearls from the *bunnias*, most crews were forbidden from opening oysters on board the boats. The usual practice involved dividing up the haul of unopened oysters on

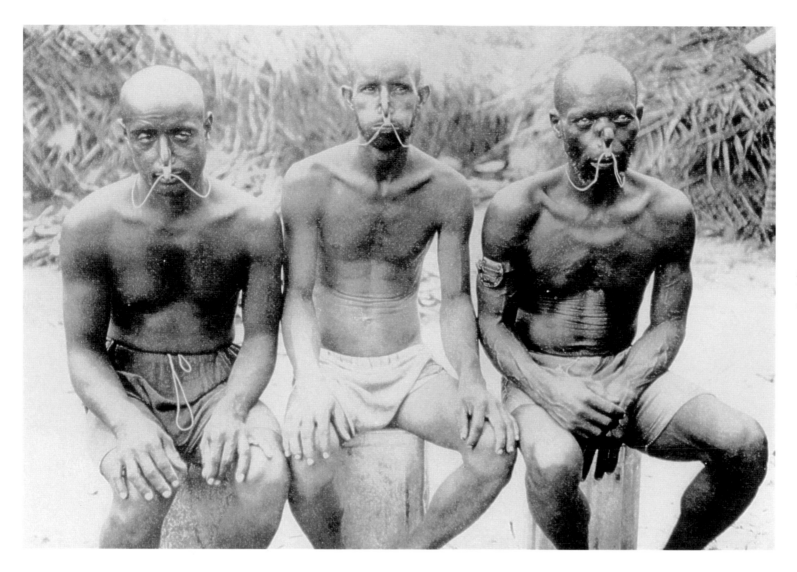

Three Bahrainian pearl divers in the early 20th century.

shore, with one share going to the *bunnias*, one share to the local government, and one share to the crew. During the period of Portuguese rule, a quarter of all oysters caught went to the king, a quarter to the Jesuit missionaries in the region, and a quarter to the soldiers, leaving only a quarter of the catch for those actually engaged in pearl fishing. Under these circumstances, pearl divers kept very few of the oysters they fished from the water.

Divers in need of a secure, if small, income—as most were—could auction their shares to the dealers who greeted the arrival of each pearling fleet. Those inclined to risk all for the possibility of a great reward could open their oysters individually and search for pearls. *Bunnias* and government representatives, by contrast, conducted large-scale oyster-processing operations. Dumping their oysters into cribs called *ko-toos*, they left the creatures to rot until their shells fell open. Ill-paid washers then rinsed the maggots and putrefied flesh away and sifted through the shells for pearls. These employees worked nearly naked amid the appalling stench, prohibited from removing their hands from the filthy water lest they secret a pearl in their mouth or loincloth. Many stages of rinsing and picking ensured that no pearl would escape notice.

Before the pearls went to market, those with blemishes or irregularities were treated by "pearl doctors." If one of these technicians judged an imperfect pearl to be a promising candidate, he carefully removed a few layers of nacre in an effort to produce a more beautiful gem. Sometimes the pearl doctor's ministrations paid off, but sometimes they reduced a pearl to worthless fragments. Doctored or not, most marketable Persian Gulf pearls made their way to the city of Hormuz, also known as Ormus, in present-day Iran. There, merchants from India bought them at auction, acquiring batches of gems from each *bunnia*. The Indian merchants took their purchases to the great pearl markets of Bombay, while mother-of-pearl fished from the gulf went directly to Europe. The pearl trade brought such luxury to Hormuz that Milton, in his epic work *Paradise Lost*, celebrated "the wealth of Ormus and Ind . . . where the gorgeous East with richest hand/Show'rs on her kings barbaric pearl and gold."

For centuries, the hunt for pearls was slow and costly even on the biggest luggers. But, as in so many other industries, rapidly advancing technology revolutionized Persian Gulf pearl fishing in the 19th century. In a matter of a few decades, the steamship, the dredge, and the diving bell boosted to unprecedented levels the productivity and profitability of pearling expeditions. This productivity, however, hastened the depletion of the oyster banks. The amazingly rich fisheries of the region supported the economy for a few years longer, but the advent of the oil industry eventually spelled their demise. Workers left the fisheries for the refineries, and pollution killed off many oyster beds in the 20th century. Today, little remains of the once-great pearl-fishing industry of the Persian Gulf.

In many respects, the story of pearl fishing in India and Sri Lanka resembles that of the Persian Gulf. If anything, the fisheries in the Gulf of Mannar, between India and Sri Lanka, are even more ancient than those of the Persian Gulf. They, too, were controlled for thousands of years by local rulers or Arab and Persian princes, until the Portuguese invaded the region in the 16th century. The Dutch succeeded the Portuguese and leased the fisheries back to the local population, followed by the British in 1796. Since the departure of the British in 1947, the pearl fisheries of India and Sri Lanka have yielded very few gems.

In contrast to pearl fishing in the Persian Gulf, the pearling season in India and Sri Lanka spanned only one or two months a year, from early March to late April.

Oyster populations appeared and disappeared unpredictably from known pearl beds, so not every location could be fished every year. The approach of the pearling season each spring triggered an exodus of laborers, traders, and hangers-on of all descriptions to great camps located near the pearl beds in the Gulf of Mannar. Within days of their arrival, thousands of workers transformed quiet beaches and sleepy fishing villages into raucous, sprawling tent cities. Each pearling camp displayed, during its brief life, the full range of human drama—the camps brimmed with every earthly pleasure and danger imaginable.

In *The Book of the Pearl*, Kunz and Stevenson recorded the scene at a Sri Lanka pearling camp in the 19th century:

> Besides the eight or ten thousand fishermen . . . there are pearl merchants . . . boat repairers and other mechanics, provision dealers, priests, pawnbrokers, government officials, Koddu-counters, clerks, boat guards, a police force of two hundred officials, coolies, domestic servants, with numbers of women and children. And for the government of these, and to obtain a share of the wealth from the sea, there are jugglers, fakirs, gamblers, beggars, female dancers, loose characters, with every allurement that appeals to the sons of Brahma, Buddha, or Mohammed . . . the whole making up a temporary city of forty thousand or more inhabitants.

Those who thronged to the pearling camps in search of adventure found what they were looking for more often than did those who came seeking wealth. The makeshift eateries and crowded streets offered an abundance of fascinating sights, sounds, and smells, and a heady, cosmopolitan brew of races, cultures, and customs. Food, spices, fabrics, and handicrafts from across the globe crammed the bazaars and tempted passersby. Talk of fortunes built on a single, spectacular pearl fueled the hopes of divers and merchants, who dreamed of becoming rich overnight. Animated by the promise of the profits to be made, the camp's transient residents moved a little faster, bargained a little louder, worked a little harder than they did at home.

Among them was the *abraiaman*, or fish charmer. Because divers encountered all kinds of hostile creatures beneath the water's surface, they employed any means at their disposal to ensure their safety. Payment of a few oysters to the *abraiaman* bought peace of mind, if not actual protection against sharks and rays. Marco Polo told of the practice in the account of his travels, *The Book of Marco Polo:*

In recent years, archaeologists have investigated the old Caribbean pearl fisheries established by Spanish explorers. Dr. Joseph M. Cruxent discovered a 400-year-old jug containing hundreds of pearls on Margarita Island, Venezuela.

They must pay those men who charm the great fishes to prevent them from injuring the divers whilst engaged in seeking pearls under water, one-twentieth of all they take. These fish-charmers are termed abraiaman; and their charm holds good for that day only, for at night they dissolve the charm so that the fishes can work mischief at their will.

Braving treacherous conditions in exchange for meager wages, the divers of the pearling camps also endured a workplace governed by strict rules, in which any shortcoming or error meant instant replacement by another eager laborer. Most divers were deep in debt to their employers, who fed and housed them during the season in exchange for loyalty and the lion's share of the catch. If he could tolerate the long hours and miserable surroundings, a diver might join the ranks of the few lucky ones who got rich by finding the right pearl. That dream sustained many divers through back-breaking days.

In Sri Lanka, the diver's day began at sunrise and lasted until midday, when rough seas and intense sun made work impossible. Pearl boat crews consisted of the master's or the owner's representative, known as the *sammatti*; the pilot, referred to as the *tindal*; the *todai*, or water-bailer and provisions man (charged with feeding the crew and keeping the leaky craft afloat); and anywhere from five to thirty divers and an equal number of attendants, depending on the size of the boat. Sometimes a government inspector or guard came along to make sure the ruling powers got their full share of the haul.

Pearl fishers traveled in fleets of sixty to seventy vessels, which could collect a total of ten tons of oysters in a day. Divers used much the same methods as those prevalent in the Persian Gulf, and they could collect perhaps a dozen oysters in the typical forty-five-second dive. Although most dove by holding their breath, a few used breathing tubes to lengthen their dives. Leonardo da Vinci illustrated the use of breathing tubes by Indian pearl divers in his *Codex atlanticus*.

The pearling fleets returned to a noisy welcome each afternoon. In *Pearls and Pearling Life*, Edwin Streeter includes a passage from Robert Percival's *An Account*

of the Island of Ceylon (1803), which evoked the tumultuous atmosphere of one pearling camp, describing

> . . . the multitude of boats returning in the afternoon from the pearl banks, some of them laden with riches; the anxious expecting countenances of the boat-owners while the boats are approaching the shore; the eagerness and avidity with which they run to them when arrived, in hope of a rich cargo; the vast number of jewelers, brokers, merchants of all colors and all descriptions, both natives and foreigners, who are occupied in some way or other with the pearls, some separating and assorting them, others weighing and ascertaining their number and value, while others are hawking them about, or drilling and boring them for future use.

Activity in the pearling camps encompassed not only the onshore tasks of the pearl-fishing crews but also the preparation of pearls for market and the actual sale, auction, and barter of the precious commodity. Oyster catches were divided among the crew, the boat owners, and the government. Gamblers often bought individual oysters from divers, investing a few rupees in hopes of a large payoff. The pearl-picking surroundings were as odiferous as those in the Persian Gulf, prompting Kunz and Stevenson, in *The Book of the Pearl*, to remark, "The lady who cherishes and adorns herself with a necklace of Ceylon pearls would be horrified were she to see and especially to smell the putrid mass from which her lustrous gems are evolved."

The entrepreneurs who financed the pearling expeditions paid top price for the services of skilled pearl artisans who could enhance the value of raw pearls with their talents. Pearl drillers, for example, painstakingly pierced holes through the gems so they could be strung as beads. Their work required a steady hand and an aptitude for working under pressure, for even a minor error could crumble an expensive pearl into dust. Dealers from the pearl markets of Bombay purchased the products of the Gulf of Mannar at auction and transported them north, where merchants from around the world gathered.

In India and Sri Lanka pearl-fishing techniques changed little until 1904, when entrepreneurs employed the world's first pearl-fishing steamships. The boats quickly demonstrated the advantages of industrial technology. Steamships could carry sixty or even one hundred divers, in addition to heavy, new pearl-fishing equipment. Divers on the steamships combed the pearl beds with dredges, harvesting hundreds of oysters

at a time. As the teeth of a dredge raked over the open valves of the mollusks, the device stimulated their defense reflex and they snapped shut, often clamping onto the dredge itself. The crew then lifted the dredge from the sea and harvested the oysters on the ship's deck. Meanwhile, other divers plumbed the ocean depths using diving bells, which provided an air supply via a pump and rubber tubing. Diving bells allowed divers to go deeper and stay down longer, so they could find potentially valuable mollusks tucked away in more remote hiding places. As in the Persian Gulf, these methods soon ravaged the pearl beds of India and Sri Lanka.

The third great pearl fishery of the world, the Red Sea, shared a similar fate. Its early history differs somewhat, for it was never controlled by one central power. Beginning many centuries before the birth of Christ, individual pearl fishers had far greater freedom to pursue their work without official interference. That independence had its drawbacks, however, in that pirates made frequent raids on unprotected operators. Still, pearl fishing was a way of life for many in the region. The promise of wealth overpowered the fear of pirates and other perils, sending generation after generation of divers to the pearl beds. They used the same methods and faced the same dangers as pearl divers everywhere.

For Red Sea pearl divers, as for all who simply held their breath while they hunted for oysters, working within the limits of their lung capacity presented a number of hazards. Divers suffered constant nosebleeds, coughed up blood, or sometimes became paralyzed from staying down too long. Blindness, deafness, and loss of bladder control counted among the common long-term effects of working as a pearl diver. One French observer wrote of the Red Sea divers:

The divers were easily recognizable because of their exaggerated chest development. Invariably they were young, rarely over twenty-five years of age. In these regions men begin diving as mere boys and abandon the profession after a few years, to avoid the eye and bladder troubles inevitable if they prolong the dangerous occupation over too many years.

Although they took the same risks, Red Sea pearl divers collected fewer pearls during the season from early spring to early fall than did divers in the Persian Gulf

and the Gulf of Mannar. Instead, they drew most of their living from the abundant mother-of-pearl harvests they sold to Arab and European customers. The pearls they did find went to the Bombay markets via Indian dealers, where they were traded alongside the finest pearls from around the world. Brought from their sources by merchants who often disguised themselves as vagrants to avoid robbery, pearls passed through elaborate analysis before being sold in the Indian markets.

Dealers first sorted pearls into ten lots, according to size. Each lot was then divided into twelve classes, based on the quality of the gems—a valuation based on luster, color, and shape. After grading, dealers assessed the price of each pearl on the basis of its weight. Pearls of lesser quality were assigned a price corresponding to their weight, while finer pearls were priced according to the square of their weight. Traders from every nation gladly invested in the gems, knowing that they could make hefty profits when they returned home. Especially huge fortunes in pearls flowed from the markets of Bombay to the leading jewel emporiums of London, Paris, and Berlin.

Many of the world's pearls, of course, never passed through Bombay. The freshwater and saltwater pearls of China often went to Arab traders who took them to the Middle East or to Europe. Japan kept many of its own pearls and purchased others from China. Pearls found in Europe, especially the lovely freshwater rarities from Scotland, generally stayed there, while Central American and Australian pearls went mainly to Europe. South Seas pearls from the Sulu Archipelago of Malaysia, the Tuamotu Islands, and the Philippines made their way to China and thence to the rest of Asia and Europe. In the 19th century, the freshwater gems of North America found an eager market at home.

In the South Pacific, pearl divers used the same techniques as their colleagues elsewhere, although in the Sulu Archipelago some fished with tridents onto which oysters would clamp when poked at. Before venturing below the water's surface, divers in certain areas of the region performed breathing exercises—involving much hyperventilation—meant to extend the length of time for which they could remain submerged. Many local fisheries were tapped only sporadically and remained unknown to outsiders for years; the bulk of exports went to China until the 1800s. Arriving on the scene early in that century, Europeans immediately set about exploiting the South Seas pearl beds. Henry Taunton described the virtual enslavement of Malaysian divers by Europeans in his *Australind* (1900):

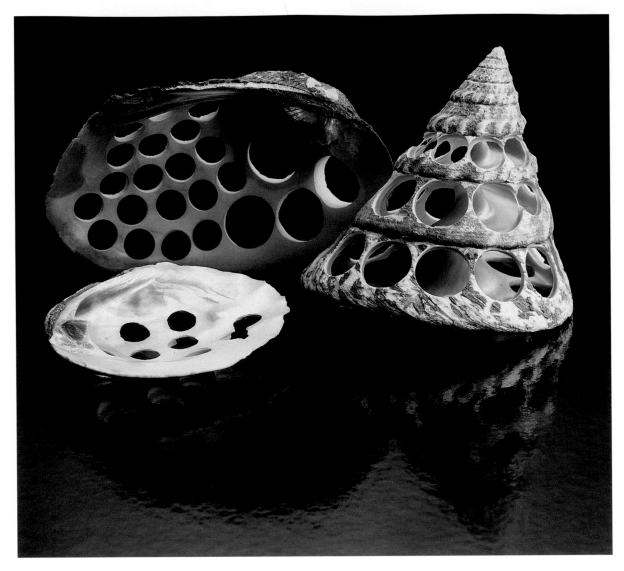

*Assorted shells
from which buttons
have been cut.*

When three or four white men had to control and compel some thirty or forty natives
to carry on work which they detested, a very strict discipline had to be maintained.
It was the rule that no talking was allowed amongst the divers when in the dinghy,
nor were they even permitted to address the white man. . . . Sometimes, indeed, I
have pushed off from the vessel's side of a morning and have not heard a word
spoken until we returned on board at night.

Europeans started fishing the pearl beds off Australia in 1861, using the aborigines
as divers. Before then, the aborigines had placed no special value on the pearl and
had not dived for them, so they considered pearl fishing an undesirable occupation, to
be undertaken only when Europeans forced them into it. The previously undisturbed
oyster banks stretched 3,000 miles, from Freemantle in the southwest to Cooktown in
the northeast; others were located in the Torres Strait and on the Great Barrier Reef.
Tremendous demand for pearls resulted in careless overfishing and rapid depletion of
the pearl beds. By the early 20th century, few natural pearls could be found in Austra-
lian waters.

Pearl fishing in the Americas originated with the indigenous populations, who

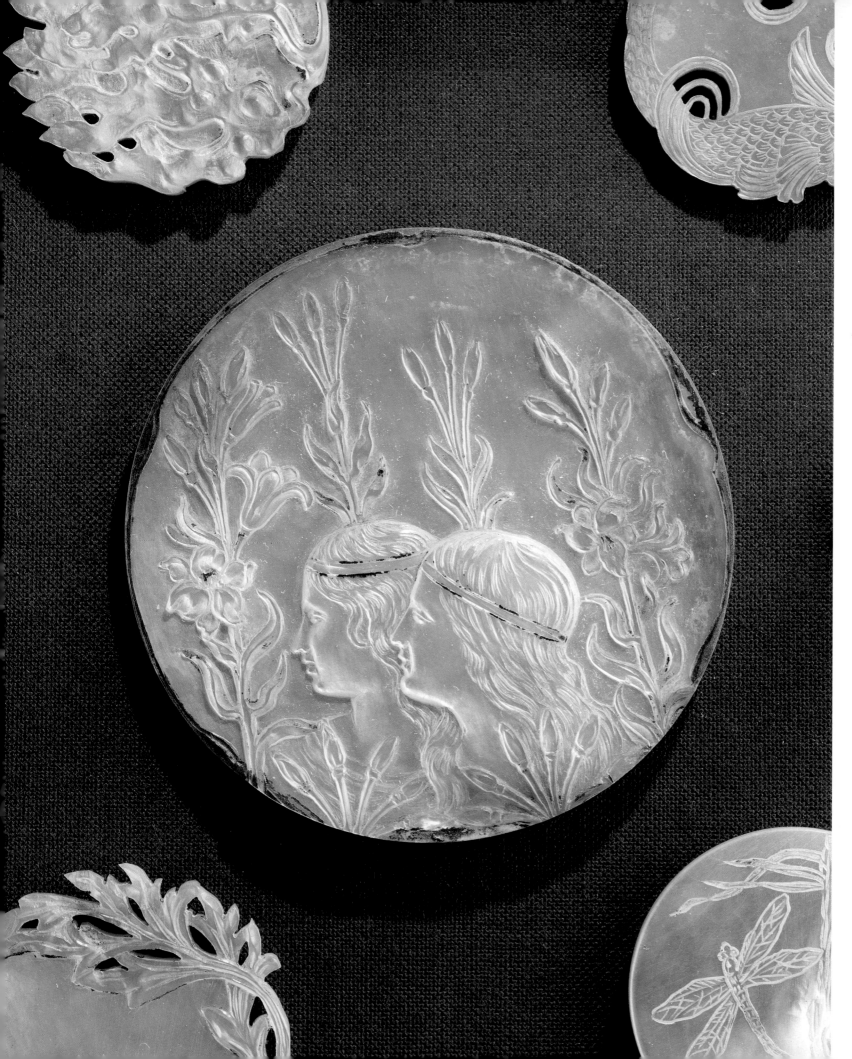

Portraits such as this one were a popular motif for mother-of-pearl buttons.

British subjects known as "pearlies" sport their button-studded costumes on Derby Day. During the early 20th century a craze for holiday clothing adorned with mother-of-pearl buttons swept England.

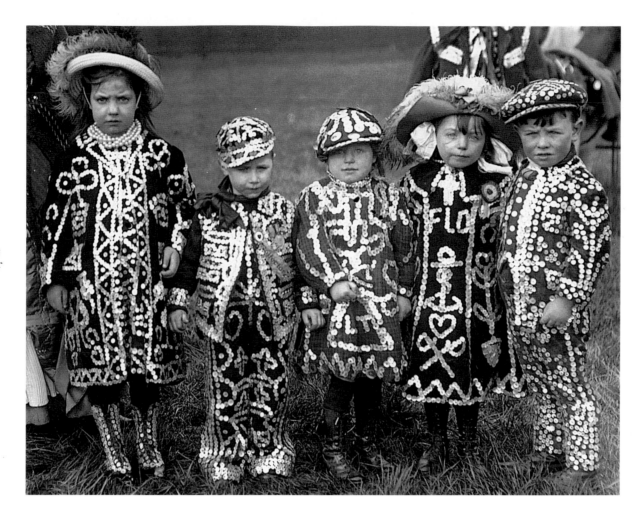

Young pearlies show off their outfits.

discovered pearls in North American rivers, as well as along the seacoasts of Central and South America. In the areas now known as Panama, Venezuela, and Baja California, Spanish conquerors enslaved native divers and shipped the shimmering bounty to Europe. The freshwater pearls of North America were all but ignored until the 19th century, when discoveries of high-quality specimens in such places as Notch Brook, New Jersey, and southwestern Ohio set off local pearl rushes. As the freshwater gems found a growing market, especially in America, river fishing extended to Tennessee, Kentucky, Arkansas, and the upper Mississippi River valley, particularly in Wisconsin.

Mother-of-pearl from American freshwater mollusks brought the German immigrant John Boepple to the United States in 1887. An artisan who crafted small items such as buttons and buckles from horn, shell, and bone, Boepple saw the possibilities of the new American material and headed for the upper Mississippi region. Settling in Muscatine, Iowa, he began manufacturing mother-of-pearl buttons from local shell. By 1893, Boepple had a brick factory and more than a hundred employees; competitors set up shop nearby, and before long all America was clamoring for mother-of-pearl buttons. For fifty years, people flocked to Muscatine to fish for pearl shell and work in the button industry. The only thing that brought the boom to an end was the introduction of pearlized plastic buttons in the middle of the 20th century.

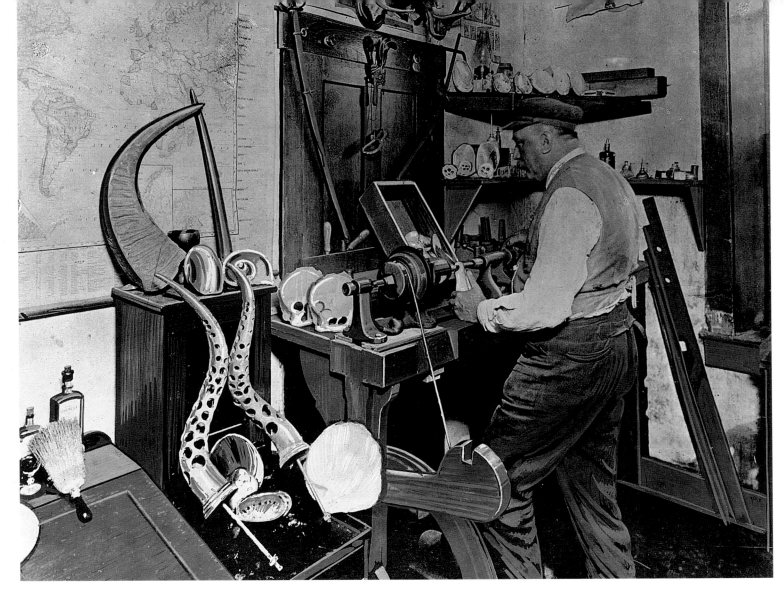

John Boepple, who launched the American pearl-button craze, cutting buttons from mussel shells at his original machine in Muscatine, Iowa.

Whatever their source and use, pearls and mother-of-pearl fell victim to their own beauty. Centuries of demand for the gem resulted in less than circumspect exploitation of the world's pearl beds; shortsighted avarice severely reduced the global oyster population's production of natural pearls. The sorry state of the pearl fisheries was painfully apparent by the 19th century, when greatly reduced pearl harvests yielded far fewer gems of quality. Jewelers remained in business by selling these pearls at inflated prices and by dealing in heirloom pieces made from pearls harvested long before. But it was clear the pearl industry would die unless some miracle occurred. Periculture, of course, proved to be that miracle.

MIKIMOTO THE PEARL KING & PERICULTURE

Just as the origins of the pearl long puzzled humans, so the origins of periculture are shrouded in mystery. The Chinese, who several centuries before Christ placed carved Buddha figurines in mollusks so they would become coated with mother-of-pearl, can lay claim to the first success in blister pearl culturing. The Swedish naturalist Carolus Linnaeus, who in the 18th century implanted irritants in European mussels to stimulate the production of pearls, was the next to make progress. But pearl culturing as it

is practiced today did not develop until the turn of the 20th century, when a flurry of activity in Japan yielded the world's first scientifically induced gem-quality pearls.

The name most closely associated with the development of periculture is that of Kokichi Mikimoto. Mikimoto was born in Shima Province on January 25, 1858, five years after the arrival of the American naval commodore Matthew Perry heralded the end of Japan's policy of isolation from the outside world. The eldest son in a large family that operated a noodle shop, Mikimoto spent his youth seeking an education and learning the family business. When his father died, the twelve-year-old boy assumed his responsibilities as the first son and took over the noodle shop. Relatively independent and growing up during the Meiji restoration, which rapidly modernized Japanese culture and commerce, Mikimoto had access to new ideas and social mobility unknown to prior generations. He became fascinated with pearls at the age of twenty, when he traveled alone to the trading centers of Yokohama and Tokyo. As a dealer in marine products such as seaweed, he was curious about pearl-bearing oysters and began spending more of his time with the fishermen in his hometown on Ago Bay.

After a decade of speculation and investigation, and marriage to a young woman named Ume, Mikimoto went to the national fisheries fair in 1888. There he met Narayoshi Yanagi, an authority on pearl-bearing mollusks. Yanagi taught Mikimoto all about oysters and had to agree when Mikimoto, a quick study, suggested it might be possible to farm pearls, just as some Japanese had begun to farm oysters. Armed with his new knowledge, Mikimoto returned to Shima and set up a pearl farm on a few islands in Shinmei Inlet, including Ojima Island—now known as Pearl Island. He understood little about the mechanics of pearl formation, however, so at first his akoya oysters, left to their own devices, produced only a few imperfect mabe and blister pearls. Undaunted, Mikimoto took his work to an 1890 fisheries fair, where he met Dr. Kakichi Mitsukuri, an expert on pearl formation. The professor shared his knowledge with Mikimoto, who returned to his farm inspired to succeed.

Working side by side, Mikimoto and his wife poured all their money into their pearl farm. Many of their neighbors considered them crazy and called them *baka*, or stupid, for they worked tirelessly and without success. The couple inserted all sorts of possible pearl nuclei—sand, lead, wood, glass, and so on—into their oysters, which they suspended underwater in bamboo baskets. When nothing happened, they tried new materials, including mother-of-pearl. Then, in 1892, a suffocating red tide of

*Kokichi Mikimoto,
the Pearl King.*

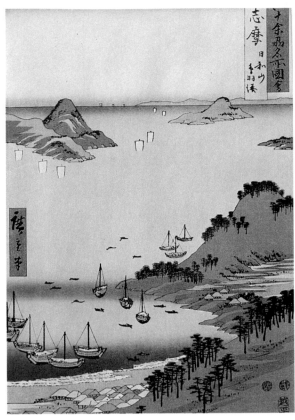

Above: Female pearl divers, or ama, *dry their hair in this traditional Japanese pearl-fishing scene.*

Above right: Ago Bay, where Kokichi Mikimoto produced his first spherical cultured pearl.

plankton wiped out many of their akoyas. The tide spared those around Ojima Island, though, and the Mikimotos kept working. Finally, on July 11, 1893, Ume discovered a mabe pearl formed around an implanted mother-of-pearl nucleus. Mikimoto immediately applied for a patent.

After receiving a patent for his hemispherical pearl process in 1896, Mikimoto moved his pearl farm to Tatokujima Island in Ago Bay, where conditions were more favorable for akoyas. His wife died suddenly that year, but the tragedy only strengthened Mikimoto's resolve to produce a spherical cultured pearl. Two other experimenters were also working on the problem, independently of each other: a carpenter named Tatsuhei Mise and a fisheries bureau technician named Tokichi Nishikawa. Mise succeeded in generating a spherical pearl by 1904, but because of Mikimoto's mabe pearl patent he was denied a patent of his own.

That year, a more devastating red tide than that of 1892 wiped out 850,000 of Mikimoto's oysters. Forlorn at the setback, as well as at his continuing failure to make a spherical cultured pearl, Mikimoto set about inspecting the mounds of dead akoyas. He was overjoyed to find five gleaming spherical pearls among the thousands of broken shells. The victory gave him the energy to go on with his work. Seeking to refine his spherical pearl culturing process, Mikimoto collaborated with a dentist named Otokichi Kuwabara while Mise and Nishikawa joined forces. Nishikawa applied for a spherical pearl patent in 1907 on the basis of a process he originated in 1899; Mikimoto patented his own process, which involved wrapping pearl nuclei in nacre-producing mantle tissue, in 1908. In 1916, both teams received patents for their perfected methods.

Before long, Mikimoto recognized the superiority of the Mise/Nishikawa method and adopted it in his own periculture operations. His business boomed as his aggressive marketing style left competitors floundering, and he earned the title "Pearl King." At first, Mikimoto sold his products from a shop that he had opened in Tokyo in 1899, but in 1921 he made his business international, exclaiming, "I want to adorn the neck of every woman in the world with a pearl necklace." The sudden abundance of perfect pearls from Japan made dealers in New York, London, and Paris suspicious that they might be fakes, so they cut a few open and discovered the mother-of-pearl nucleus within. A French jeweler took Mikimoto to court for fraud, but the judge ruled in favor of the Japanese entrepreneur.

The Pearl King cleverly turned bad publicity into good by sending cultured pearl exhibits to museums all over the world. Now, the public could see the pearl culturing process for itself and learn how little it differed from natural pearl production. Cultured pearls gained a following, but most of the world's premier jewelers dismissed them as *boules blanches* (white beads) and refused to carry them. Mikimoto, however, believed in his product and traveled the world to campaign for international acceptance of the cultured pearl. The Great Depression flattened demand for pearls, and World War II devastated the Japanese pearl farms, but Japan steadily established its place as the world's leading cultured pearl producer. From a 1927 total of one million oysters, K. Mikimoto and Company increased its rate of production to fifteen million nucleated oysters in 1934. By dominating the Japanese industry, Mikimoto controlled the international cultured pearl market.

The extreme scarcity of natural pearls and the high quality of his own product helped Mikimoto win the world over to cultured pearls. Consumer demand for the gems eroded jewelers' resistance to them, and more shops began selling Mikimoto's offerings. Among the leading houses, Tiffany finally acquiesced in 1955, a year after the Pearl King's death. The cultured pearl market has since grown steadily, supporting the rise of one of Japan's major industries. Today, about two thousand pearl farmers work the waters surrounding Japan. Large or small, all the periculturists use essentially the same techniques to raise oysters and generate pearls. Ongoing research permits continual improvement of the field, applying scientific innovation to the delicate art.

Many of the smaller pearl farmers breed akoyas in open waters, placing special

The ama of Japan,
shown here as
photographed by
Fosco Mariani
in the early 1960s,
occupy twenty-four
villages on the
coastline and islands
of the Sea of Japan.
Known as the
"children of the
sea," the ama
have always taken
their livelihood
from the ocean.

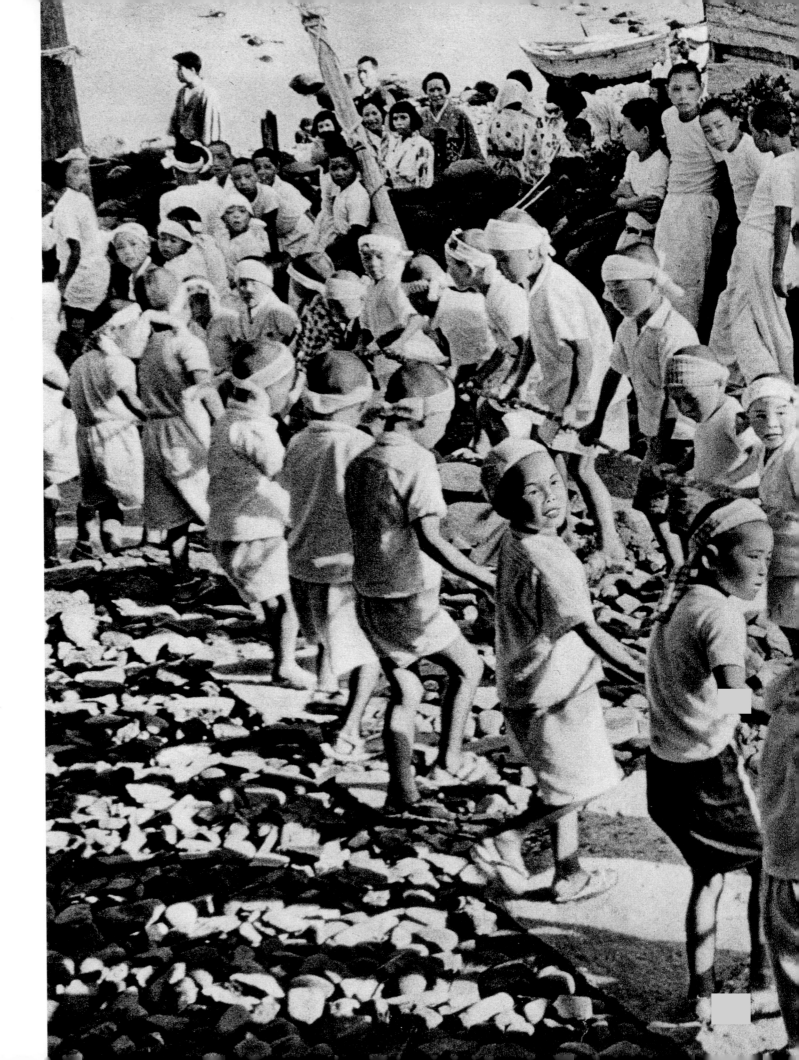

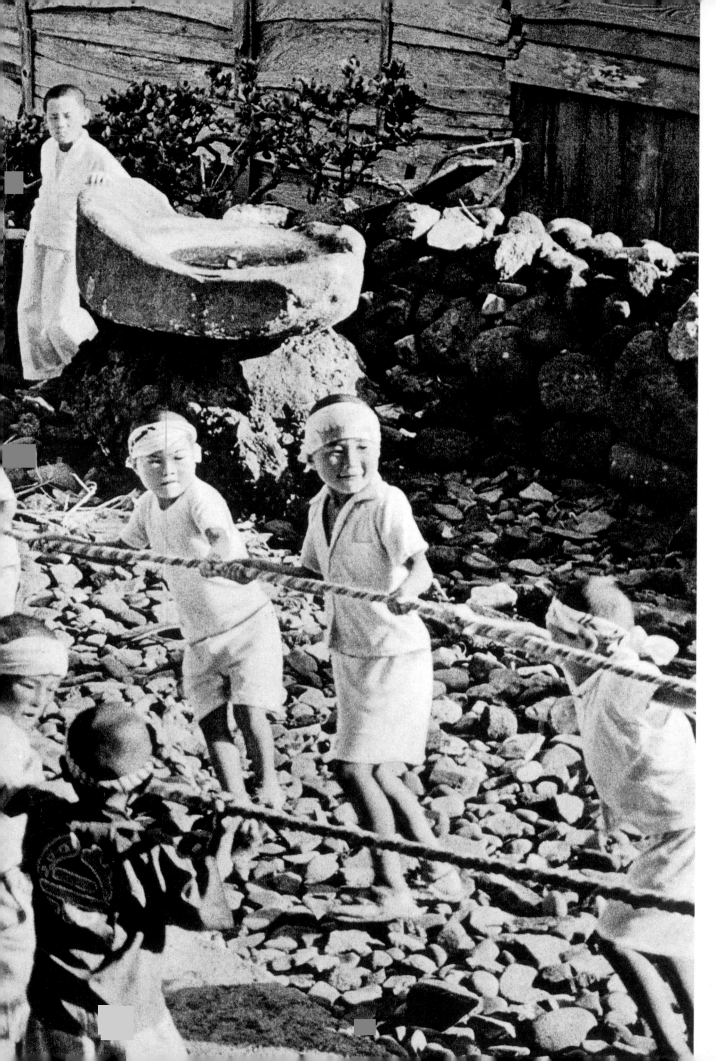

The ama *were long famed as skilled pearl divers who could descend as deep as 60 feet wearing nothing but primitive goggles and* koshi-maki *(loincloths).*

Originally employing
their talents to forage for awabi
(abalone) and nori (seaweed),
the ama found work as pearl
divers when the Japanese pearl
industry started to grow. Teenage
girls and middle-aged women
alike tended pearl beds and
harvested oysters in surf that was
often rough, frigid, and infested
with sharks and octopi. Their
bronzed, supple bodies could be
seen diving, swimming, and
surfacing among the waves, their
graceful movements seeming
effortless as they went about their
tasks. Each time they rose to the
surface and exhaled, they
sounded the haunting ama-bui
whistle. In the age of mechanized
pearl fishing, the ama-bui is now
seldom heard along the coast of
Japan. Some ama, however, work
for modern pearl farmers,
performing tasks that require
their unique skills.

More typical of modern periculture, an Australian pearl farmer employs the latest diving technology for underwater work. Photo courtesy of David Doubilet.

Right and opposite: Seen primarily in exhibitions now, ama divers were employed by Mikimoto & Company well into the 20th century, but a dress code was instituted. Instead of the traditional loincloth, Mikimoto's ama pearl divers wore white cotton garments that covered them from neck to knees. These uniforms were believed by many ama divers to repel sharks.

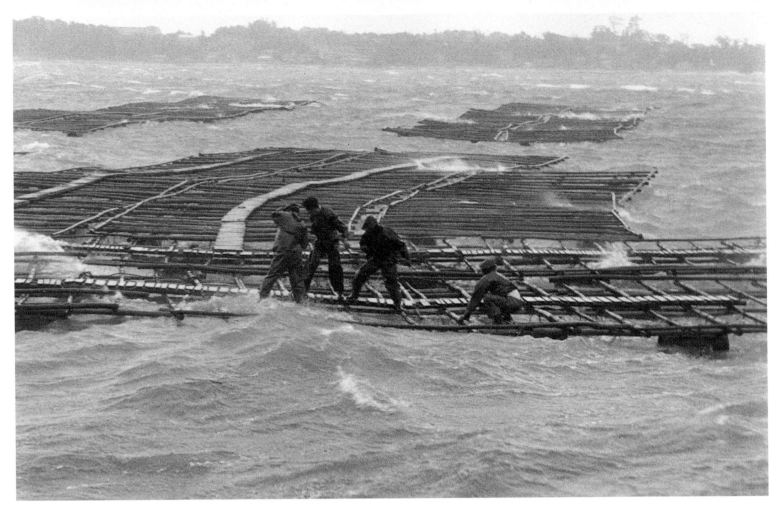

Periculturists securing their rafts before a typhoon in Ago Bay, Japan. Oysters are suspended from the rafts in cages.

A rare photograph of a cultured pearl being extracted from a live South Seas oyster. Photo courtesy of Michael Freeman.

collectors near oyster populations to gather baby oysters, or spats. At Mikimoto and other large companies, technicians breed the oysters in tanks, using sophisticated methods of artificial fertilization. Either way, young akoyas are moved to protected nursery habitats to grow for two to three years before they are used for pearl culturing. When the oysters are ready for implantation of pearl nuclei, they undergo carefully monitored preparation for the traumatic operation. First, technicians slow down their metabolism by packing them into close quarters and depriving them of food. This process minimizes shock to the sensitive creatures. Then a wooden wedge is inserted between the shells to hold the oysters open for the operation.

To nucleate, or seed, an oyster, technicians place it in a special eye-level stand to hold it steady, and then secure its muscular foot with a clamp so it does not move during the operation. Next, they cut a narrow strip of tissue from the outer edge of the mantle and slice that strip into small squares. Moving the oyster's mantle aside to reveal its viscera, technicians then make an incision near the reproductive organ, or gonad. They select an appropriately sized, perfectly spherical mother-of-pearl nucleus made from freshwater American mussel shell, and insert it next to the gonad along with a piece of mantle. A skilled technician can insert about 400 to 500 nuclei per day.

Japanese periculturists prefer American mother-of-pearl because its color and hardness make it an ideal nucleus. Since 1960, the rivers of the United States have provided almost all of the mother-of-pearl used as nuclei in cultured pearls. Divers and dredges, which are called brails, pull pig-toe mussels and other varieties from the

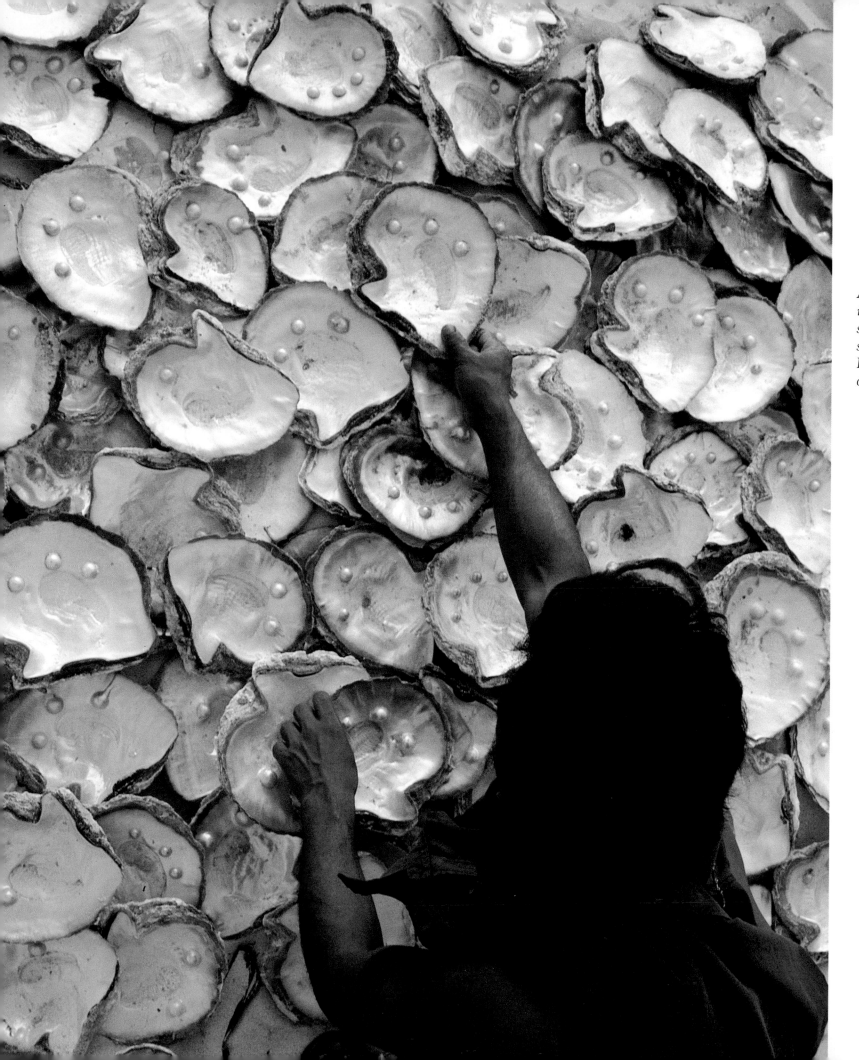

*A pearl farmer
in the South Pacific
sorting pearls
still in their shells.
Photo courtesy
of Michael Freeman.*

Ohio, Tennessee, and Mississippi rivers and their tributaries. Four or five American suppliers ship a total of up to 6,000 tons of mussel shell to Japan annually; about 60 percent of this comes from the Tennessee Shell Company, operated by John Latendresse in Camden, Tennessee. Latendresse has recently initiated attempts to culture American pearls without Japanese assistance.

After a brief period of recovery, seeded akoyas are returned to the outdoor cages from which they came. These cages hang beneath rafts that form floating islands in the bays and inlets of southern Japan. During the one- to two-year period required for pearl growth, the oysters are regularly cleaned of growths that cling to their outer shells and are moved to warmer waters in winter. The pearl harvest takes place in cold weather, when the gems are most lustrous. Each oyster is opened and thoroughly inspected for pearls; approximately one-third of those nucleated will contain marketable specimens. In some instances, pearl farmers recycle oysters from which pearls have been taken, implanting new nuclei and returning the creatures to the water.

The pearls are sorted for size and quality and sold at pearl markets held each December through February to coincide with the harvest. Japanese and foreign buyers can check nacre thickness and other indicators of quality with a number of tests and devices, placing bids on pearls by lot. The best pearls have nacre thicknesses of at least .35 millimeters, although Mikimoto's often have half a millimeter or more. Since 1952, strict government controls have regulated the quality of cultured pearls sold for export. Despite the law, inferior pearls still find their way out of the country fairly often. Some farmers sell pearls that have been cultured for only six months, from which the fragile layer of nacre wears off quickly.

Some Japanese cultured pearls, called *yoshoku-shinju*, receive a hydrogen peroxide bath to bleach out impurities before they are sold. According to "The Pearl," an article by Fred Ward in the August, 1985, issue of *National Geographic* magazine, many experts familiar with the industry assert that Japanese pearls are routinely dyed to produce greater quantities of uniformly colored gems in popular tints. But whether or not Japanese cultured pearls are altered in any way, they remain enormously popular, especially in Japan and the United States. The gems represent Japan's largest single marine export: in 1980, Japan exported more than $220 million worth of pearls to the United States, where retail cultured pearl sales reached $830 million in 1988.

Cultured pearls from other nations have joined Japanese pearls on the market

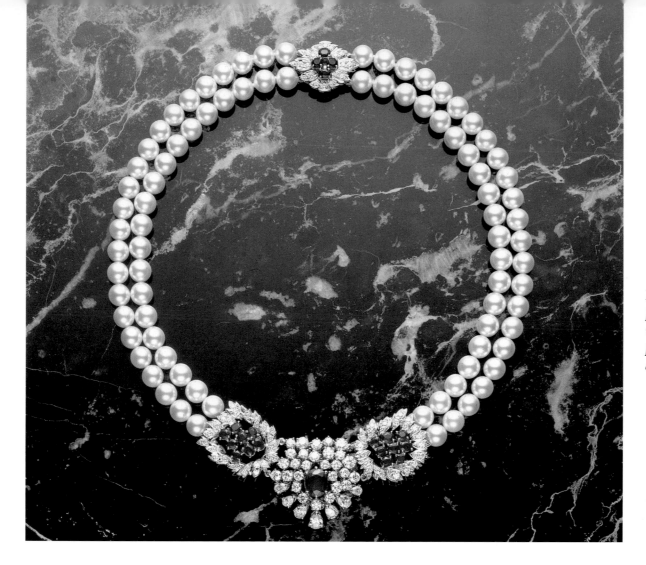

*Mikimoto cultured
pearl necklace
with a diamond and ruby
pendant
and clasp.*

since the 1950s, when Burma (Myanmar), Australia, and the Philippines entered the industry. Tahiti, Marutea, and other islands of French Polynesia also grow the South Pacific's distinctive large pearls, as well as the stunning black varieties so popular today. All these cultured pearl sources, though, rely on the expertise of Japanese periculturists, for Japan has closely guarded its valuable pearl farming technology. Wherever periculture thrives, Japanese technicians participate and Japanese concerns like Mikimoto maintain large investments.

Most of the black pearls now available to consumers are cultured on Marutea, a small island in the Tuamoto archipelago. There, Jean-Claude Brouillet has established a monopoly on black pearl production, assisted by Japanese technicians. The enormous investment of capital and energy pays off handsomely in today's market, as black pearls increase in popularity with each passing year. Skillfully controlled by the American entrepreneur Salvador Assael, this relatively new area of the international pearl business is possibly the fastest-growing segment of the industry. Black pearls are coveted the world over for their sultry chic and deep luster, placing them among the most costly gems offered by jewelers.

In response to the thriving demand for cultured pearls, the Japanese have taken a deep interest in protecting the world's pearl-bearing oyster populations through biotechnology. Since the 1960s, scientific experimentation at such respected institu-

Oyster shells produced by the periculture industry are packed and sold for other purposes. Photo courtesy of Fred Ward.

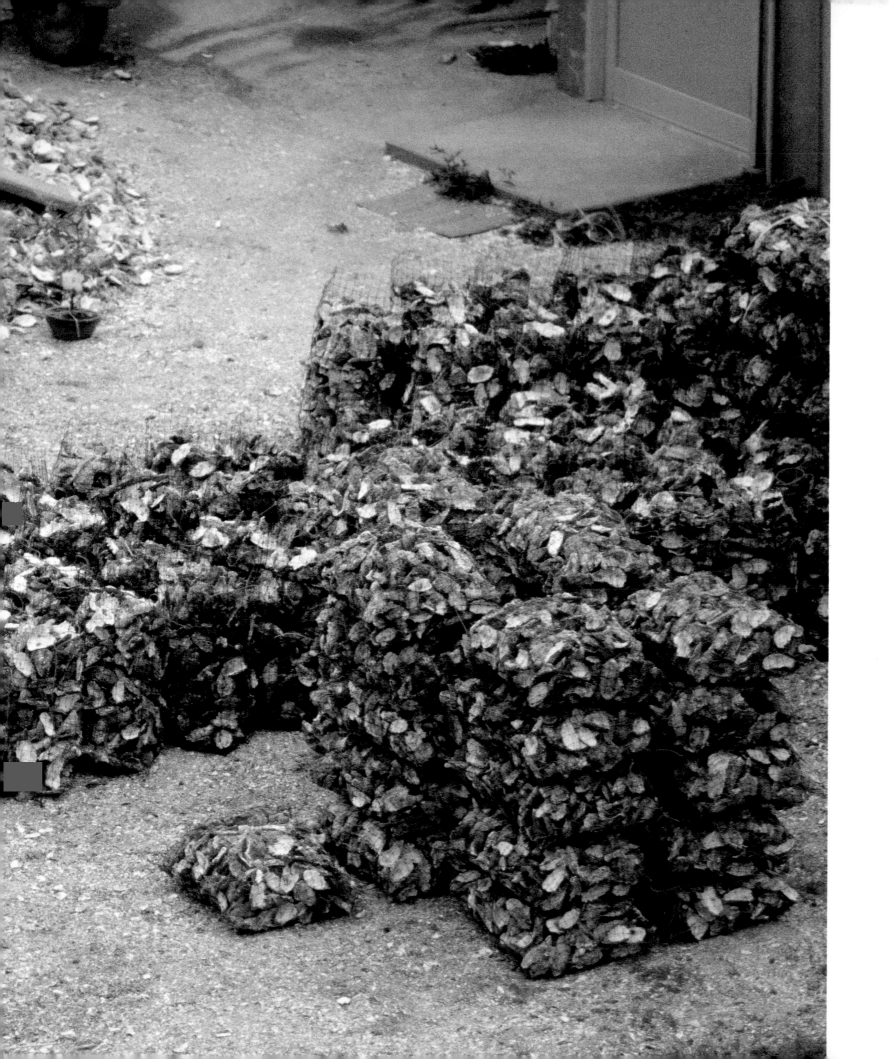

Biotechnologists
specializing in
periculture employ
state-of-the-art
scientific techniques
to breed superlative
oyster strains that
can withstand modern
environmental
conditions. These
pictures of spats, or
baby oysters, were
shot through a
specialized microscope.

Australia, where periculture was introduced in 1956, today produces some of the world's most valuable cultured pearls. Although not as prolific as Japanese akoyas, Australia's Pinctada maxima oysters (shown here) generate gems up to 20 millimeters in diameter, double the size of the largest Japanese pearls. Pearl farmers Down Under must capture young oysters in the wild before they can seed and cultivate pearls. But the warm waters and nutrient-rich high tides of Australia's northern coast foster the formation of magnificent pearls, making the effort highly profitable. Photo courtesy of David Doubilet.

tions as the Mikimoto Research Laboratory has led to advances in genetic engineering, mollusk nutrition, and marine management. Selective breeding and artificial spawning have produced hardier oysters, capable of thriving in dirtier, more crowded waters. Japan's akoya population, which was shrinking in the 1970s, has since recovered and is now growing. The new varieties mature earlier, making greater numbers of healthy oysters available for culturing. Farmers have even learned how to breed oysters that produce pearls of more desirable colors. Some of these pedigreed mollusks feed on ultra-nutritious plankton "super soup," a scientifically developed oyster food. And research into nucleus implantation techniques has resulted in faster production of better pearls.

Biotechnology has done much to safeguard the world's endangered pearl-bearing oysters. Pearl farmers have learned not to overcrowd the waters in which they grow their precious crops. Nonetheless, environmental problems beyond the control of periculturists continue to threaten the delicate mollusk. Only international attention to the contamination and destruction of marine habitats will guarantee the survival of the oyster and the security of the world's pearl supply.

Iridescent paints and pigments are applied to a wide variety of items, including custom automobiles like this Lotus.

Gary Knox Bennet created this "pearlescent silver plate" lamp.

Pearlized plastic telephone from Mikimoto.

A vintage 1940s handbag of pearlized celluloid.

Bird's-eye maple table inlaid with a pearlized laminate, French Deco Linoleum (also called rhodoid), by John Dunnigan.

UNEXPECTED PEARLIZED PRODUCTS & PROCESSES

Much to the delight of pearl lovers throughout history, the pearl's significance as a commodity has always extended far beyond the market in natural and cultured gems. Mother-of-pearl represents the earliest and most enduring variation, one that has shown up in jewelry, furniture, buttons, artwork, and the like. Faux pearls created with essence d'orient have spread iridescent joy for hundreds of years. But in the last century, the diversity of artificially pearlized goods has multiplied, encompassing items from the most mundane to the unarguably bizarre.

The direct descendants of Jacquin's 17th-century creation, the pearly lacquer known as essence d'orient, pearlescent paints and varnishes crowd the market today. These pigments no longer use the fish-scale essence discovered by Jacquin, relying instead on other compounds to produce the effect of iridescence. Substances such as lead carbonate, bismuth oxychloride, and simple mica form similar transparent, crystalline platelets that arrange themselves in irregular, parallel layers when suspended in the right solution. The pigment's structure generates a pearl-like orient that can be applied to almost any surface. Printer's ink, furniture and wall finish, automobile paint, and other coatings employ this principle of iridescence, with opulent results.

The iridescent glass of 16th-century Venice also has its 20th-century descendants, in the form of some beautiful pearlescent products. Most notable is Foval, or Pearl Art Glass, a favorite of Americana collectors. Manufactured by the H. C. Fry Glass Company between 1901 and 1933, Pearl Art Glass got its luster from aluminum oxide. Molded into custard cups, pie plates, ramekins, and other cooking and serving dishes, and blown into dinner plates, bowls, cups, and glasses, the glass was made in several different grades of opacity, depending on how much aluminum oxide was used. Some pieces sport trim in hues of blue and green; blown lamp shades were a specialty. Extremely scarce today, Pearl Art Glass pieces command high prices. Their charms are echoed in contemporary glass works produced by top contemporary designers.

The luxurious look of pearls has also transformed all manner of proletarian plastic products. From telephones and bowling balls to costume jewelry and floor coverings, pearlescent plastic has been a favorite since the introduction of this modern material. Inventors first pearlized celluloid, the organic forerunner of petroleum-based plastic,

*A pearly confection
from Rosebud
Cakes in Beverly
Hills, California.*

*With the invention
of pearlized plastic,
durable pearly buttons
could be produced
more cheaply. Plastic
buttons greatly
reduced demand
for their pearl-shell
counterparts.*

using lead phosphate. The resulting substance showed up in pocketbooks, combs, and dozens of other items. Rhodoid, a pearlized laminate also known as French Deco Linoleum, became popular as an inlay for furniture. Subsequent iridescent plastics have appeared in buttons, dinnerware, window shades, and even artificial fingernails. The introduction of pearlized plastic put many mother-of-pearl industries, such as the button works of John Boepple, out of business.

One of the oldest cosmetics, pearls have inspired countless beauty aids, particularly in the last century. Face creams and lotions incorporating pearl powder, and others simply named for the jewel of the sea, promise the user lustrous, glowing skin. Mikimoto produces lines of pharmaceuticals and makeup that contain real cultured pearls. Yves Saint-Laurent plays on the pearl's appeal in the marketing of its glistening Hydra-Perles skin cream. Pearl based or not, iridescence has always been an especially popular quality in eye makeup and lip coloring. During the late 1960s and early 1970s, for example, pearly white lipstick and nail polish helped millions of women achieve the "mod" look. Scores of soaps, bath products, shampoos, hair sprays and colorings, and toothpastes suggest pearls with their names, inspiring thoughts of shimmering purity even when they contain nothing remotely pearly.

Pearlescence has such strong appeal that people have invented processes to pearlize just about anything. Special optical finishes, such as those produced by Du Pont, give certain fabrics an iridescent look, while the inherent luster of nylon has been translated into pearly-looking pantyhose. Inventive pastry chefs have found ways to create pearlescent confections. Rose gardeners have named several varieties of that flower—the Perle Noire, the Sea Pearl, and others—for the gem, just as dozens of businesses have named their products after pearls. Whether electric guitar pickups (Pearly Gates), water softener beads (Pearls) or floor wax (Pearlite), aquarium gravel (Pearl Gems), percussion instruments (Pearl brand), or beer (Pearl Cream Ale), a startling number of consumer items cash in on the natural gem's eternal allure.

Every corner of the world of commerce, it seems, has room for the pearl, even if in name alone. The gem that played so prominent a role in the trade of ancient times continues to do so today, figuring in several dozen different industries and supporting one of the major enterprises of one of the world's leading industrial powers. Although the natural pearl is all but extinct, the cultured pearl and the pearlized product carry on the gem's rich history as one of humanity's most valued commodities.

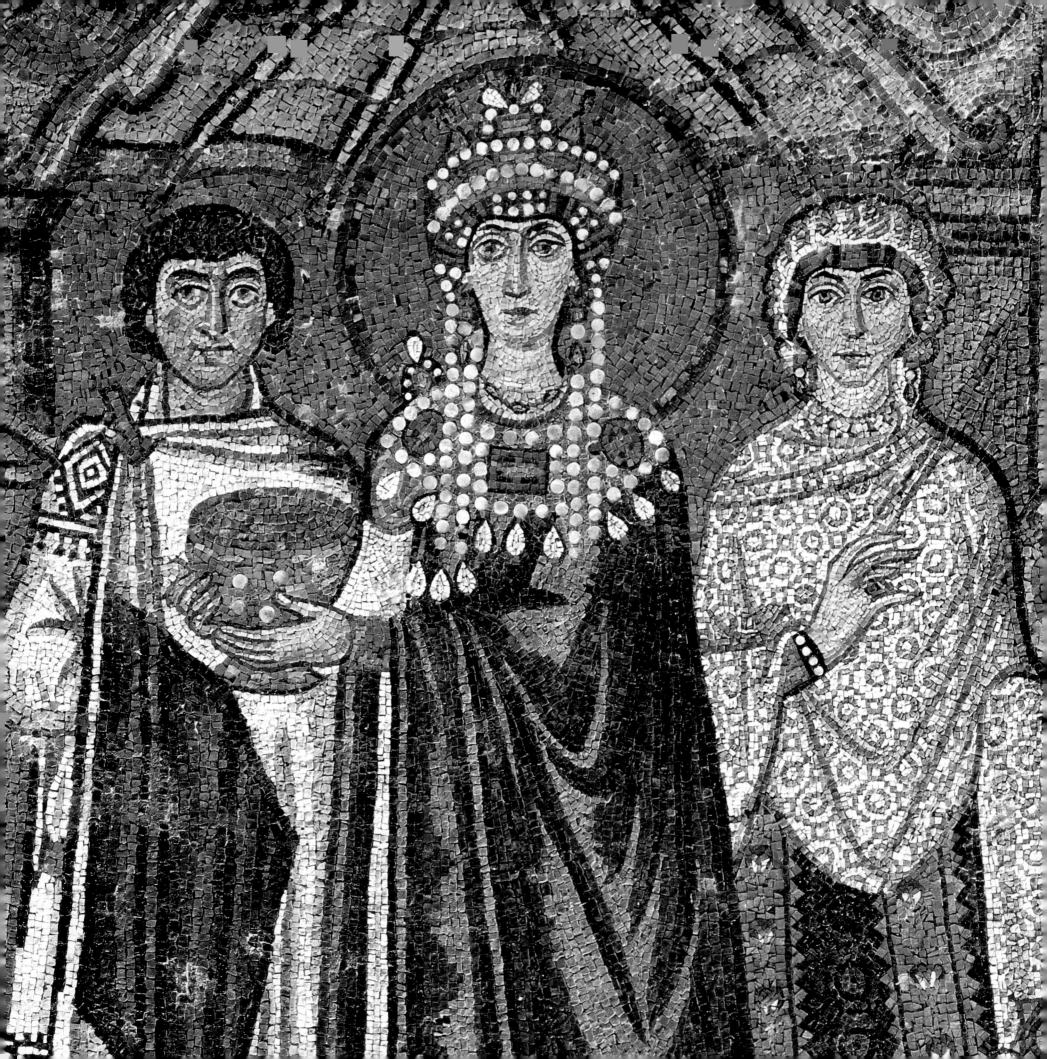

The Gem Which Dims the Moon

AN ENDURING

SIGNATURE OF STYLE

IN THE

DECORATIVE ARTS

Empress Theodora and her courtiers are portrayed in this mosaic from 6th-century Byzantium. Roman influence is apparent both in the use of a quintessentially Roman medium and in the abundance of pearls worn by the empress.

From the fabled treasures worn by Scheherazade to the simple refinements of Chanel, humankind's ageless obsession with pearls has manifested itself most richly in a marvelous array of ornaments for the body. Necklaces, brooches, earrings, head-dresses, bracelets, and rings—people have created a dazzling variety of pearl jewelry with which to decorate themselves. But the luminous beads and gleaming mother-of-pearl produced by certain mollusks adorn much more than the human figure. Every culture familiar with these iridescent delights has used them to embellish all kinds of objects. Pearls beautify not only people, but their surroundings as well. In doing so, they have become a preeminent emblem of classic style.

The impulse to adorn one's body and one's environment is as old as humanity itself. Paintings decorate the walls of early cave dwellings and depict, among other things, people wearing jewelry. Because the chief purpose of adornment is to bring pleasure through beauty, its practice sets humankind firmly apart from the rest of the animal kingdom. But the role of ornament extends even further, for ornament informs observers about the significance of the adorned. Throughout history, embellishment has had sociopolitical meaning, distinguishing powerful personages, demarcating sacred places, and defining the exceptional, the venerated, the potent.

Pearls, one of the earliest gemstones, figured prominently in decorative endeavor from the start. The wondrous radiance, spiritual aura, and astronomical price of pearls made them ideal vehicles for communicating the importance of the objects and persons they bejeweled. Only the wealthy, mighty, and holy were privileged to possess them, and whoever did so acquired an air of influence and prestige. Such was the pearl's ability to awe that some believed only the worthy should own one. "Do churls/ Know the worth of Orient pearls?" wrote Ralph Waldo Emerson in *Friendship*. "Give the gem which dims the moon/To the noblest or to none." Pearls, nature's emblems of purity, celebrated the nobility of the person or object adorned by them.

Of course, many of those who owned pearls, though perhaps noble in name, harbored far from noble sentiments. Inspired more by greed than grace, countless aristocrats, merchants, sultans, and queens collected massive quantities of the gem and commissioned lavish fashions, furnishings, and objets d'art studded or inlaid with pearls and mother-of-pearl. Consumed by a passion for luxury and determined to dazzle competitors and subordinates with displays of status, they pursued the object of their desire relentlessly, often at great cost. Pleased to demonstrate their power and standing, they paid little heed to the shaky finances or starving subjects they exploited to build their empires.

The pearly artifacts left behind by autocrats and magnates offer a legacy of adornment gone awry. Although unmistakably beautiful, these objects speak of the abuses of the past. Modern designers and collectors have for the most part rejected the tradition of excess in favor of elegance. Pearls now complement rather than dominate their context, whether it's a bride's ensemble or an architect's vision. The occasional flight of whimsy allows for a lavish display of the gem, but always in good fun—if not in good taste. Whether scaled down or vamped up, the pearl remains a magnificent adornment for the human body and its environment. The gem sets a magnificent standard of classic dignity in international style.

HANDICRAFTS, ARCHITECTURE & FURNISHINGS

The earliest artisans esteemed mother-of-pearl as one of their most beautiful materials. Archaeologists have discovered mother-of-pearl artifacts in the ruins of Sumeria, one of the world's oldest civilizations. Shell carving, engraving, and intarsia, plus an

Detail from the late 15th-century gothic tapestry The Lady and the Unicorn. The six tapestries done at Aubusson, France, in honor of the marriage of Demoiselle de Viste include this image of a woman who charms all the senses.

This brocade tapestry employs the traditional Persian "ring of pearl" motif to frame the hunting kings. It dates from the Parthian or Sassanid period (c. 200 B.C. to A.D. 640).

Seed-pearl
embroidery, like
that found on
this silk tunic,
flourished in
dynastic China.
The fierce
creature was
most likely
meant to protect
the wearer
from harm.

inlaid stone bowl from 3000 B.C., attest to the importance of mother-of-pearl to the Sumerian craftsperson. The Sumerians also invented mosaic, an art form that later cultures would elaborate to include mother-of-pearl.

From Sumeria, the practice of mother-of-pearl crafts spread to ancient Persia, where geometric inlay designs predominated, and to India, where mother-of-pearl inlay decorated Hindu temples and masks. When the technique reached Siam (now Thailand), artisans there carved Buddha and animal figurines from pearl shell and used mother-of-pearl inlay to create trays for religious offerings, begging bowls for monks, and book covers for sacred texts. Chinese craftspeople working in the first millennium A.D. produced splendid wood boxes inlaid with pierced, engraved, and carved mother-of-pearl. They also used pearl shell to craft miniature pagodas, carved dessert plates, and fans. Traders found a ready market for these stunning objects in foreign lands.

One of the exported Chinese products—black lacquer boxes inlaid with mother-of-pearl designs—was especially popular in Japan. Devised during the 7th century under the T'ang dynasty, the inlaid lacquer method was introduced to Japan in the 8th century. Japanese artisans started imitating the Chinese craft, before long surpassing their neighbors in skill. They used far more delicate shell pieces, painstakingly rubbed into the thinnest, most transparent sheets, to create lovely designs. Their work was so superb that the Chinese eventually came to believe the Japanese had actually invented the black lacquer box inlaid with mother-of-pearl.

In the West, meanwhile, the citizens of Greece, Rome, and Byzantium perfected the art of mosaic. Available only to the wealthy, this expensive mode of decorating walls and floors incorporated mother-of-pearl to add light and sparkle to colorful pieces. Western mosaic flourished especially during the Middle Ages, when the culture of Byzantium reached its height. Byzantine artisans exported the craft to czarist Russia in the 11th century. There, mother-of-pearl highlighted mosaic images of empresses and Eastern Orthodox patriarchs.

Along with mother-of-pearl work, techniques of applying pearls to textiles traveled and evolved. Europeans learned how to incorporate pearls into the tapestries and brocade that warmed the walls and furnishings of stone castles. The Chinese developed means of embroidering clothing and wall hangings with intricate patterns of seed pearls. And in India, needleworkers created opulent cloaks and rugs encrusted

This mother-of-pearl inlaid clock in the form of a folded shirt was awarded to a shirt company employee in 1938, in recognition of fifty years of service.

with pearls and other jewels. Tales of Asian and Middle Eastern thrones covered with pearls excited the European imagination even as artisans studded Roman Catholic and Eastern Orthodox altars, shrines, and icons with fortunes in pearls.

During the Renaissance, shell carving became popular in Europe. German workers had started the practice in the 5th century, crafting small religious items from mother-of-pearl. Their art reached its height during the 15th and 16th centuries, at the same time that Italian artisans carved miniature portraits in mother-of-pearl. The Renaissance also brought Europeans to the New World, where they came upon indigenous peoples who made lavish use of the abundant local supplies of pearls and pearl shell. Dutch and English settlers encountered native populations that used mother-of-pearl in beads and utensils; Spanish explorers were excited to find the inhabitants of Aztec Mexico bedecked with pearls and mother-of-pearl.

Archaeologists have determined that the use of mother-of-pearl in Mexico dates back to the Maya and Toltec forebears of the Aztec civilization plundered by Cortés. These earlier cultures engaged in shell carving, while the even more ancient Incas of Peru inlaid mother-of-pearl designs in wood. By the time the Spanish arrived, however, only the Aztecs survived to carry on the ancient craft traditions. Aztec artisans applied mosaics of mother-of-pearl and bright red thorny oyster shell to wood bases,

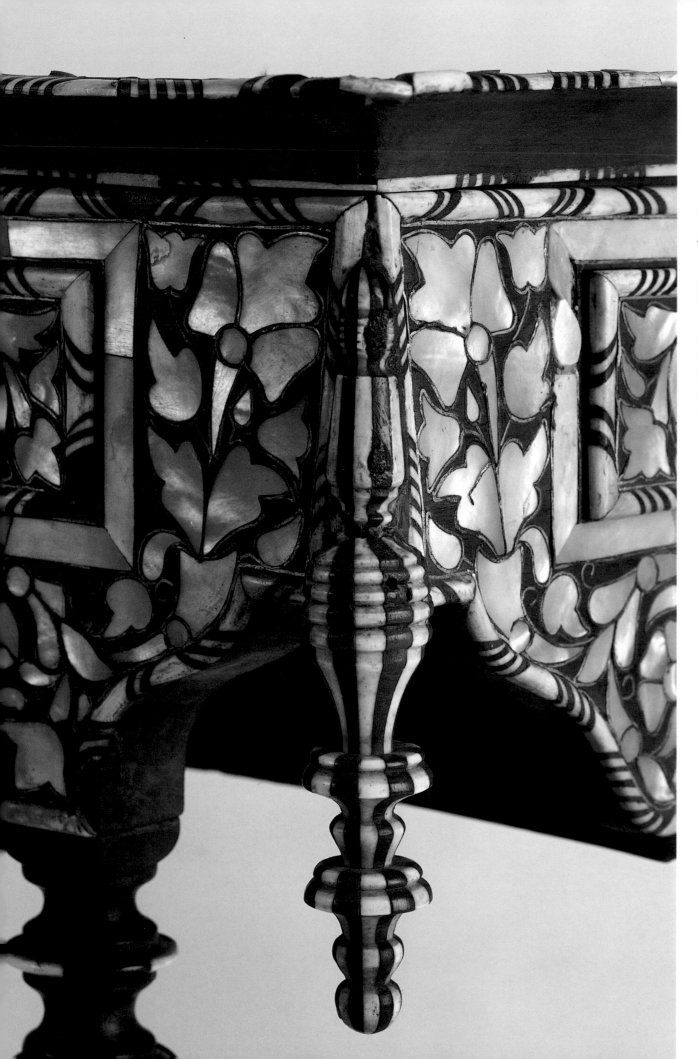

Nineteenth-century furniture from Damascus, lavishly inlaid with mother-of-pearl. The inlay technique used in these pieces originated in the court workshops of the Ottoman Empire during the 16th century.

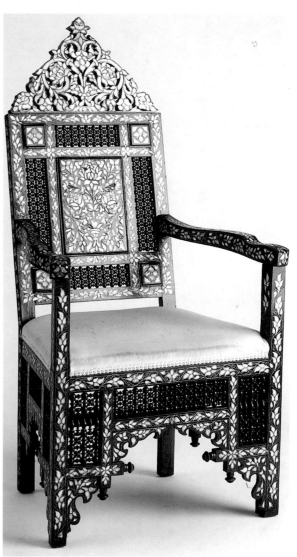

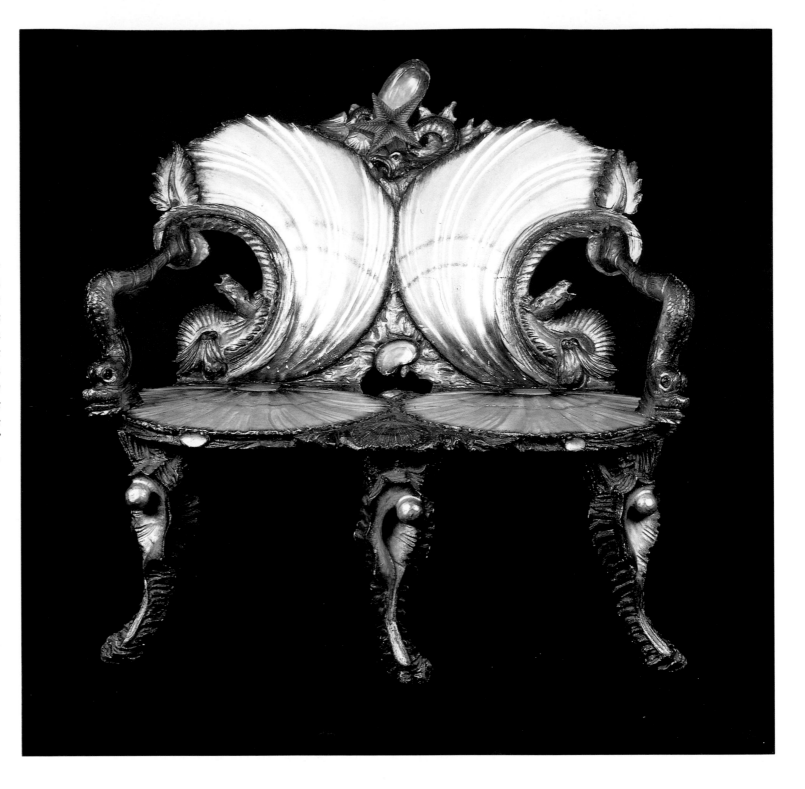

This double-chair-back love seat from late-19th-century Venice acquires its pearly luster from a special silver nitrate finish. Venetian artisans frequently employed aquatic imagery to produce whimsical "grotto" furnishings.

using the lustrous white pearl shell to represent the teeth of animals, the whites of eyes, and skulls. Mosaics decorated temples and palaces, and covered idols and masks used for worship and battle. The quality of work dazzled Cortés, who received some examples as gifts before he launched his bloody conquest.

The discovery of pearls in the Americas launched a pearl rush that helped stoke the pearl craze of the Renaissance. Although the mania for pearl jewelry died down in the 1600s, furniture inlaid with mother-of-pearl flowered during the late 17th and early 18th centuries. One man, André-Charles Boulle, can take credit for the best inlay

work of the time. His inlaid chairs and tables of tortoiseshell, brass, ivory, and mother-of-pearl represent some of the finest examples of furniture from that period. Modern pieces in the same style are known as Boulle, after the originator of the technique.

The 18th century also saw a revival of pearl shell carving in Italy, centered in Naples. There, artisans developed an efficient technique of coating portions of shell pieces with wax, dunking them in acid that ate away the unprotected areas, and then refining the details with files and scrapers. Mother-of-pearl crafts were also revived in 18th-century Palestine. Local residents started carving mother-of-pearl rosaries and trinkets and applying inlay to crosses and amulets for sale to European pilgrims who traveled to the Holy Land. These articles sold especially well to devout Russians, but this market disappeared after the revolution of 1917.

Mother-of-pearl found dozens of decorative applications in the 19th and 20th centuries. In France, England, Italy, and the United States, pearl shell carvers crafted buttons, studs, sequins, book covers, knife handles, and playing-card holders. Cabinetmakers, woodworkers, and workers in papier-mâché chose mother-of-pearl to inlay boxes, baskets, trays, and dishes, and to decorate book covers, buckles, and penholders. With the invention of rhodoid, innovative artisans used that material to inlay tabletops and other furniture; other pearlized plastics went into ingenious handbags and personal accessories. Those pieces have since become collectors' items. The eternal attraction of pearly materials has thus had a lasting impact on the decorative arts.

OBJECTS, WEAPONRY & MUSICAL INSTRUMENTS

The decorative and symbolic power of pearls and mother-of-pearl have made these iridescent materials ideal for ornamenting objects of value and significance. In the South Pacific, where island inhabitants long drew their livelihood from the sea, buoys that supported fishing nets were often inlaid with mother-of-pearl. The sparkling shell attracted fish to the nets and made the floats easily identifiable to their owners. Islanders also decorated their canoes with mother-of-pearl, giving especially lavish treatment to vessels used for war. Light reflecting from the inlays dazzled opponents in battle and threw off their aim, protecting the canoes' occupants from harm. In many South Pacific cultures, restrictions on the use of pearl shell reveal that material's

Jane Kaufman, Pearl Screen, glass pearls, 1980. In her pursuit of form without regard to function, Kaufman exemplifies in her work the architecture and design movement known as ornamentalism.

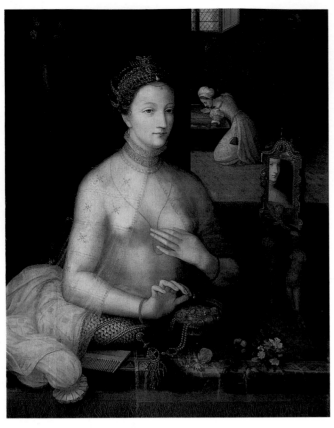

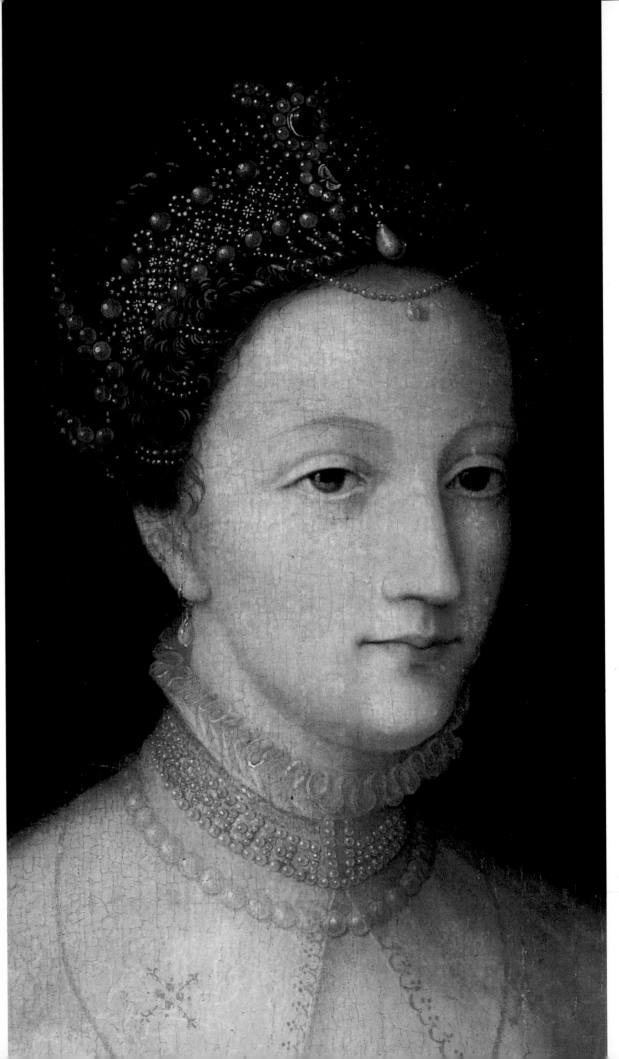

Ecole de Fontainebleu, Woman at Her Toilette, 1550–70, oil on panel. Believed to be Diane de Poitiers, mistress of King Henri II of France.

Ecole de Fontainebleu, Diane Chasseresse (Diana the Huntress), 1550–70, oil. Renaissance painters frequently used pearl imagery, especially when depicting the classical world. Here, Diane de Poitiers, also considered King Henri II's confidante and counsel on issues regarding his ruling of France, is portrayed as the Roman goddess of the hunt carrying a quiver decorated with pearls.

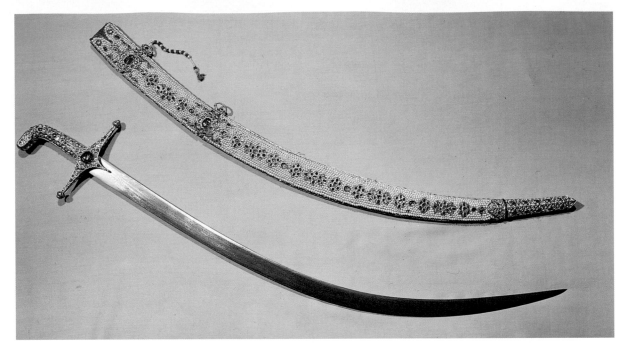

The saber of the Muslim ruler Fath Ali has a hilt and scabbard studded with pearls and other jewels. Such displays were meant to empower a weapon's owner and intimidate enemies.

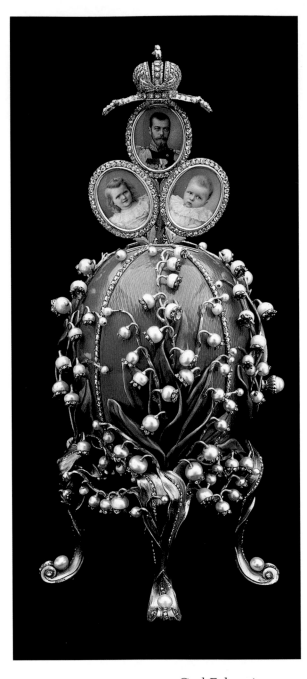

Carl Fabergé, "Lilies of the Valley" egg. Fabergé's exquisite jeweled Easter eggs often featured pearls.

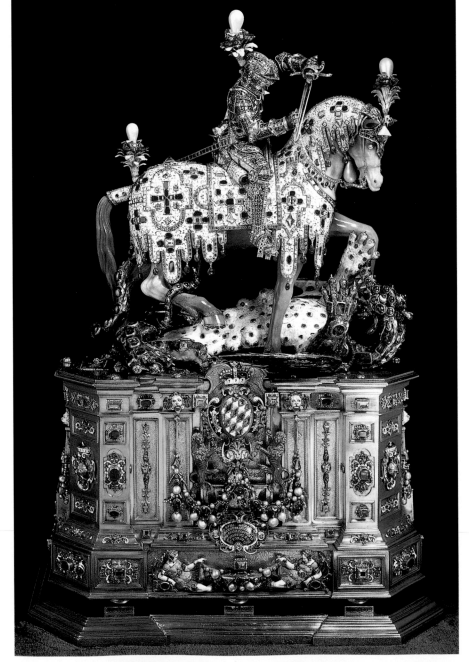

Reliquary of Saint George, German, 16th century. A pearl-encrusted Saint George slays the dragon.

special significance. Only high-ranking people were permitted to own items decorated with mother-of-pearl; Puli Island chiefs, for instance, kept wood bowls inlaid with shell for the sole purpose of serving wine to distinguished guests.

On three continents, the abundance of pearls and pearl shell inspired a wide variety of ornamental uses for nacreous material. Indian maharajas commissioned pearl-studded statuettes of themselves and decorated anything and everything with the gems. Syrian craftspeople based in Damascus made inlaid mother-of-pearl chess and backgammon boards for the leisure class. The traditional crowns, orbs, and scepters of European monarchs sparkled with pearls and other gems. In Saint Petersburg, the jeweler Peter Carl Fabergé at times employed pearls in the design of his ornate Easter eggs, favored by Russian and European royalty. During the 19th and 20th centuries, many clocks, lamps, and other objects crafted in the United States featured mother-of-pearl embellishments.

Around the world, pearls and mother-of-pearl served as ornamentation for all manner of weaponry. Such decoration was meant to intimidate one's foes, impress one's allies, and protect one's life through the pearl's mystical powers. Depictions of Diana, goddess of the hunt, show her wearing a quiver slung from a strap decorated with pearls. Arab and Indian rulers wielded pearl-studded sabers and scimitars in battle, while Japanese samurai sheathed their swords in black lacquer scabbards inlaid with mother-of-pearl. In the Americas, some northern Indian nations bore weapons made with pearl shell; the belligerent Aztecs applied their intricate mother-of-pearl inlay to helmets, knives, blowpipes, and breastplates. Spanish conquistadores reported that Aztec shields covered with pearl shell could repel anything but an arrow fired from a crossbow. When firearms became available in 16th-century Europe, the wealthy people who could afford them liked to decorate their guns with mother-of-pearl inlay. Later centuries saw the creation of handguns trimmed with mother-of-pearl.

From ancient times to the present, mother-of-pearl has also found a more peaceful use, in musical instruments. In Arab lands, for example, the sides of drums were often inlaid with pearl shell. Ukrainians often applied pearly designs to the outer surface of their bandores, stringed instruments similar to the lute and the zither. In the 18th century, German and French artisans started inlaying European stringed instruments, such as guitars, violas, and citterns, with mother-of-pearl. Harpsichords and clavi-

*Electric guitar
by Gibson,
inlaid with
pearlized plastic.*

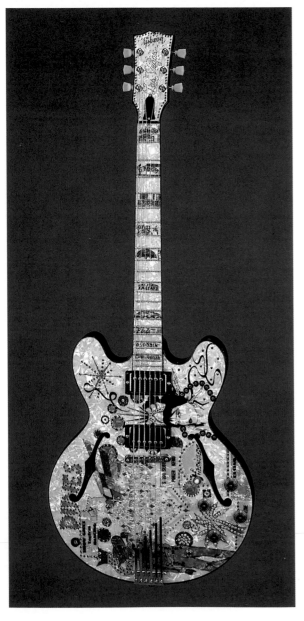

chords also incorporated mother-of-pearl decorations, as have pianos in the 19th and 20th centuries. More modern still, various brass and woodwind instruments—such as the saxophone, the clarinet, the trumpet, and the flute—employ mother-of-pearl keys. And, most currently, high-quality electric guitars often have mother-of-pearl as a support material for the pickups on hollow-bodied models; the frets and tuning pegs of these instruments incorporate mother-of-pearl as well. Without a doubt, this ancient decorative material retains its appeal even in the electronic age.

EXCEPTIONAL FASHION FOR HEAD, HAND, BODY & FOOT

By far the most glorious use of the earth's pearly bounty has been in jewelry. The Sumerians of Mesopotamia and the Babylonians of Palestine created, before 3000 B.C., the oldest known mother-of-pearl jewelry. Mother-of-pearl armlets, rings, and bangles were popular among the Nubians of East Africa, who brought their tastes in jewelry with them when they migrated to Egypt in the 17th and 16th centuries B.C. In Egypt, archaeologists unearthed a necklet of blister pearls that belonged to Queen Ahhotpe, a ruler of the fabled Eighteenth Dynasty in the 16th and 15th centuries B.C. The most ancient surviving spherical pearl jewelry is a necklace found in Iran and identified as the possession of a Persian princess of the 4th century B.C. Archaeologists discovered another example of ancient pearl jewelry—a pin of the third century B.C. with one large and one small pearl—at Paphos, on the Mediterranean island of Cyprus.

Throughout the centuries of the Middle Kingdom, Egyptians used mother-of-pearl, rather than the much rarer pearls, in their jewelry. During the last three hundred years before the birth of Christ, however, pearl beads, chokers, and earrings became more prevalent. Greek and Roman trade and conquest brought pearls to Egypt and Europe from the East, where they had long been used in jewelry. The pearl fashions of the Mediterranean originated on the Greek island of Crete in the 2nd century B.C., when women wore pearls in their hair, but not until the rise of the Roman Empire did pearl jewelry truly blossom in the West. Inheriting a passion for jewelry from the Etruscans, the Romans prized pearls as the ultimate gems and turned them into earrings, necklaces, rings, bracelets, headdresses, and all kinds of decorative accessories, which they wore in great quantity. Most often, Roman jewelers pierced

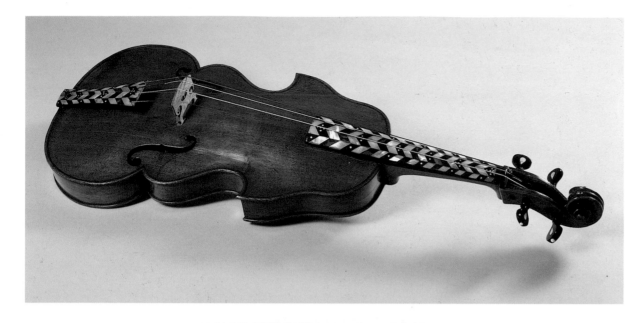

17th-century viola da gamba romagnolla inlaid with mother-of-pearl. Not only was pearl-shell inlay ornamental, it also enhanced the sound of the instrument.

Gibson banjo with elaborate pearly inlay.

Contemporary inlaid banjo, made by Gibson.

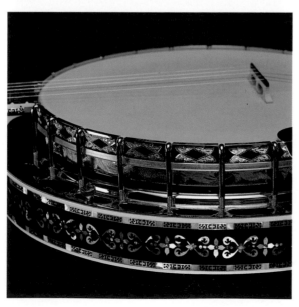

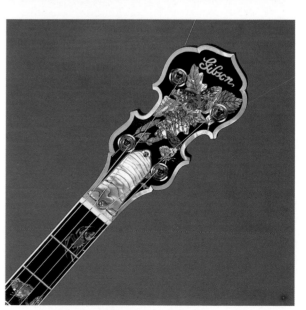

This miniature portrait of an 18th-century Indian woman shows several types of traditional Indian jewelry.

Chinese breastplate embroidered with pearls, 19th century.

pearls and strung or wove them on fine wire, a technique that changed little until the Renaissance.

In the East, meanwhile, the pearl-rich cultures of Persia, China, and India crafted sumptuous jewelry worn in profusion by fantastically wealthy rulers. The Chinese draped themselves with pearl headdresses, sashes, and heavy necklaces of large pearls. Intricately embroidered robes and breastplates featured seed pearl patterns, and sparkling mother-of-pearl clasps accented colorful silk clothing. Large mother-of-pearl buttons attached to the hats of Mandarins identified high-ranking men when they appeared in public. Likewise, Persian royalty wore pearl-studded tiaras and head-dresses, heavy pearl rings and ropes, and cloaks and brooches covered with pearls.

Pearl jewelry reached dazzling heights of luxury in India, where pearls were so esteemed that they were referred to by many different names, depending on their exact place of origin and their auspicious or inauspicious qualities. In addition, Indian gods were portrayed wearing pearl jewelry, as evidenced by the statuettes, paintings, and stories that depict arm bands, bracelets, earrings, and other adornments for the gods. Ancient and modern Indians alike have created some of the most sophisticated jewelry the world has seen, much of it featuring pearls. The importance of jewelry in Indian life was reflected in the elaborate distinctions made between the literally hundreds of types of ornaments, for every part of the body. Each specific piece of jewelry for the head, forehead, ears, nose, teeth, neck, arms, wrists, fingers, waist, ankles, and toes had a unique name, derived from its design and the materials from which it was made.

Pearl jewelry was worn as frequently by men as by women in India. Kings wore pearl tiaras and crowns; women wore pearl hairnets and special pieces that accented the hairline. Pierced pearls were woven into the hair, while pearl "third eyes" sparkled on foreheads. Nose studs and nose rings, ear cuffs, tooth studs, toe rings, and other exotic pearl ornaments bedecked wealthy Indians, as did the more ordinary but equally dazzling pendants, bracelets, and earrings. Traditional Indian jewelry produced today closely resembles that produced thousands of years ago.

To the west, the jewelers of Byzantium designed remarkable pearl jewelry while Europe sank into the Dark Ages. Along with other decorative arts, Byzantine pearl work made its way to Russia, where pearls appeared in needlework as early as the 9th and 10th centuries. Seed pearl embroidery embellished the ecclesiastical vestments

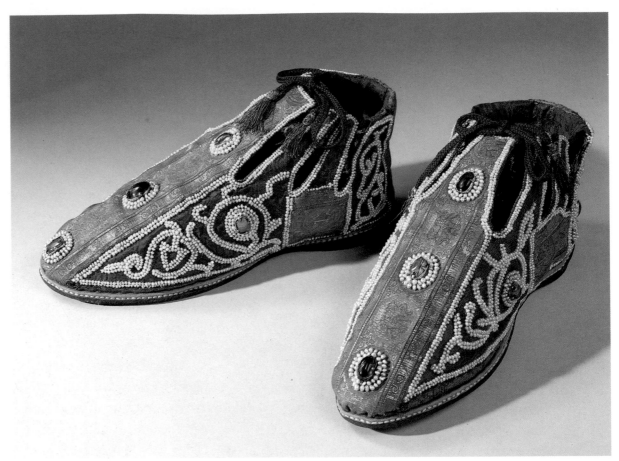

These red-and-gold shoes were made to match Emperor Friedrich II's red silk gloves.

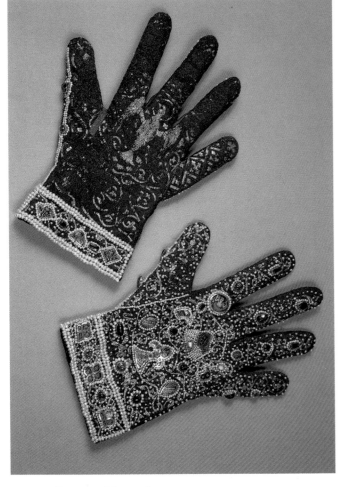

Presumably made for Holy Roman emperor Friedrich II in the early 13th century, these red silk gloves from Sicily are embroidered with gold, rubies, sapphires, and pearls.

of the clergy of the Eastern Orthodox Church, as well as the gloves, boots, and clothing of the aristocracy. By the 17th century Russian pearl embroidery had reached its height, in the *kokochnik* headdresses of the Boyard noblewomen. The faceted beadwork of seed pearls, found in local rivers, was used in combination with mother-of-pearl to form lacelike patterns on the *kokochnik*.

When Europe emerged from the Middle Ages and embarked upon the Renaissance, elaborate pearl jewelry came into fashion. By the 15th century, the aristocracy had become politically and financially secure enough to spend large amounts of money on jewels and to wear them in public. The humanistic world view fostered during the Renaissance allowed people to adorn themselves without pangs of religious guilt, so demand for jewelry went up. Jewelers became more sophisticated and introduced many innovations in response to the strong demand for their products. Demand for pearls, the most coveted gem of the time, accelerated rapidly.

The pearl mania sparked by England's King Henry VIII and his daughter, Queen Elizabeth I, spread throughout Europe and sent Spanish ships to the New World for cargoes of pearls. Intricate pearl necklaces, heavy pearl rings, and gleaming pearl earrings appeared on every nobleman and noblewoman. Even the children of the upper classes wore pearl strands and clothing embroidered with the gem. Matched jewelry suites, or parures, became de rigueur for those with enough money to spend on pearl ensembles. Instead of a random assortment of individually designed brooches, chokers, and "whisk" ropes, pearl lovers commissioned complete jewelry sets. Pearl head-

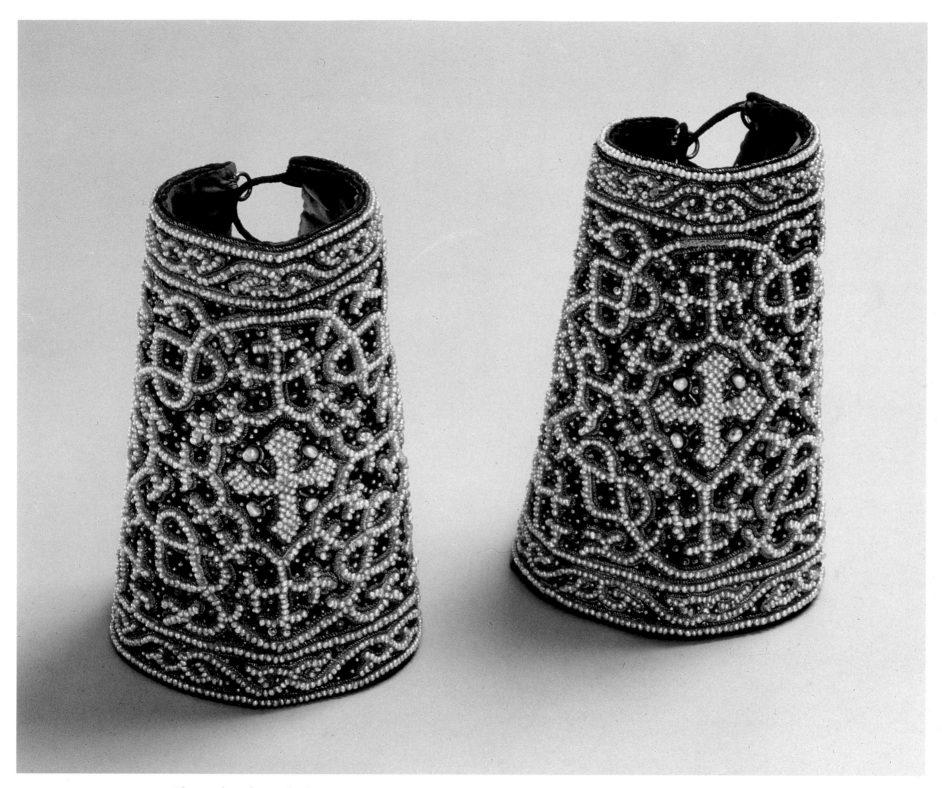

The combined use of red velvet, solid seed-pearl embroidery, and gold spangles in these ecclesiastical cuffs typifies the work produced in the Kremlin workshops of late-17th-century Moscow.

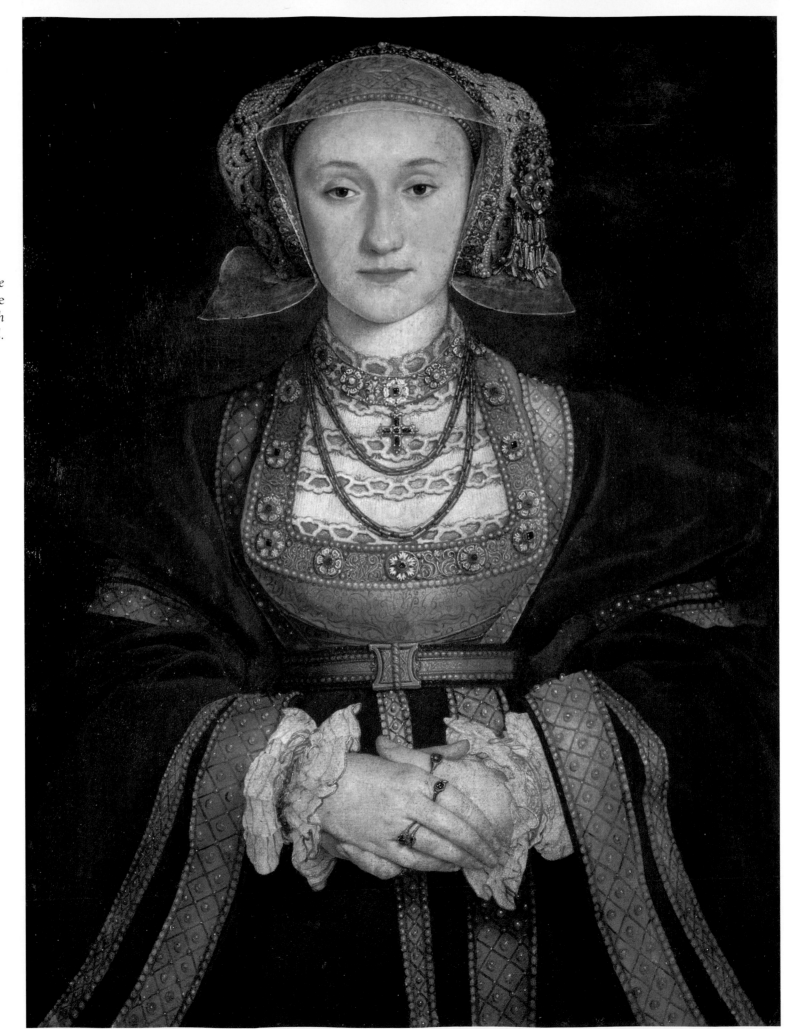

Hans Holbein the Younger, Anne of Cleves, *16th century, oil.*

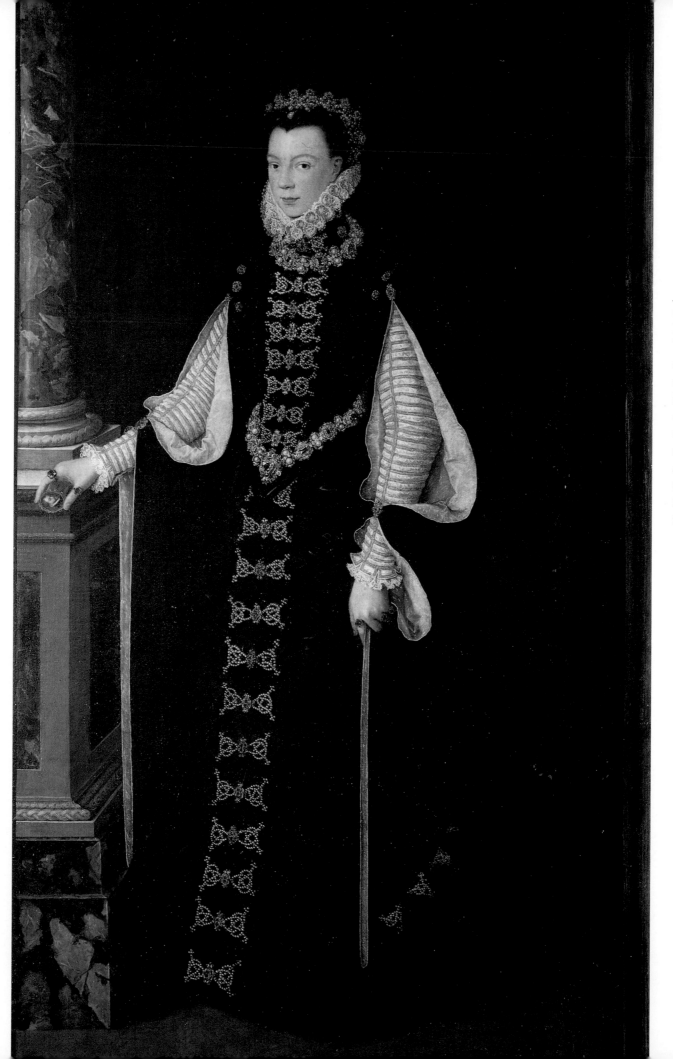

Juan Pantoja
de la Cruz, La
Reina Isabel de
Valois (Queen Isabel
of Valois), 1579,
oil. This French-
born queen of
Spain was the wife
of King Philip II,
whose formidable
armada defended
the pearl-rich
Spanish empire in
the Americas.

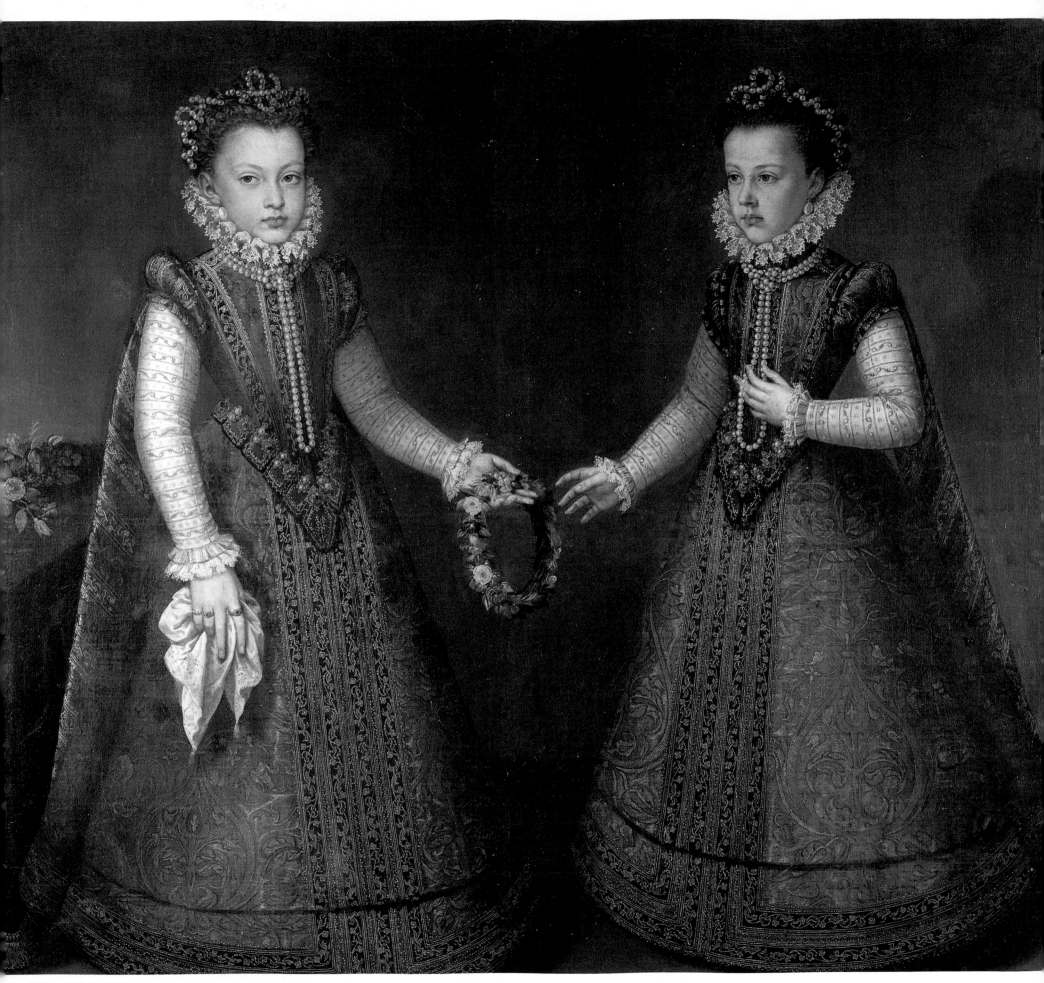

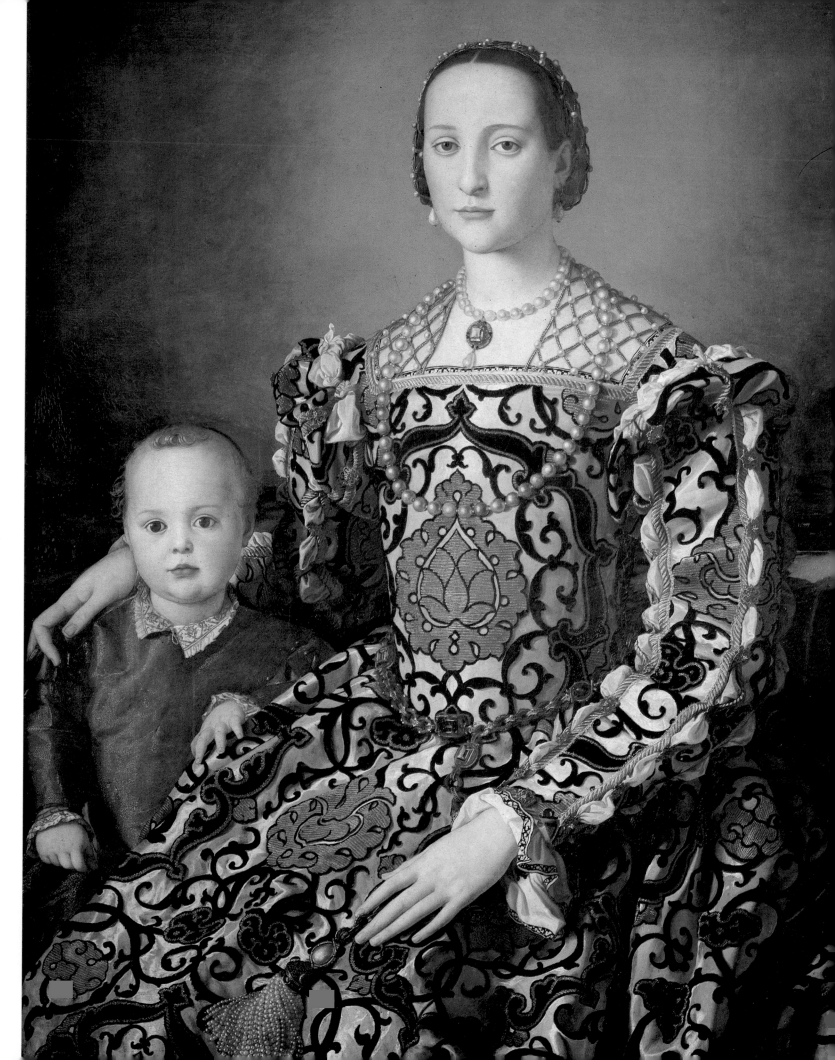

Left: Alonso
Sánchez Coello,
The Princesses Isabel
Clara Eugenia and
Catalina Micaela,
late 16th century,
oil. The daughters
of Spain's King
Philip II wore
pearly plunder
from the
Americas.

Bronzino, Eleonora
di Toledo (Eleanor
of Toledo), 16th
century, oil. A
member of the
Spanish royal family
during the Pearl
Age appears in
the pearly fashions
of the time.

This contemporary Venetian ball mask recalls the 17th-century custom of wearing jeweled masks to daylight galas.

dresses, some inspired by Persian designs, adorned noble heads, while pearls sparkled on masks worn to festive balls. Large baroque pearls were set with smaller pearls and other gems to create whimsical animals, gods, and human figures whose bodies or limbs were formed by the irregular pearls.

The first Spanish explorers to reach Mexico encountered the great Aztec civilization and its treasures of gold, pearls, and other gems. Cortés and his men saw Aztec rulers and citizens wearing bracelets, headbands, and ear and nose ornaments inlaid with mother-of-pearl, as well as coastal peoples draped with strands of pearls. In North America, English and Dutch settlers met indigenous peoples who made necklaces from freshwater pearls. When the English navigator Captain James Cook charted the Pacific Ocean in the 18th century, he, too, came upon aboriginal populations adorned with pearls and pearl shell. In July 1769, Cook noted in his journal that the

This Art Deco purse, embroidered with seed pearls and accented with teardrop pearls, is owned by one of the foremost jewelry collectors in the United States.

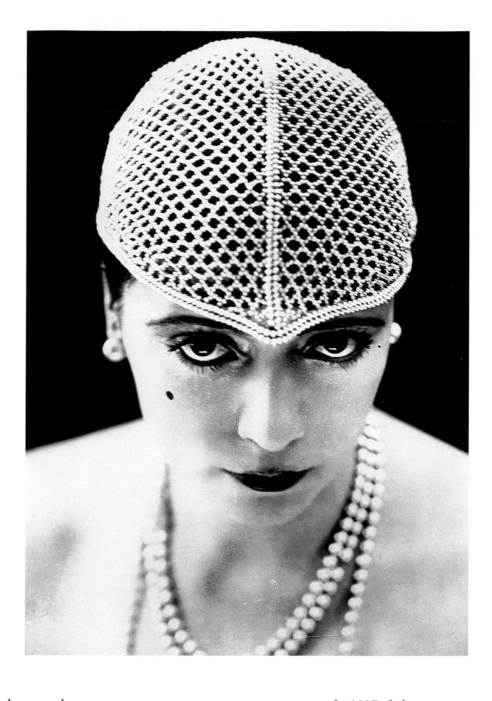

In 1927, fashion designer Judith Barbier introduced this crocheted pearl head piece resembling the pearl headdresses popular in the 14th century.

people of Tahiti "have earrings by way of orniment but wear them only at one ear, these are made of Shells, Stones, berries, red pease and some small pearls which they wear three tied together." The men and women of the South Pacific wore mother-of-pearl as an emblem of status; in the Admiralty Islands, round shell pendants called *kopkop* could be worn only by men who had killed in battle.

During the 17th and 18th centuries, the ostentatious display of wealth became less accepted in Europe. Many of the grand crown jewels of the ruling houses were sold or tucked away as a simpler aesthetic prevailed. But when Napoleon Bonaparte became emperor of France in 1805, luxury became fashionable once more. The emperor's taste for pearls and the preferences of his wife, Josephine, boosted demand for the gems in France at the same time that the imperial couple's fondness for clothing and jewelry turned Paris into the world's fashion capital. Pavé jewelry, literally paved

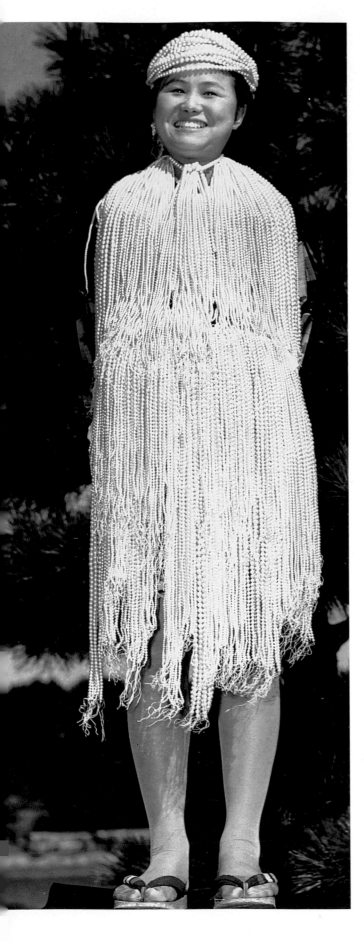

with an unbroken layer of pearls, was a particular favorite of the time.

A freshwater pearl rush in the United States, combined with Queen Victoria's ascent to the British throne, revived interest in pearl jewelry in the middle and late 19th century. Empress Eugénie of France introduced the world to the mysterious black pearls of the South Pacific, expanding the jeweler's repertoire. But it was Victoria's fondness for white pearls that rekindled their popularity all over the world, inspiring jewelers to create new designs. In the 1840s, seed pearl jewelry in floral motifs epitomized the trend: the tiny pearls were affixed to mother-of-pearl shapes using fine horsehair, with texture added by using multiple layers and different pearl sizes. Seed pearl jewelry and mother-of-pearl pieces in the Art Nouveau style enjoyed high visibility into the early 20th century, and were considered particularly appropriate for young, unmarried women. Some parents bestowed a single pearl upon their daughters at each birthday, so that by the time they reached adulthood they had the start of a fine necklace.

The industrial revolution made pearl and mother-of-pearl accessories affordable for the middle class by ushering in the age of machine-worked jewelry. Previously restricted to the upper classes, ownership of pearl jewelry—especially the less expensive American freshwater gems—became more commonplace. During the 1920s, long pearl strands were all the rage, and some designers created dresses with sleeves or backs constructed entirely of rows of pearls. Coco Chanel introduced inexpensive costume jewelry that made unabashed use of faux pearls; as the century progressed, the fashion industry devised designs for handbags, shoes, and other accessories highlighted with freshwater pearls, faux pearls, and the new cultured pearls from Japan.

Throughout the 20th century, firms such as Cartier, Van Cleef and Arpels, Boucheron, Tiffany, Lalique, Vever, Fouquet, and Mikimoto sold the world the pearl jewelry it desired, gradually finding room for the increasingly popular—and eminently affordable—faux and cultured pearls. European royalty still dabbled in elaborate jewelry made from priceless natural gems, but for most of the world the simple single or multiple strand of cultured pearls became the norm. Women came to consider pearl necklaces and earrings a basic, necessary part of a complete jewelry wardrobe. Those who could afford them purchased cultured pearls, while others turned to faux pearls for that "classic" look. Today, the ever-alluring pearl remains an elemental force in jewelry design and classic style.

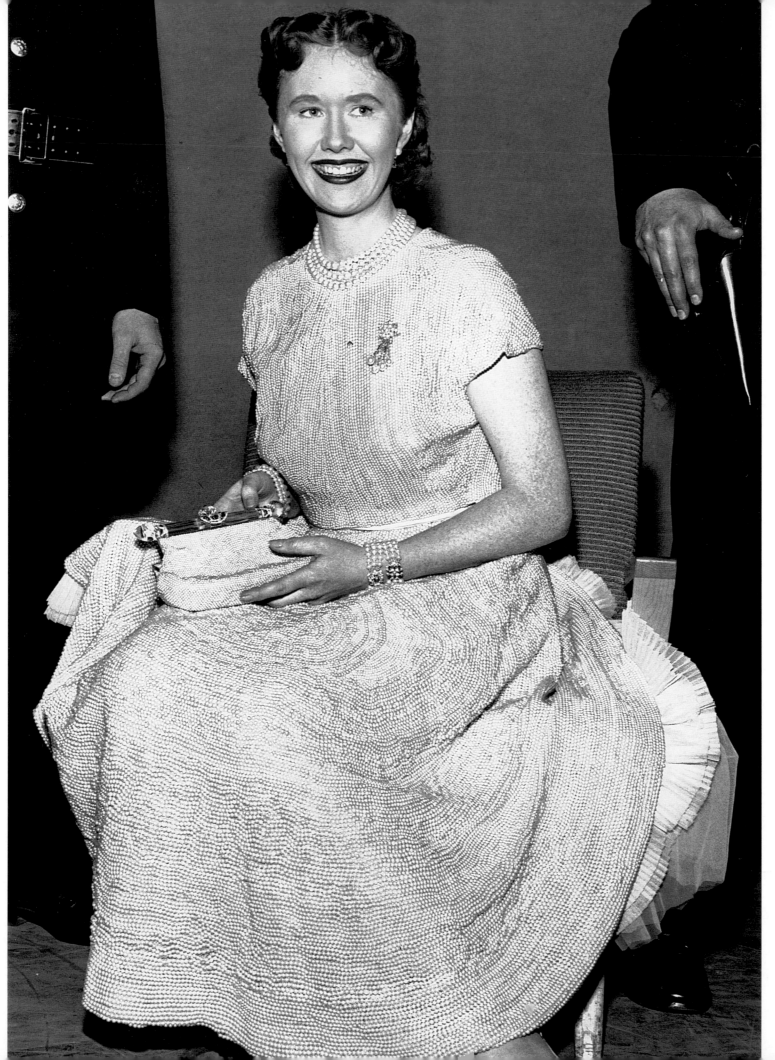

In 1952 this dress of
100,000 cultured
pearls toured the
United States, along
with the accompanying
cultured pearl jewelry
and handbag. The
total value of the
collection at that time
was $900,000.

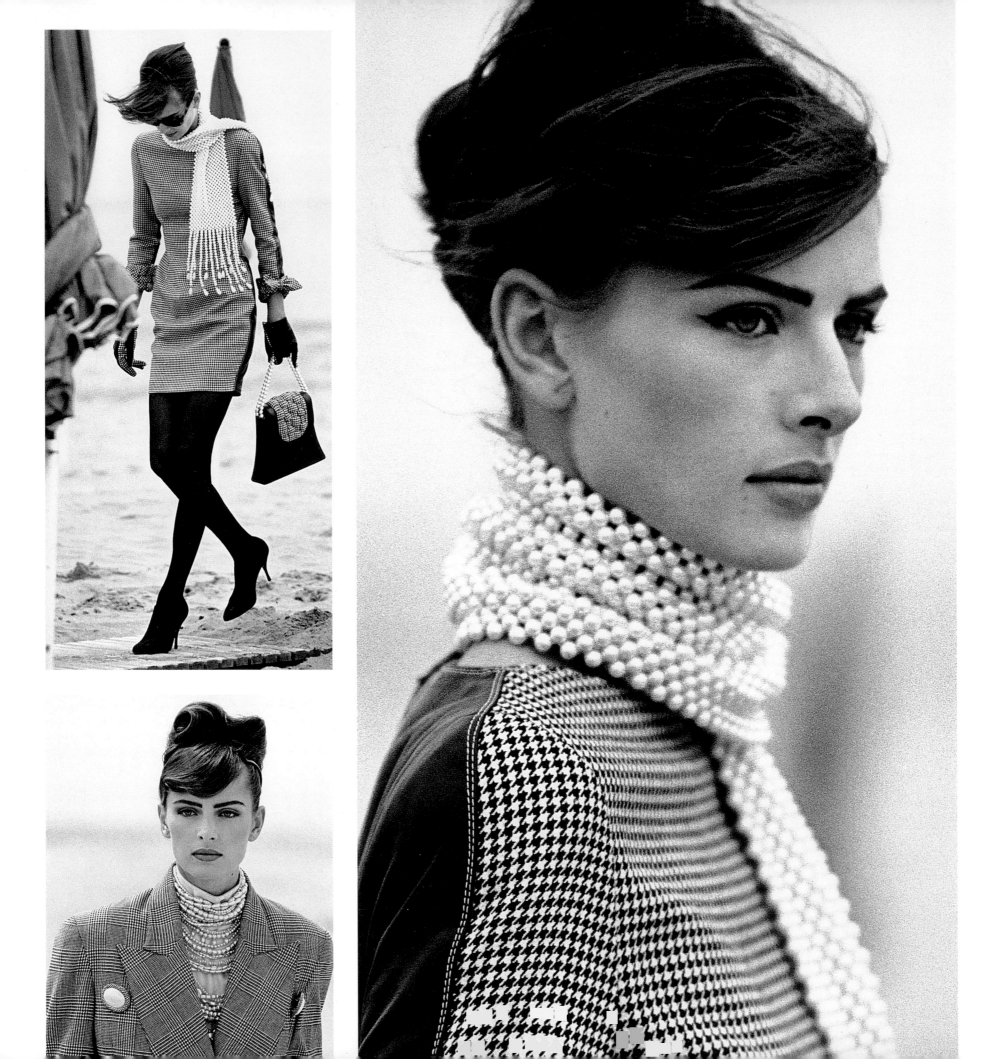

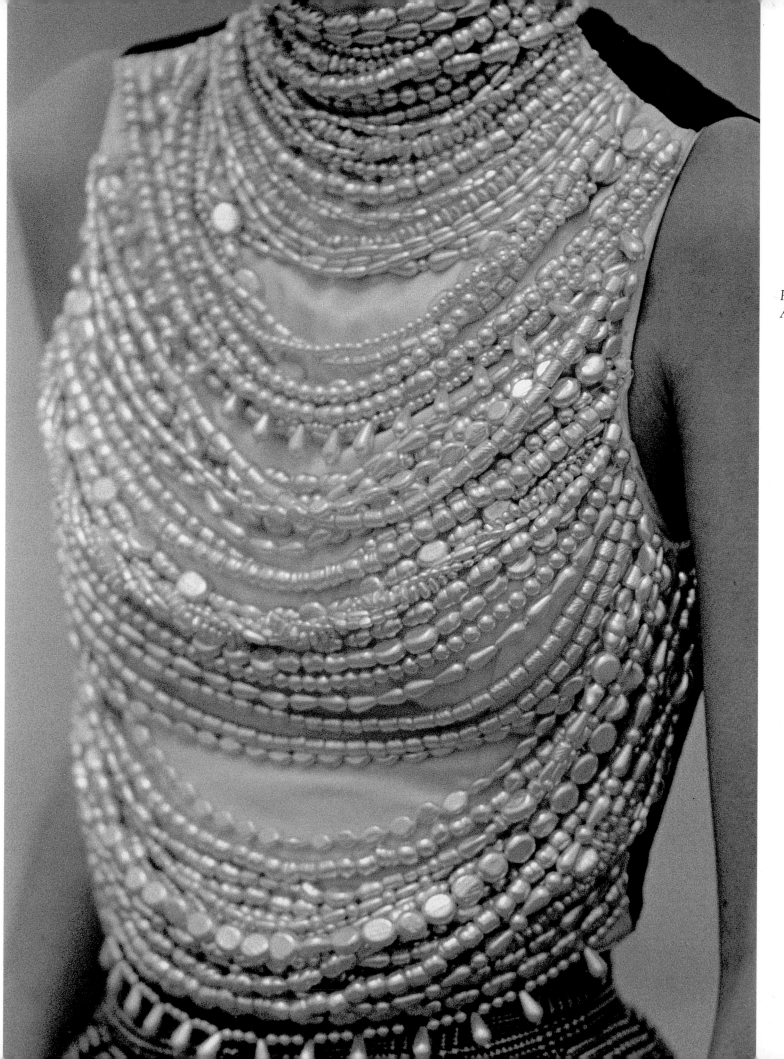

*Pearl fashions by
Alma Gruppo.*

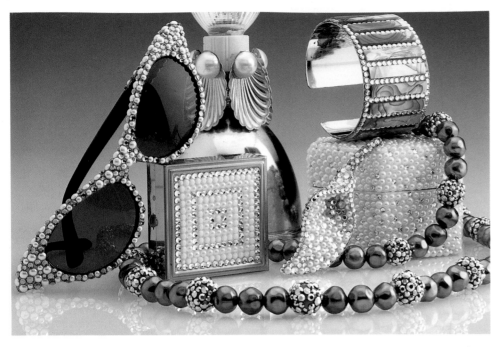

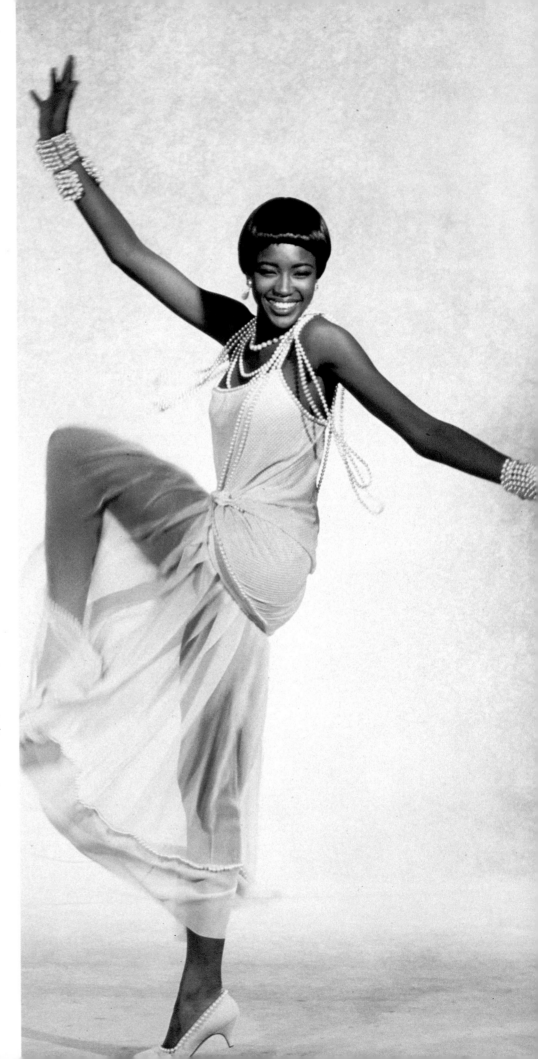

The above designs by James Arpad replicate the pavé technique developed by his father.

Coco Chanel revolutionized fashion by popularizing costume jewelry. Karl Lagerfeld, her successor at the House of Chanel, carries on her tradition of "nonchalance de luxe" with ensembles like this one.

In 1990 Manolo Blahnik designed these Ottoman velvet boots studded with faux baroque pearls and other faux stones for Diana Vreeland.

PERSONAL ADORNMENT
& CELEBRATED STRANDS

In her book *The Body Decorated* (1979), Victoria Ebin wrote, "The body is the physical link between ourselves, our souls and the outside world. It is the medium through which we most directly project ourselves in social life." What does it mean, then, when people ornament their bodies with jewelry? Ebin claims:

> The first and essential fact of body decoration is that it distinguishes man as a social being, distinct from animals of the forest and other humans outside his particular group—
>
> for he regards both as equally alien. Through decorating his body . . . the individual expressly conveys his allegiance to his own group, making a precise distinction between those in society and those beyond its confines: it is the crucial factor in his relations with the rest of the world, the distinction between beauty and the beast.

Personal adornment serves as a form of communication, used both in the ordinary situations of daily life and the exceptional events that punctuate human existence. Highly esteemed by people of many cultures and many times, pearls are an element of personal adornment that has helped to define the exalted entities, venerated ideas, and special occasions of human history. In cultures as diverse as those of Bali, tribal North America, and Renaissance England, births, engagements, weddings, retirements, funerals, and any number of personal and social milestones have been marked by the display and exchange of pearls. Warriors wore them into battle, political dignitaries presented them as tokens of good will, monarchs bejeweled themselves at coronations and other official events. Wherever pearls appeared in history, they proclaimed exceptional moments and celebrated powerful people.

The extraordinary pearl objects created for special purposes endure in memory and in fact as some of the world's most precious treasures. Some are notable for their beauty alone, others for their heritage. Among these celebrated gems are individual pearls whose quality and history have earned them fame even apart from a jeweler's setting. Others have gained notoriety from the storied collections of which they are or have been a part. Whatever their circumstances, these pearls rank as elite jewels.

Coco Chanel in 1936, wearing her trademark strands of pearls.

A Seminole Indian couple at their wedding in Florida, 1930. Like many Native American peoples, the Seminoles adorned themselves with pearls for sacred events and special occasions.

Mrs. Edsel Bryant Ford, née Eleanor Lowthian Clay, bedecked with pearls on her wedding day. Her marriage made her the daughter-in-law of automobile baron Henry Ford.

Many of history's great pearls have been lost to time or are hidden away in the vaults of Arab sheiks, never to be seen by the world at large. The pearl that Cleopatra ground up and drank on a wager with Marc Antony is gone, as is its mate, which was cut in half to make earrings for a statue of Venus in the Pantheon in Rome. A large and perfect pearl owned by a Sassanian king of Persia was trampled by horses during a battle with the Huns, when the king flung it to the ground so his enemies could not capture it. Countless other pearls of great value have been lost through theft, carelessness, and disaster.

La Peregrina ("the wanderer" or "the incomparable") survives, however. Found in 1560 by a slave diving for the Spanish off the coast of Panama, this marvelous pear-shaped gem won its discoverer his freedom. It traveled to Spain, into the possession of King Philip II, and from there to the collections of various monarchs, including Mary Stuart, Queen of Scots. The vagaries of history brought La Peregrina back to the New World, via the English actor Richard Burton, who bought it for his wife Elizabeth Taylor in 1969. But in recent years, the actress's dog chewed the gem, damaging it and greatly reducing its value.

The pearls of Queen Elizabeth I, some of which remain in the possession of England's current royalty, collectively achieved prominence as a result of her appetite for pomp and display. Perhaps the most bizarre episode reflecting Elizabeth's passion for pearls was her funeral, at which a wax effigy of the queen rode atop her coffin dressed in wax facsimiles of her pearls. Kunz and Stevenson quote a poet of the period,

Designer Jeanne Lanvin called this pearly 1924 wedding dress "Hyménée," for Hymen, the Greek god of the wedding feast. The Romans often depicted Hymen holding a strand of pearls, which represented the marital bond between Cupid and Psyche.

Icons of their eras, 1920s actress Louise Brooks and 1950s actress Marilyn Monroe wore the "little black dress" and strands of pearls.

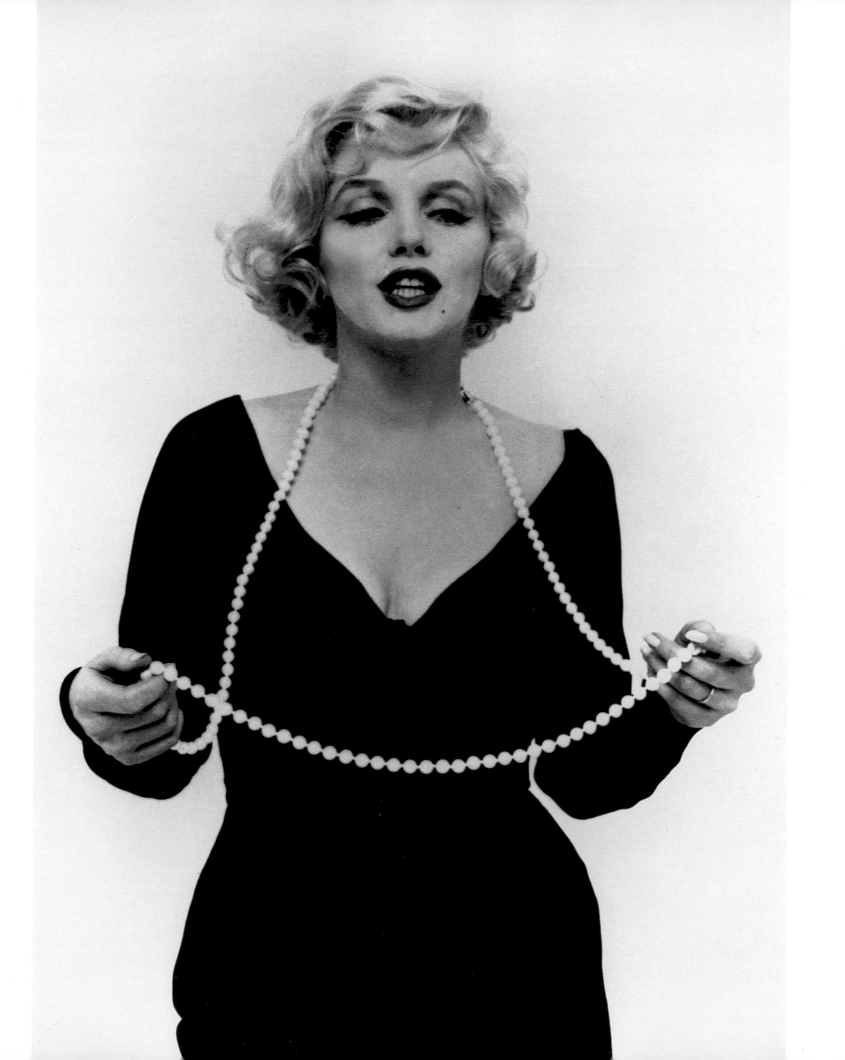

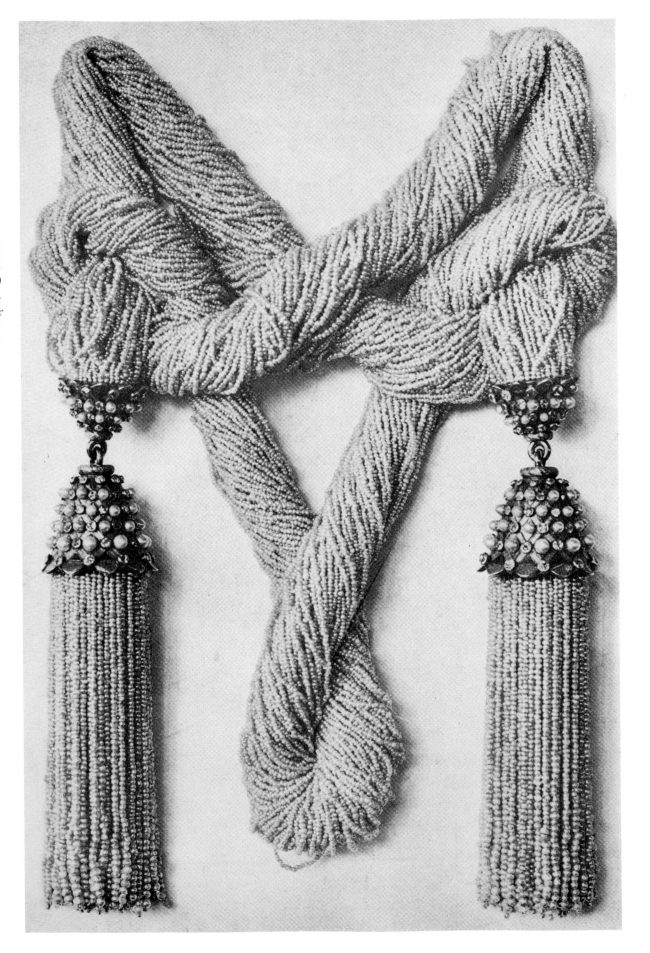

This necklace of the Louis XVI period consists of 126,000 seed pearls. Its style is reminiscent of the Louis XV era.

who wrote that, as the funeral procession passed along the Thames River, "Fish wept their eyes of pearl quite out/And swam blind after." The effigy was long preserved alongside others like it in Westminster Abbey, still wearing its wax jewels.

England's crown jewels include some of the Western world's most famous pearl pieces, which frequently appear on the persons of the Queen Mother, Queen Elizabeth II, and Diana, Princess of Wales. One necklace notable for its absence from this collection was commissioned by Edward VIII, Duke of Windsor, who abdicated the throne in 1936 to marry the American divorcée Wallis Warfield Simpson. Since no one in the royal family claimed the duke's gift to the duchess after she died, the necklace was auctioned off. The American fashion designer Calvin Klein bought it for his wife, Kelly.

For sheer size, no known pearl has surpassed the Pearl of Asia, a huge baroque specimen weighing 2,400 grains (five and a half ounces). Shaped like an eggplant, this giant is now mounted with several other pearls and some pink jade, and resides in a London bank. The Hope Pearl is the only other fine pearl to approach the Pearl of Asia in size, weighing in at 1,800 grains (four ounces). Purchased by the banker Philip Hope as part of the famous jewel collection he assembled in the early 1800s, the roughly pear-shaped baroque pearl measures 51 millimeters long and has a particularly fine luster.

Another baroque pearl of note is part of the Canning Jewel, a whimsical piece in the form of Triton, the Greek sea god who bore a trumpet made of a large shell. Designed in the 16th century, the Canning Jewel consists of numerous gems in an intricate setting, including an unusual baroque pearl that serves as the god's muscular torso. Other famous pearl oddities include the Southern Cross, discovered off the coast of Australia in 1866. This concretion of nine spherical pearls forms a cross, with seven pearls as its vertical and two pearls as the arms. The Southern Cross is now part of England's crown jewels. Even more peculiar is a brain-shaped pearl retrieved from the waters surrounding the Philippines in 1938. It measured twenty-two centimeters long and ten across.

Two notable freshwater pearls are the Tiffany Queen Pearl and the Abernethy Pearl. Found in the town of Notch Brook, New Jersey, in 1857, the Tiffany Queen Pearl started the American freshwater pearl rush. Perfectly spherical and richly lustrous, the pearl weighs 93 grains. The Abernethy Pearl was fished from Scotland's

River Tay by William Abernethy in 1967. Delicately pink, the spherical gem sits in state in a jewel shop in Perth. It is known affectionately as "Little Willie."

Some of the most celebrated strands of the 20th century belonged to Coco Chanel, a designer who revolutionized women's fashions. The originator of simple, comfortable chic, Chanel valued pearls for their beauty but cared little for the monetary value assigned them. Though an admirer, Grand Duke Dimitri of Russia, showered her with priceless pearls from the Romanov crown jewel collection, Chanel wore them like costume jewelry, often mixing them with faux pearls. The designer also helped popularize cultured pearls, which to her offered all the decorative qualities of natural pearls. In 1988 a volume entitled *Costume Jewelry in Vogue*, the jewelry historian Jane Mulvagh wrote, "The development of cultured pearls and the perfection of imitation pearls, combined with Chanel's sanctioning of them, was the most distinctive costume jewelry trend of the Twenties."

Chanel's legacy of faux pearl costume jewelry and simple pearl strands endures today as one of the strongest influences on contemporary fashion. Thanks to the proliferation of cultured and faux pearls, the pearl strand has come to define classic women's fashion. Its newly affordable appeal guarantees the iridescent gem a place in the decorative arts far into the future. This most compelling of jewels, this ornament that has inspired human obsession, still reigns over the world of adornment.

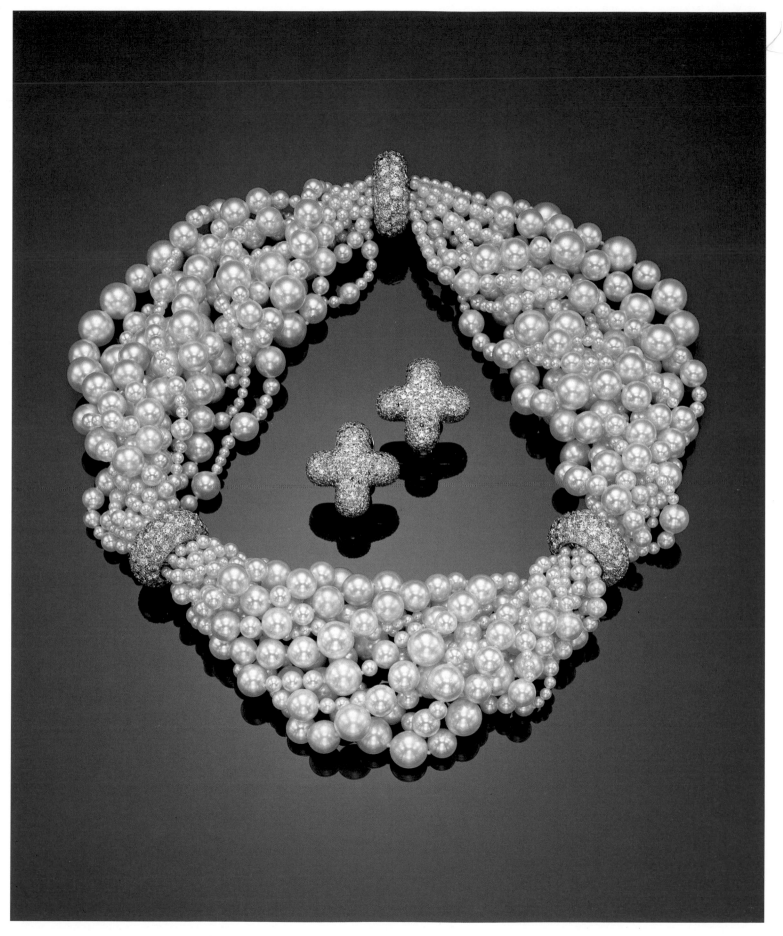

The "opulent"
necklace by Sean
Gilson for
Christopher Walling
combines eleven
strands of
cultured pearls
with three diamond
pavé rings, and
is complimented
by a pair of
diamond pavé
earrings.

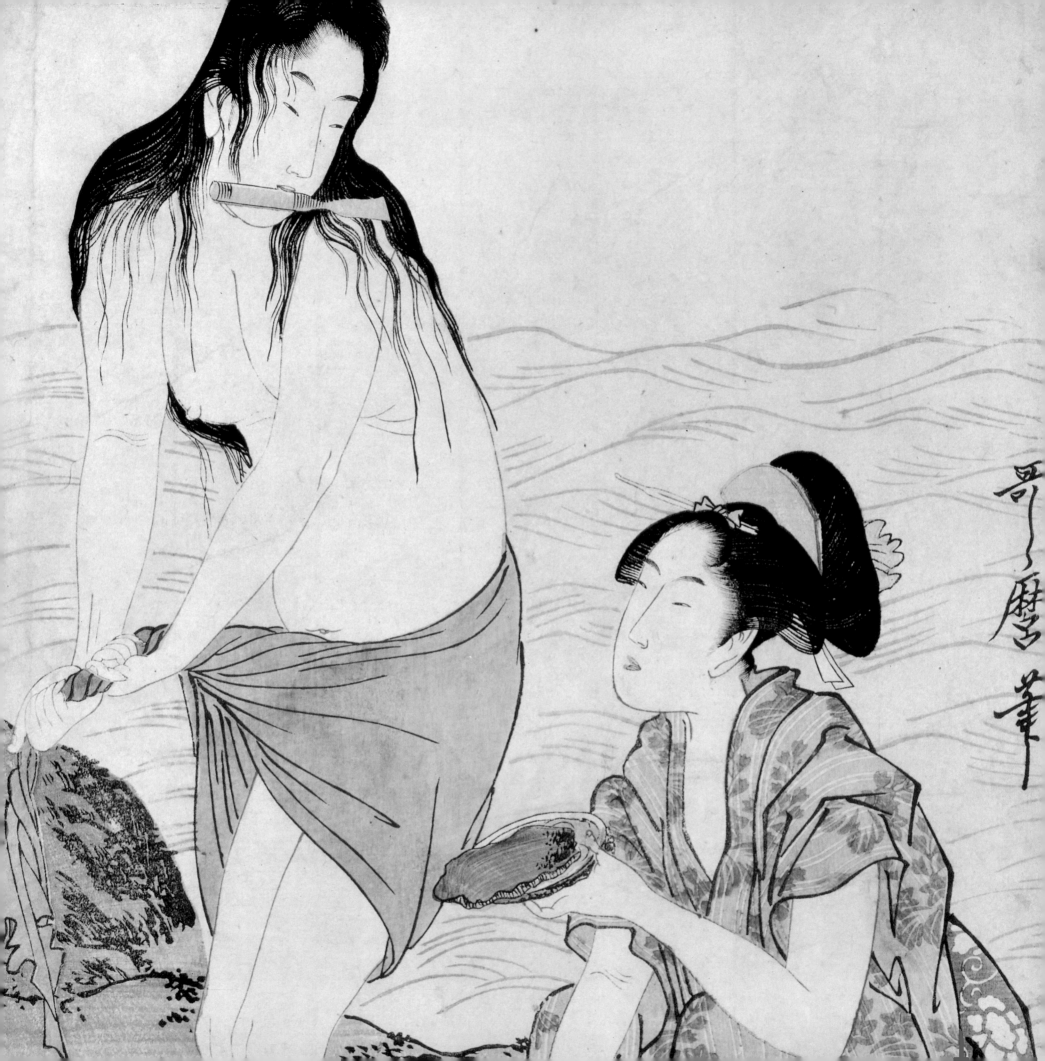

Oh Pale Poetic Pearl

CELEBRATIONS

OF THE PEARL IN

THE ARTS

& LITERATURE

*Detail from
Kitigawa Utamaro's
19th-century
print triptych,
The Abalone
Divers.*

In every century and every culture where pearls have appeared, the lustrous treasures have exerted a firm grip on the human imagination. These objects of spiritual awe, scientific examination, political intrigue, mercantile pursuit, and decorative inspiration have bewitched many. Their beauty and cost have placed them among the most coveted of the earth's natural resources; their metaphorical significance has imbued them with a cachet unique among gems. Without a doubt, the pearl stands alone as a jewel of subtle power and mystical charm. Few other substances possess the pearl's ability to haunt, and even to rule, the human soul.

Not surprisingly, artists through the ages have seized upon the pearl as a visual and literary device of great allegorical and aesthetic force. In fiction, poetry, drama, dance, film, music, sculpture, and painting the pearl shows up repeatedly, both as a decorative element and as a symbol. From epic Greek poetry to Japanese musical theater, from the bullrings of Spain to the art galleries of SoHo in New York, the pearl glows in every area of artistic endeavor. Artists have celebrated the gem itself, used it to glorify a host of people and ideas, and at times inverted its traditional meanings to critique all it stands for.

Creative fascination with "the pale poetic pearl" extolled by Herman Melville in

his novel *Moby-Dick* underscores the iridescent gem's deeply compelling character. As for people in all walks of life, the pearl's wondrous qualities have proved irresistible to artists through the ages and around the world. They have turned the gem into an artistic icon and made it a noteworthy element in the worlds of literature, the visual arts, and the performing arts.

FINE PAINTING TO MODERN GRAPHICS, CLASSICAL OPERA TO KITSCH LYRICS

As the functions of music and the visual arts have evolved, so has the role of the pearl within these disciplines. Ancient artists worked for the greater glory of their gods; thus the Vedic hymns of India and the temple statues of Rome incorporate pearls as the embodiment of certain supernatural or divine principles. In Europe, art and music continued to function primarily in service to the Christian God well into the Renaissance. Twentieth-century artists in industrialized cultures mirror contemporary values and mores in their work, which are largely secular. Over time and across cultures, artists and musicians have adapted the pearl to their purposes.

Pearl imagery was perhaps put to its richest use during the Renaissance, when European painting flowered at the same time that pearls reached dizzying heights of popularity. By the 14th century, when the Renaissance dawned, Catholicism, Europe's dominant religion, had mandated a complex system of iconography in the creative arts, which supported the church's teachings. Whether in song, parable, architecture, or sculpture, every object and detail contained spiritual meaning. Pearls, long an emblem of purity throughout the world, came to represent faith in the Catholic canon. This meaning echoed the pearl metaphors of Matthew's gospel, where Christ warns of casting one's pearls of faith before swine and compares the kingdom of heaven to a merchant "seeking goodly pearls" of faith. The pearl's association with purity also made it a symbol of the Virgin Mary, the immaculate conception, and Christ himself; the expression "pearls of the gospel" was used to refer to Christ's teachings.

Jan van Eyck, a Flemish painter of the early 15th century, produced many works on religious themes, some of which included pearl imagery. One of his most famous creations is the *Altarpiece of the Adoration of the Mystical Lamb,* an elaborate backdrop for the altar of the Catholic church in Ghent. It depicts various sacred figures on

both sides of its twelve panels, so that it conveys a spiritual message whether closed or open, as it was during religious services of special importance. Adam and Eve, prophets of the Old Testament, the Virgin Mary and the Angel Gabriel, Saint John the Baptist, and Christ himself are painted alongside holy judges, knights, and angels. Pearl adornments worn by some of the figures—notably the choir of angels—not only add to the grandeur of the work but symbolically reinforce its message of Christian faith.

Pearls appear in a specifically allegorical role in *Faith*, a painting by the 17th-century Dutch painter David Teniers. In this work, a woman surrounded by visual metaphors—including cupids, cherubs, a skull, a globe—gazes heavenward in a state of religious rapture. Around her neck she wears a double strand of pearls, lifted toward the sky in her left hand as if to display her faith to God. The woman simultaneously grasps her pearl earring with her right hand in a manner sure to draw attention to the object's particular significance. Whereas in the religious paintings of the Renaissance pearls in general represented faith, pearl earrings in particular conveyed the special qualities attributed to the ear by Catholics of the time. As the organ through which the faithful received their understanding of divine truth, the ear was considered doubly holy when graced with a pearl ornament.

In an article entitled "Pearls of Virtue and Pearls of Vice," the Dutch art historian E. de Jongh notes that "a little sphere can reflect the entire universe, as the human mind, for all its apparent limitation, is able to contain the vastness of belief in God." The comment pertains directly to the use of sphere imagery in Christian painting, but by extension applies to pearls. Both a glass sphere representing heaven and a strand of pearls representing faith appear in *Allegory of Faith*, painted by one of the leading Dutch artists of the 17th century, Jan Vermeer. Filled with symbolic imagery, the painting presents a visual summary of the Catholic faith. Its central figure is a woman who wears a pearl necklace, which she touches as she sits in an attitude of spiritual abstraction.

Of course, Renaissance painting did not use pearl imagery solely as a metaphor for religious notions. The many contemporary portraits of Queen Elizabeth I, for example, depict her adorned with various selections from the vast pearl collection for which she was famous. Here, the gems highlight Elizabeth's regal magnificence and also, as emblems of purity, draw attention to the chastity of the Virgin Queen. Pearls

Jan van Eyck,
panels from
Altarpiece of the
Adoration of
the Mystical
Lamb, 1432,
oil.

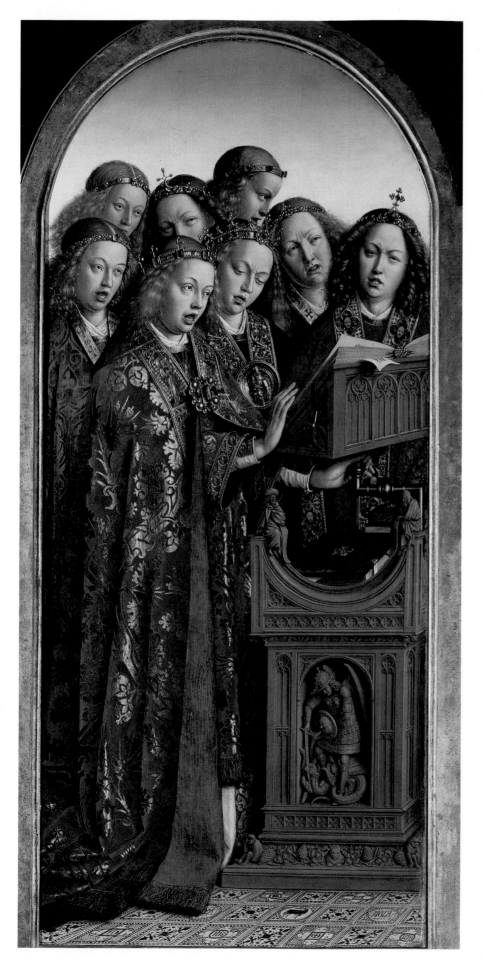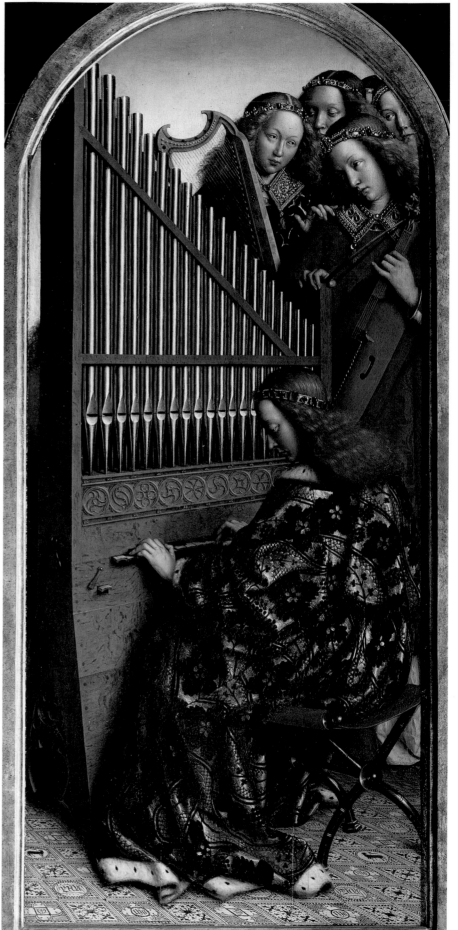

as a metaphor for womanly virtue appear elsewhere, too, as in Jacob Gerritszoon van Hasselt's *Wedding Feast* (1636). This painting of a Dutch wedding reception shows the bride holding a string of pearls in her left hand to signify her supposed virginity.

Numerous portraits of the era's wealthy men and women show them adorned with pearls, and in these instances the jewels serve no other purpose than to remind the viewer of the affluence of these people. Secular still lifes could also display the wealth of the art patrons who commissioned them by featuring such elements as pearls and other gems. *Cabinet of Curiosities*, a trompe l'oeil painting by Johann Georg Hainz, a German artist of the 17th century, achieved just that for the king of Denmark. In it, various treasures owned by the king, including several pearl necklaces and an iridescent nautilus shell, impress the viewer. The startling realism of the trompe l'oeil technique makes the expensive items seem all the more dazzling.

During the Renaissance, the insatiable lust for pearls harbored by the upper classes turned the gem into a symbol of vanity and decadence. But instead of shedding their alternate identity as a symbol of Christian purity and faith, pearls simultaneously embodied a double meaning of piety and profligacy, saintliness and sensuality. Some allegorical paintings depict women rejecting immorality, in the form of pearls, in favor of godliness, in the form of some more worthy object. Many artists of the period portrayed women observing their reflections in a mirror, and these images often incorporated pearl jewelry. In such efforts by Vermeer, Godfried Schalcken, and others, the gems may signify feminine beauty, vanity, or a combination of the two. Pearls are also featured in paintings that depict amorous scenes, where they underscore the pull of womanly charms.

The pearl's contrasting meanings show up in Renaissance paintings of seduction and rape, where in one case the gem represents carnality and in another chastity. In Jan Van Bylert's *The Seduction*, for instance, an avid lover dangles a string of pearls before his female companion, who turns away from the symbol of sensual pleasure and rejects the bribe with a wave of her hand. By contrast, the 16th-century Italian artist Tintoretto produced *Tarquin and Lucretia*, in which an inflamed Tarquin prepares to rape Lucretia. As Lucretia struggles in Tarquin's grasp, the outcome of the scene is foreshadowed by her pearl necklace, which has broken. Lucretia's virtue, the viewer knows, will be lost along with her pearls.

The humanism ushered in by the Renaissance and cultivated during the En-

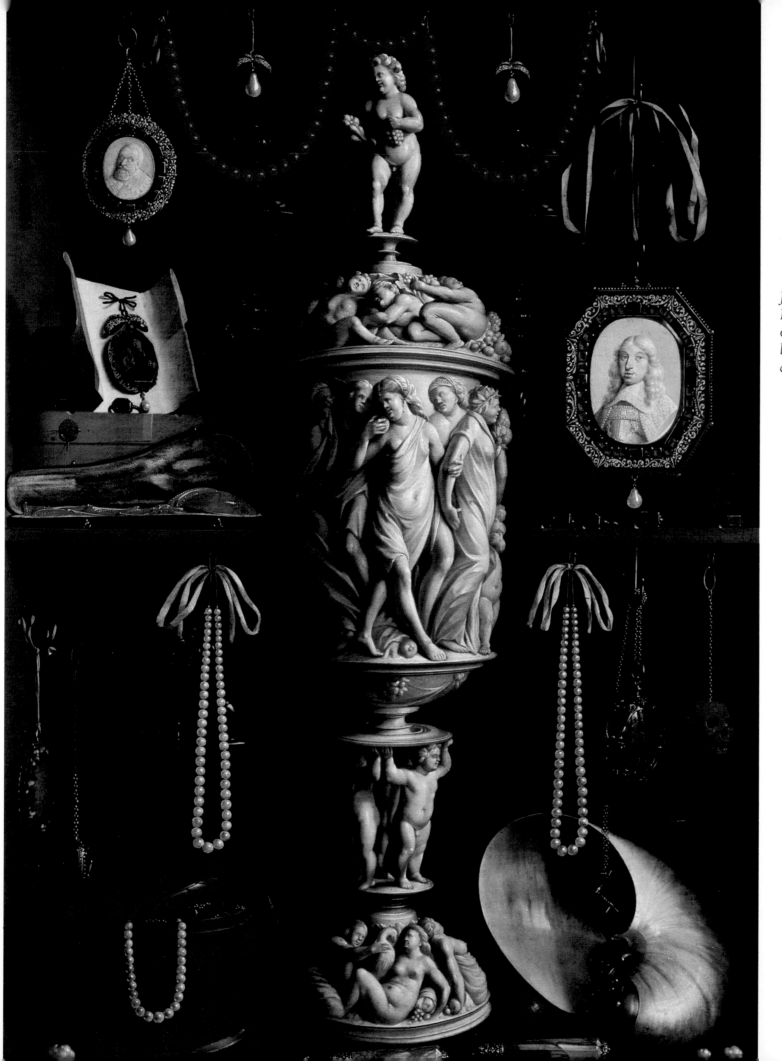

*Johann Georg
Hainz,* Cabinet
of Curiosities,
*late 17th
century, oil.*

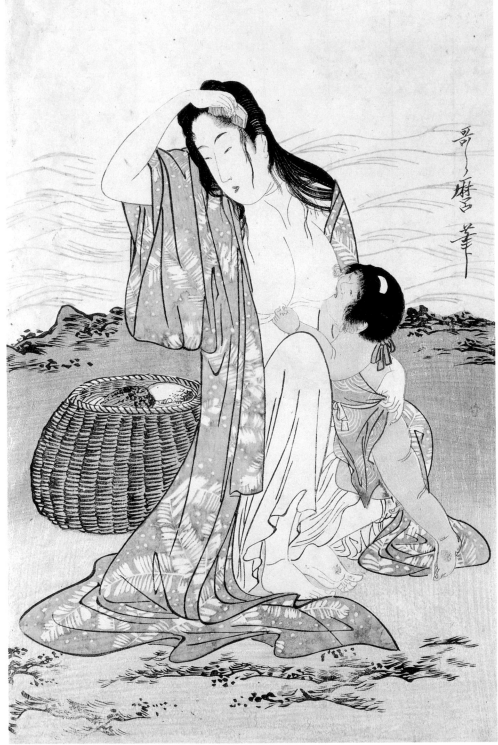

lightenment and the industrial age eventually relegated pearl symbolism in the visual arts to the attic of the past. Still, pearls remained a reminder of wealth and romance, while their mysterious, aquatic origins retained a suggestion of eroticism. In 18th- and 19th-century Japan, the makers of traditional ukiyo-e prints frequently chose pearl divers as a subject and depicted their activities with an inviting sensuality. Japan's ama female, pearl divers who plunged naked into the sea, are prominent in the work of ukiyo-e masters such as Kitigawa Utamaro. Surrounded by sinuous sea creatures,

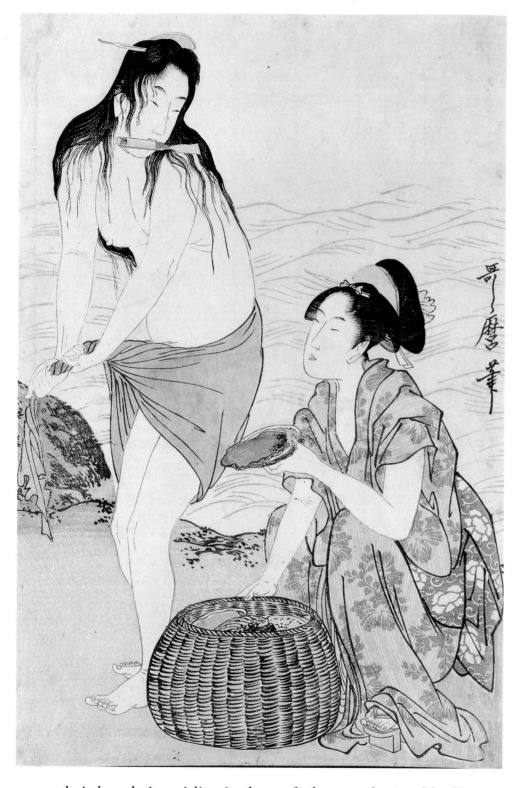

Kitigawa Utamaro, The Abalone Divers, 19th century, print triptych.

their long hair swirling in the surf, the ama depicted by Utamaro are charged with an unmistakable sexual energy.

This tradition of erotic innuendo endures in the work of Masami Teraoka, whose 1986 *Waves and Plagues* series includes a watercolor entitled *Ama ni Tako,* or *Pearl Diver and Octopus.* The undulating tentacles of the sea creature hold the ama diver in an almost passionate embrace, suggesting the fervent sexuality of new lovers. Though pearls do not appear anywhere in the painting, the image of the athletic female pearl

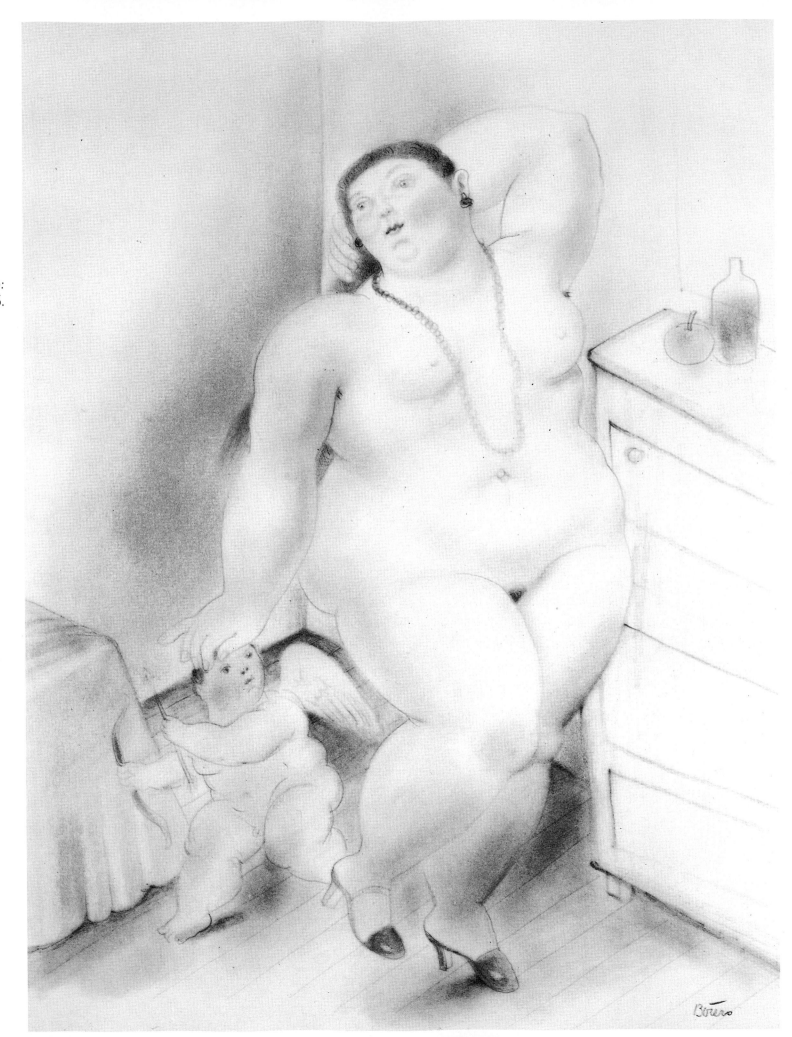

Fernando Botero:
Venus, 1986.

diver recalls the gem's voluptuous appeal. At the same time, the image of an ama diver wrestling with an octopus, an enemy long feared by the ama, evokes thoughts of the confrontation between natural beauty and human peril. Masami uses the sexually suggestive juxtaposition to comment on the assault of the AIDS virus on a robust society.

In the United States, contemporary art has adopted pearl imagery not so much for its erotic and natural power as for its relevance to modern materialism. Some innovative artists working in sculpture and collage employ faux pearls to comment on current notions of fashion, elegance, financial success, and the commercialization of the arts. Buster Cleveland combines fake pearls with various other industrial materials to create collages that decry the excesses of consumerism in mass culture. Arch Connelly uses faux pearls to make an ironic statement on contemporary aesthetics and economics; he transforms the pearl, a paragon of chic, into the exemplar of kitsch. Connelly's critique of popular culture relies on camp elements like cheap pearls to point up the banality of such social constructs as "good taste." At first glance, his mirrors, tables, and other objects encrusted with pearly plastic beads suggest wealth, but a moment later they trumpet tackiness. For Cleveland and Connelly, the glitter of fake gems parallels the glitter of a spiritually bankrupt society.

Other contemporary American artists work in faux pearls in order to explore the conjunction of crafts and fine arts and to tap into the gem's historical and cross-cultural significance. Sherry Markowitz uses faux pearls and mother-of-pearl buttons and beads in her three-dimensional pieces assembled with craft techniques. As a means of responding to the popular images of Western culture, fake pearls have the multilayered meaning of mass-produced baubles masquerading as natural gems. William Harper also uses beads in his craftlike work, but he uses genuine pearls to create wearable art. His interest in primitive art, ritual, myth, and totem is readily apparent in such works as *Pagan Baby #8: White Writing*, a brooch that resembles a piece of tribal jewelry.

Interesting to visual artists for its decorative and symbolic aspects, the pearl has also fascinated musicians, particularly as a component of costumes to be worn during performance. Long ago, traditional musical theater performers in China, Japan, and India appeared in lavish costumes studded with pearls, as did classical opera and musical theater singers in Europe and the United States. Musical instruments and

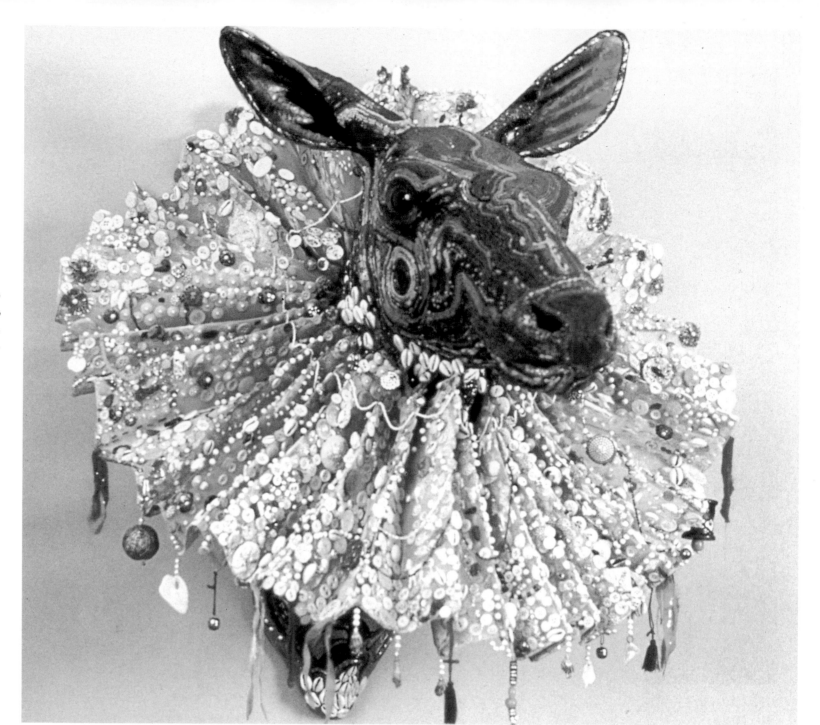

*Sherry Markowitz,
Bow Wow Queen,
late 20th century,
mixed media.*

*Buster Cleveland,
More, late 20th
century, mixed-media
collage.*

stage sets were also decorated with pearls or mother-of-pearl. Costumes and decor with pearls not only conveyed information about the story being told by the musicians, they also added to the spectacle of the performance and enhanced the listening pleasure of the audience.

Pearls have occasionally appeared as symbols or subjects in works of sacred, classical, and popular music. One example is the hymn recorded in the Hindu text *Atharva-Veda* in 500 B.C., which invokes the protective powers of a pearl amulet:

> The bone of the gods turned into pearl; that, animated dwells in the waters. That do I fasten upon thee unto life, luster, strength, longevity, unto a life lasting a hundred autumns. May the amulet of pearl protect thee!

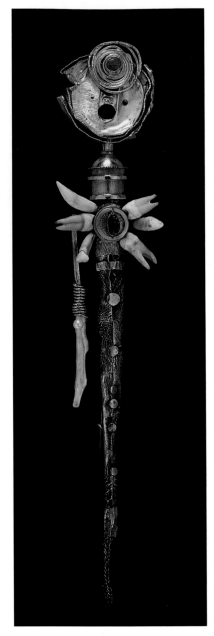

William Harper,
Self-Portrait of the
Artist Recovering
from a Migraine,
1990, mixed media.

More than twenty-four centuries later, American children sing a rhyme that humorously invokes a Christian metaphor:

> Oh, you can't get to heaven on roller skates, roller skates,
> 'Cause you'll roll right past them pearly gates.

Dozens of songs include pearls in their titles and lyrics, from the Irish folk tune *Pe'arla an Broillaig Ba'in* (The Snowy-breasted Pearl) to the 1904 melody *The Pearl of Sweet Ceylon* to *A String of Pearls*, a number from the 1954 movie *The Glenn Miller Story*. A few contemporary performers acquired pearl nicknames, such as the soul diva Dionne Warwick, who was dubbed "the black pearl" by a Parisian journalist. Blues and rock singer Janis Joplin was known as Pearl, and an album of her music released after her 1970 death took its title from the nickname.

However pearl imagery was employed in music, the mystery and romance of the pearl lingered. In 1863, captivated by the fantastic history of the gem, the French composer Georges Bizet wrote the opera *Les Pêcheurs de perles* (The Pearl Fishers), set in an ancient pearl fishery of Sri Lanka. The opera tells the love story of Nadir, a pearl fisher, and Leila, a Hindu priestess sworn to celibacy. Zurga, king of the pearl fishers and Nadir's friend, was once in love with Leila, but is now counting on her faith to keep his people safe during a fishing expedition. But Nadir and Leila cannot resist their love, and Nourabad, the high priest, catches them during a tryst. Nourabad asks Zurga to execute the couple for sacrilege, and the jealous king agrees. Leila gives the king a treasured necklace to return to her mother, explaining that it was given her by a man whose life she saved. While Nourabad prepares Nadir and Leila for execution, Zurga recognizes the necklace as the one he gave to a woman who rescued him long ago. Realizing he owes Leila his life, the king sets fire to the pearling camp and helps the couple escape in the ensuing confusion. Nourabad sees what has happened and, while Nadir and Leila flee to safety, the high priest kills the king.

Around the turn of the 20th century, when pearls experienced a revival in popularity, a number of musicals made use of the gem in their lyrics and storylines. The French lyricist Lecocq and the German composer Gustave Kerker wrote *Pearl of Peking* (La Fleur de thé), which was performed in Paris in 1888. In 1905, the lyricist Paul West and the composer John Bratton presented an off-Broadway production for

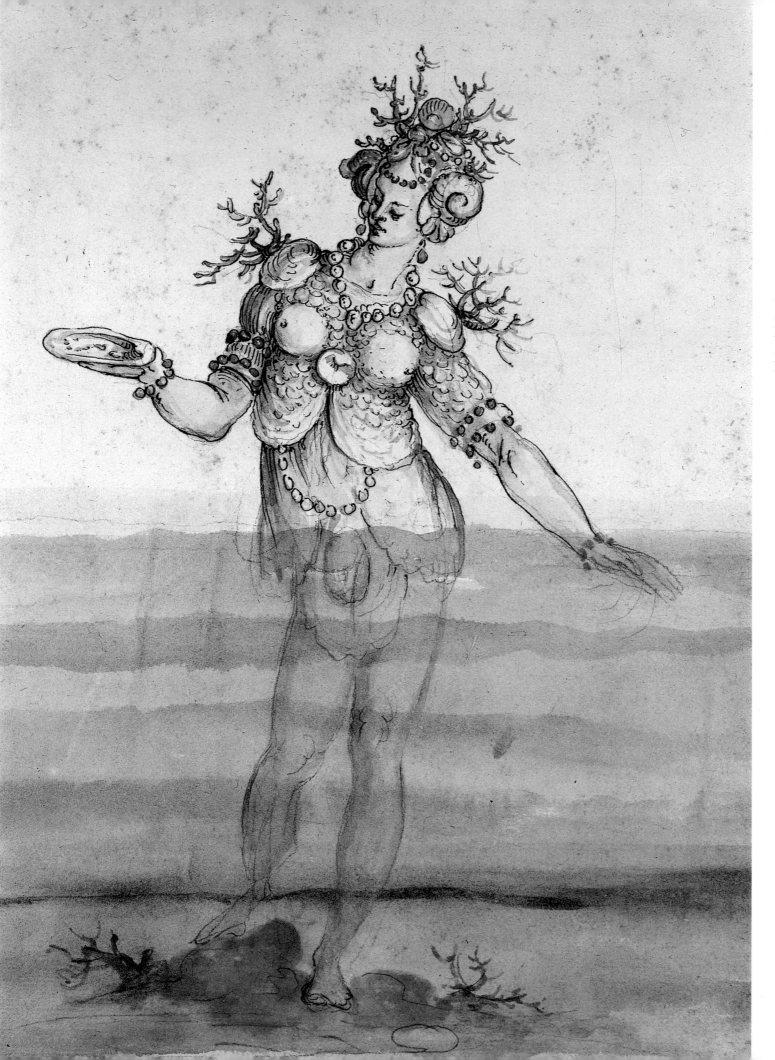

Sketch of Aphrodite by Bernardo Buontalenti for the 1589 Italian opera La Pellegrina.

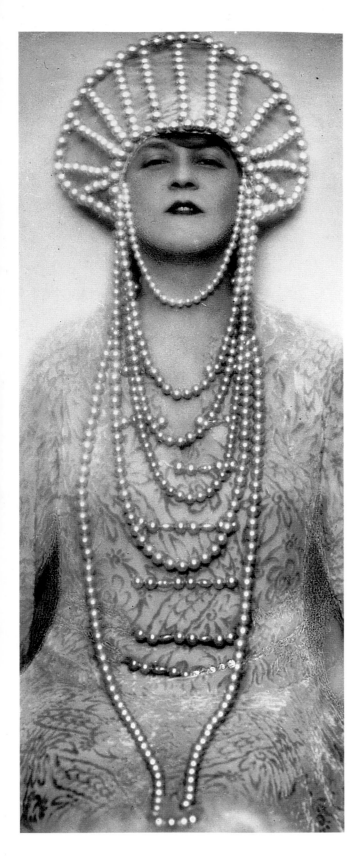

children entitled *The Pearl and the Pumpkin*, in which various characters race to find a pearl in a pumpkin patch. A Broadway show for adults, *The Pearl Maiden*, appeared in 1913; its plot involved a young "pearl maiden" and an American diplomat who fall in love in the exotic setting of a pearl fishery.

For centuries, the pearl's close association with the distant worlds of Persia, Sri Lanka, and China fascinated Western artists and musicians. The gem's romantic history, as well as its lustrous beauty, attracted painters and designers who embellished their work with it. Favored as the pearl was by these artists, their use of pearl imagery paled in comparison to its lavish display on stage and screen.

STAGE, DANCE & FILM, FROM ERTÉ TO JOSEPHINE BAKER

Performers bedecked with pearls amused sultans, queens, and crowds in the ancient and modern worlds alike. Like the Roman emperor Nero, who commanded actors appearing before him to wear masks encrusted with pearls, the rich and powerful throughout history have had a taste for luxury in their entertainments. Traditional forms of dance and theater in the Far East, Near East, and Middle East frequently included the use of costumes and props decorated with real or imitation pearls. No one, however, better understood the pearl's ability to dazzle an audience than the costume and set designers of the early 20th century. From the cabarets of Paris to the movie studios of Hollywood, costumes with pearls took center stage during the 1910s and 1920s.

About 1910, the French couturier Paul Poiret almost single-handedly launched a fashion trend known as orientalism. Poiret, fascinated with the rich fabrics and styles of Eastern dress, reinterpreted these fashions for the chic women of Paris. As a costume designer for theater he leaned toward the exotic, so that many of his creations bore little resemblance to the everyday clothing actually worn in Persia or India. Instead, his designs embodied Western fantasies about impossibly opulent Oriental courts and made ample use of pearls, the quintessential Eastern treasure. Poiret never made any claims as to the authenticity of his brand of orientalism, but his work became hugely popular and quite influential on other designers of the period.

One designer who embraced orientalism was Léon Bakst, a Russian Art Nouveau painter who conceived the costumes for Serge Diaghilev's famous Ballets Russes. The

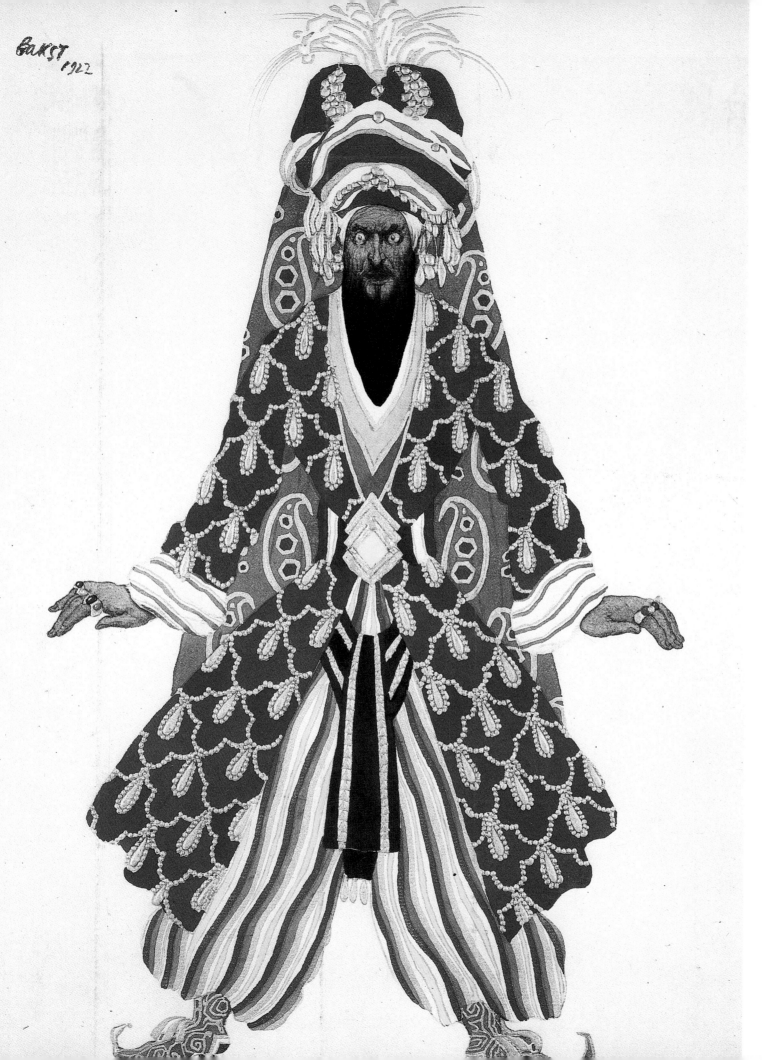

Leon Bakst's costume
designs for the 1922
ballet La Légende
de Joseph *took the
fashion movement
known as orientalism
to its height.*

A 1926 cover for Vogue magazine played to that era's insatiable appetite for pearls, even creating a typeface of the gems.

Ballets Russes had become a phenomenon by revolutionizing dance—abandoning the stiff formality of traditional ballet in favor of a more fluid emotionalism. Its romantic productions favored colorful locales and sumptuous costumes, in line with the current craze for all things Oriental. Among the ballets for which Bakst designed costumes were *Scheherazade*, *Cleopatra*, and *La Légende de Joseph*, each of which was set in "the East." Bakst's creations for these productions were studded with pearls and charged with eroticism.

The sensuality of the work being done by Bakst and Poiret in the 1910s made a profound impression on a young designer by the name of Erté. Born Romain de Tirtoff in 1892, the Russian aristocrat changed his name (Erté echoed his initials, R. T.) when he arrived in Paris to pursue a career in fashion and the theater. He first worked with Poiret, absorbing an appreciation for that designer's version of Oriental splendor. By 1915, Erté had started producing the famous cover art for *Harper's Bazaar* magazine; he later did covers for *Vogue* as well. Many of these graphics featured his whimsical clothing designs and a generous display of pearls, the most popular gems of the 1910s and 1920s. During his long career Erté also designed astonishing pearl-studded costumes for the Folies Bergère, for various opera companies, for Broadway, and for Hollywood. Upon occasion, the glamorous artist wore his own pearly inventions to great and memorable effect.

Bursting onto the Parisian scene at the same time was an African-American entertainer named Josephine Baker. At the age of eight she started learning her craft in the nightclubs of Harlem; she made her Paris debut at nineteen in a show entitled *La Revue nègre*. The journalist Janet Flanner witnessed Baker's spectacular arrival in Europe and described it fifty years later in her memoir, *Paris Was Yesterday* (Viking, 1972):

> She made her entry entirely nude except for a pink flamingo feather between her limbs; she was being carried upside down and doing the split on the shoulder of a black giant. . . . A scream of salutation spread through the theater. Whatever happened next was unimportant. . . . Within a half hour of the final curtain on opening night, the news and meaning of her arrival had spread by the grapevine up to the cafés on the Champs-Élysées. . . . She was the established new American star for Europe.

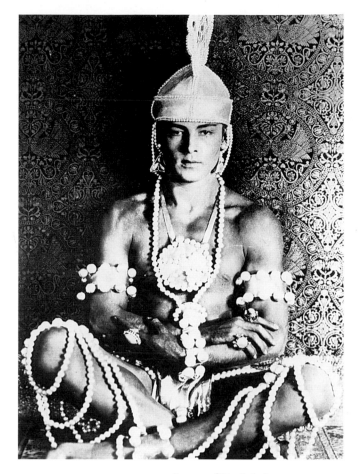

Some of Rudolph Valentino's acting roles dressed him in pearly costumes typical of those dreamed up for early movies set in exotic locales.

Erté's pearly designs often leaned toward the outrageous, as did this "cage dress."

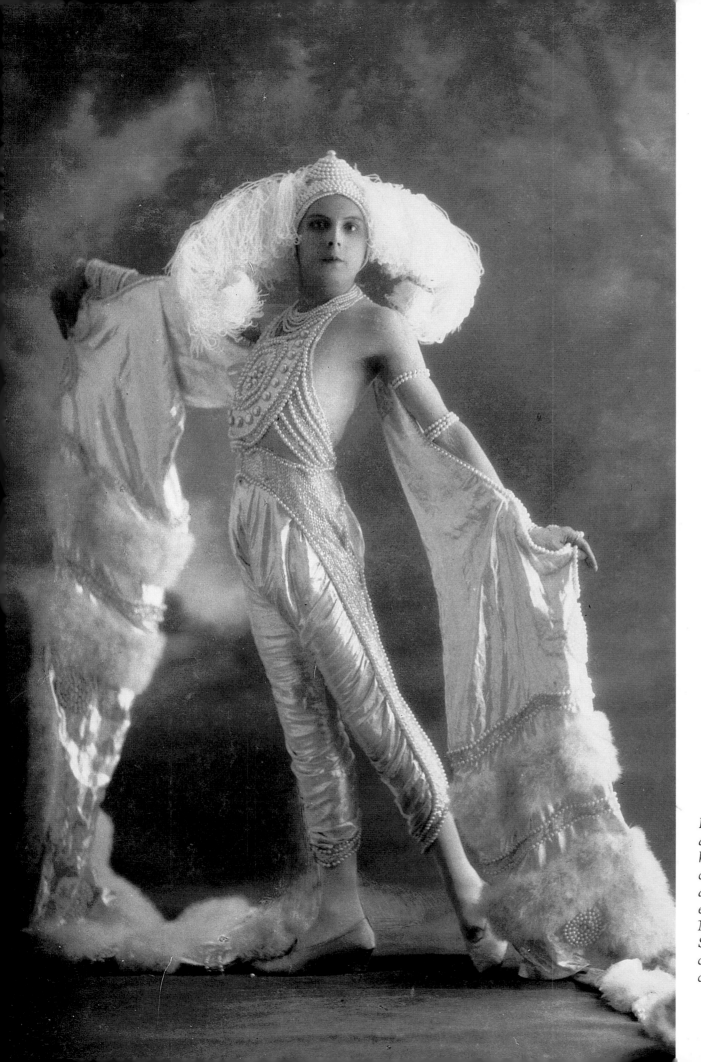

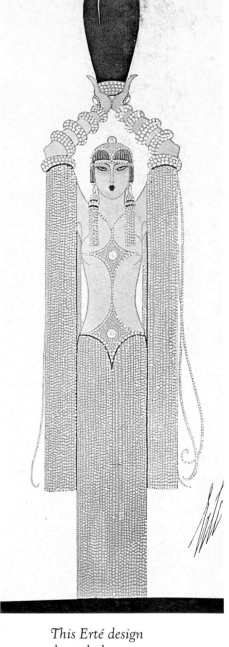

*Erté liked to
appear in
his own pearly
designs. Here he
attends a 1922
event at the
Monte Carlo
Sporting Club,
dressed as "Clair
de lune."*

*This Erté design
draped almost
every part of the
female figure in
long pearl fringes.*

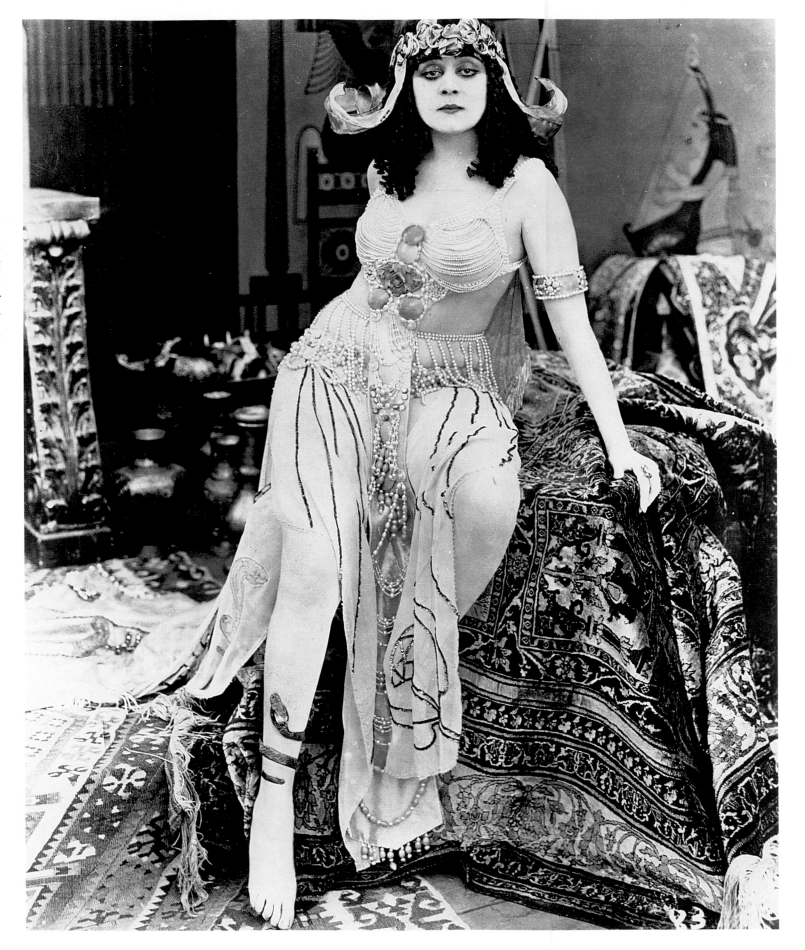

Actress Theda Bara wore this revealing pearl costume for her 1917 role as Cleopatra.

Artists and photographers clamored to immortalize Baker on canvas and film. She posed for, among others, Dunand, Man Ray, and Horst, who photographed her clad in nothing but ropes of pearls.

The pearl frenzy of Paris infected Hollywood as well, where the movie industry was generating the classics of the silent film age. Because silent films relied on visual effects to make an impact—and were limited to black-and-white pictures—exaggerated acting and elaborate sets and costumes were the norm. The costume designer Howard Greer admitted, "New York and Paris looked down on the dresses we designed in Hollywood. Well, maybe they were vulgar, but they did have imagination. If they were gaudy, they merely reflected the absence of subtlety which characterized all early motion pictures." Lustrous white pearls were well suited for the needs of silent films and meshed perfectly with the exotic settings and storylines preferred by audiences. Such screen sirens as Gloria Swanson, Louise Brooks, and Theda Bara wore pearls in quantity, especially when playing historical roles. In films depicting stories set in antiquity, pearls remained a standard element of costume design through the 1950s.

SPECTACLE, SPORT & GAMES

The prevalence of pearls in costume design for ballet, drama, musical theater, and film reveals the gem's close identification with spectacle, celebration, and entertainment of all kinds. As an ornament of great beauty and price, the pearl was a perfect motif whenever a special occasion called for the finest and most beguiling decoration. Pearls added to the festive air of any moment, whether it was a friendly game of backgammon or chess or a fight to the death between gladiators. All these displays of pearls hailed life as a form of theater, a vivid drama to be enjoyed to the fullest.

Royal celebrations, which rank among history's greatest spectacles, have always included the lavish display of pearls and other jewels. Pompey's triumphal march through Rome following his victory in the Mithradic Wars dripped with pearls, as did the cavalcades of medieval Crusaders returning to Europe from missions of conquest and plunder in the Middle East. At chivalric pageants in the Middle Ages and the Renaissance, noble spectators sparkled with pearls as they cheered jousting knights. Heirs to European thrones were christened in pearly splendor; Persian princesses

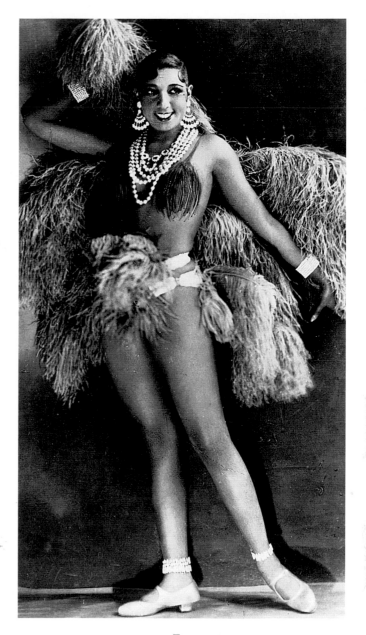

Entertainer Josephine Baker, the toast of Paris in the 1920s and 1930s, often wore pearls on- and off-stage.

Syrian chess and
backgammon
board inlaid with
mother-of-pearl
and tortoiseshell.

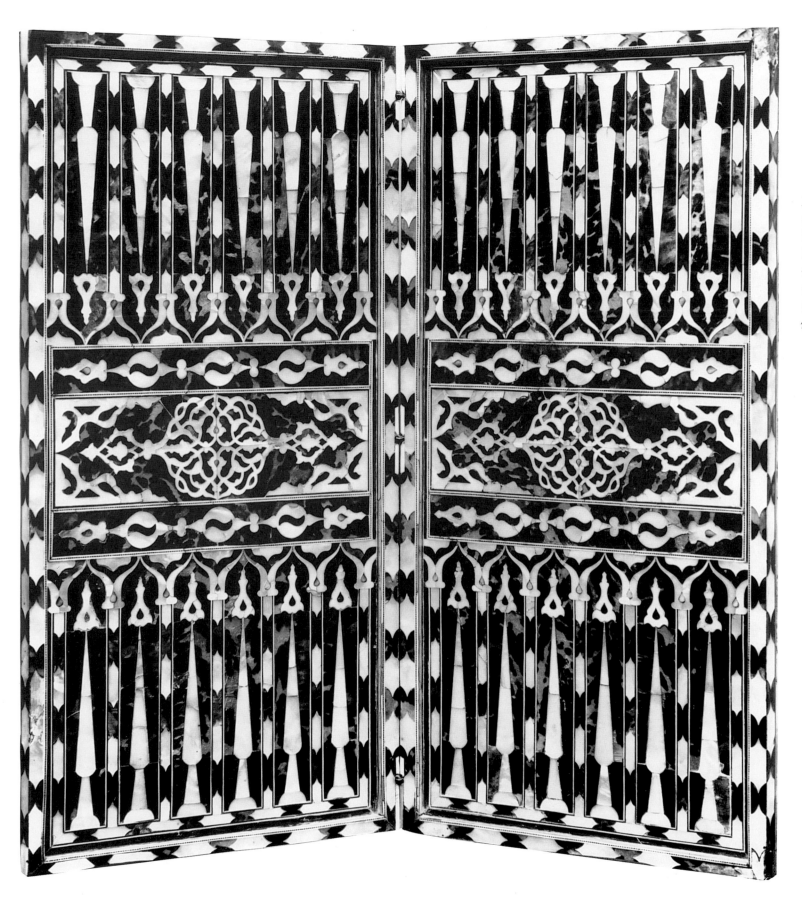

Nineteenth-century chess and backgammon board inlaid with mother-of-pearl, tortoiseshell, and ivory, probably made in Damascus.

*A modern bullfighter
in Barcelona, Spain,
wears a pearl-studded
costume.*

were wed in a sea of the luminous beads; monarchs accepted their birthright at pearl-studded coronations; aristocrats lay in state in their iridescent finery.

In modern times, the tradition of spectacles involving pearls lives on in the occasional royal wedding or coronation. Spanish bullfighters dressed in pearls still thrill crowds, while corporate public relations wizards promote their interests with such pearl novelties as Mikimoto's Liberty Bell reproduction, a model of the American icon executed entirely in pearls and mother-of-pearl. The pearl has lost none of its astonishing charm; indeed, it still awes and amazes the human spirit.

LITERARY PEARLS OF WISDOM

Writers through the ages have made the pearl one of literature's enduring symbols. From the most ancient Indian fables to the most recent American fiction, pearls appear in many guises to entertain and illuminate readers. The gem can represent spiritual or religious notions, such as Christian salvation, the chaste soul, or heaven, or it can represent more secular ideals, such as innocence, virginity, and beauty. In many instances the pearl serves as nothing more complex than an object of great value, treasured for its cost and loveliness. Elsewhere, writers refer to aspects of the pearl's history, such as its medicinal properties or the practices of pearl divers, pearl doctors, and pearl collectors. No matter what culture or era they worked in, poets, novelists, playwrights, and even pornographers have exploited the pearl's timeless power as an ornament and emblem.

Most of the earliest literary references to pearls use the gems to convey religious or moral lessons. In ancient India, a Hindu poet used pearl imagery to encourage humility and devotion among the faithful. In his poem *Pearls*, Purandaradasa equated the gems with a Hindu god to make his point:

> *Pearls, pearls, here are my pearls!*
> *Pearls, pearls, ye people, buy my pearls!*
> *Pearls beaded on a string of knowledge;*
> *Bhakti alone can buy these pearls.*
> *Not to wear on your ears and nose,*
> *Not to hold in your greedy hands,*
> *Nor has the price an end in sight;*
> *Vittal of Purandar is the name of these pearls.*

The pearl's association with deities also appears in the work of the poet Homer, who lived eight or nine centuries before the birth of Christ. In his epic works, Homer celebrated the glory of Greek goddesses by adorning them with pearl earrings. The *Iliad* describes Juno—"In three bright drops,/Her glittering gems suspended from her ears"; the *Odyssey* notes divine "Earrings bright/With triple drops that cast a trembling light." Another possible instance of pearl imagery in Greek literature appears in

Mikimoto's one-third–
scale reproduction
of the Liberty Bell
was displayed at
the 1939 World's
Fair in New York.
It is covered with
12,250 cultured
pearls and 366
diamonds.

a fable attributed to Aesop, the legendary proverb writer whose existence is still debated:

> A cock was once strutting up and down the farmyard among the hens when suddenly he espied something shining amid the straw. "Ho! Ho!" quoth he, "That's for me," and soon rooted it out from beneath the straw. What did it turn out to be but a Pearl that by some chance had been lost in the yard? "You may be a treasure," quoth Master Cock, "to men that prize you, but for me I would rather have a single barley-corn than a peck of pearls. Precious things are for those that can prize them."

The Japanese were among the first to recognize the erotic power of the pearl in their literature. A poem by Lady Nakatomi, an 8th-century writer, compares the art of pearl diving to the art of love:

> *No one dives to the ocean-bottom*
> *Just like that.*
> *One does not learn the skills involved*
> *At the drop of a hat.*
> *It's the slow-learnt skills in the depths of love*
> *That I'm working at.*

Europeans, too, gradually caught on to the pearl's romantic possibilities, as this traditional Serbian folk song reveals:

> *A youth unmated prays to God,*
> *To turn him to pearls in the sea,*
> *Where the maidens come to fill their urns;*
> *That so they might gather him into their laps,*
> *And string him on a fine green thread,*
> *And wear him pendant from the neck;*
> *That he might hear what each one said,*
> *And whether his loved one spoke of him.*

Some Western poets found the pearl incomparably beautiful in and of itself, without assigning it any particular meaning. *Pearl*, an anonymous English poem from the 14th century, celebrates the gem's physical attributes in straightforward terms:

> *Pearl! Fair enow for princes' pleasance,*
> * so deftly set in gold so pure,—*
> *from orient lands I durst avouch,*
> * ne'er saw I a gem its peer,—*
> *so round, so comely-shaped withal,*
> * so small, with sides so smooth,—*
> *where'er I judged of radiant gems,*
> * I placed my pearl supreme.*

Perhaps foremost among the writers of the European Renaissance who appreciated the pearl's unique appeal was William Shakespeare. The great poet and playwright made numerous references to the gem in his work, exploring many aspects of its form and meaning. At times he alluded to its origins, as in these lines from *A Midsummer Night's Dream*, "I must go seek some dew drops here,/And hang them in every cowslip's ear," and these from *As You Like It*— "Rich honesty dwells like a miser, sir, in a poor house,/as your pearls in your foul oyster." The following famous passage is from *The Tempest:*

> *Full fathom five thy father lies;*
> *Of his bones are coral made:*
> *Those pearls that were his eyes:*
> *Nothing of him that doth fade,*
> *But doth suffer a sea-change*
> *Into something rich and strange.*

Elsewhere, Shakespeare played on the pearl's status as a precious gem. In *Antony and Cleopatra* he wrote of its value to lovers—"I'll set thee in a shower of gold, and hail/Rich pearls upon thee"—while in *Troilus and Cressida* he noted its sway over royalty: ". . . A pearl,/Whose price hath launch'd above a thousand ships/And turn'd

crown'd kings to merchants." In *Othello*, he used the priceless jewel poignantly to illuminate a character's sense of shame and foolishness:

> *Speak of me as I am; nothing extenuate*
> *Nor set down aught in malice: then must you speak*
> *Of one that loved not wisely but too well;*
> *Of one not easily jealous, but being wrought,*
> *Perplexed in the extreme; of one whose hand,*
> *Like the base Indian, threw a pearl away*
> *Richer than all his tribe. . . .*

Shakespeare also indicated the pearl's high price in *Hamlet*, when Claudius, king of Denmark, tempts his nephew Hamlet into a contest by offering a pearl—referred to by a version of its Latin name, *unio*—as the prize. The king initiates the sword play on the pretext of cheering up the depressed prince and, in an apparent effort to tap the medicinal properties of the pearl, proposes to present the pearl to the victor in a glass of wine:

> *The king shall drink to Hamlet's better breath;*
> *And in the cup a union shall he throw,*
> *Richer than that which four successive kings*
> *In Denmark's crown have worn.*

In fact, the evil king has poisoned the pearl as well as the sword used against Hamlet in the duel, hoping that one of the two will succeed where previous efforts at assassination have failed. When Hamlet strikes his first blow against his opponent, Claudius eagerly proposes a toast and urges him to drink the deadly draught: ". . . Hamlet, this pearl is thine./Here's to thy health. Give him the cup." Hamlet does not drink the wine, but he is wounded by the poisoned sword. Before dying, though, he forces the incestuously married King Claudius and Queen Gertrude to drink the poisoned wine, which kills them both. Thus, with the poisoned pearl, Hamlet rids Denmark of its rottenness, of a monarchy tainted by "luxury and damned incest."

Throughout the Renaissance, pearls were as popular among writers, who employed them as symbols for everything from Christian purity to feminine beauty, as

they were among the nobility who collected and wore them without restraint. The pearl craze had a tremendous impact on the arts of the period, providing ample imagery for literature. One anonymous poet, for instance, marveled at the insatiable appetites of the Pearl Age:

> . . . Ocean's gem, the purest
> Of nature's works! What days of weary journeyings,
> What sleepless nights, what toils on land and sea,
> Are borne by men to gain thee!

Various poets elaborated on the romantic themes suggested by the mysterious gem. In England, Thomas Campion wrote of a woman's mouth in the following sensuous terms:

> Those cherries fairly do enclose
> Of orient pearls a double row,
> Which when her lovely laughter shows,
> They look like rosebuds filled with snow.

Similarly, in an unattributed poem entitled "The Faithful Shepherdess," a lover promises his beloved, "Orient pearls fit for a queen/Will I give thy love to win,/And a shell to keep them in."

By contrast, a 1571 poem by Matthijs de Castelein of Holland recalls the pearl's religious meanings and mourns the decline of old-fashioned values:

> Where today is Saturn's golden world?
> Who is nowadays in virtue furled?
> Where's the silver chariot of Jove?
> And these days who's with Christian love bepearled?

In 1641, Iacob Franz Sleutel, another Dutch poet, also used pearl imagery to decry the world's lack of genuine faith:

I've found it true,
That pearl of great price, that costly good
Which many, blind as moles, pursue
At mass alone, and inane pilgrimhood.
May God improve their faulty sight
And grant that they too see the light.

Secular moralists of the Renaissance put the pearl to effective use in various poems and proverbs meant to encourage clean and circumspect living. In *Houwelick* (Marriage), the popular Dutch writer Jacob Cats employed the pearl as a metaphor for a wife's chastity within marriage, warning,

A most delicious shine this jewel will emit
If no acidic juice is overturned on it
But should it be attacked by a caustic flow
This loveliest of pearls will lose its erstwhile glow.

The pearl's purity and simplicity also inspired reflection in a 1640 book entitled *Christian Moderation,* by Joseph Hall, which included the observation "Moderation is the silken string running through the pearl chain of all virtues." Another 17th-century reference, by the English poet Samuel Butler, states, "For truth is precious and divine —Too rich a pearl for carnal swine," while John Dryden, England's poet laureate from 1668 to 1688, alludes to "pearls of wisdom" in the play *All for Love:* "Errors, like straws, upon the surface flow;/He who would search for pearls must dive below."

By the 19th century, literature had branched out to explore more humanist themes and modern forms, while spirituality faded in importance. With this change, the meanings of pearl imagery evolved. The pearl remained a powerful symbol to the Romantic poets of the 19th century, but it seldom had the religious overtones of the past. Indeed, an underground journal of Victorian pornography went by the title *The Pearl,* perhaps in a reference to that gem's traditional association with female genitalia. On higher ground, some of the era's finest poets employed pearl imagery in their work, among them Emily Dickinson, who wrote in one of her untitled poems, "I taste a liquor never brewed./From tankards scooped in pearl."

Percy Bysshe Shelley offered his own lovely metaphor in "My Thoughts":

> *My thoughts arise and fade in solitude;*
> *The verse that would invest them melts away*
> *Like moonlight in the heaven of a spreading day.*
> *How beautiful they were, how firm they stood,*
> *Flecking the starry sky like woven pearl.*

From the Irish poet Thomas Moore, meanwhile, came "The Loves of the Angels," which includes the following lines:

> *Then, too, the pearl from out its shell,*
> *Unsightly in the sunless sea,*
> *(As 't were a spirit, forced to dwell*
> *In form unlovely) was set free,*
> *And round the neck of woman threw*
> *A light it lent and borrowed too.*

And in 1889, just before he died, Robert Browning offered "A Pearl, A Girl," reading in part:

> *A simple ring with a single stone,*
> *To the vulgar eye no stone of price;*
> *Whisper the right word, that alone—*
> *Forth starts a sprite, like fire from ice,*
> *And lo, you are lord (says an Eastern scroll)*
> *Of heaven and earth, lord whole and sole,*
> *Through the power in a pearl.*

The romance of the East exerted a particularly strong pull on European writers of the 1800s, prompting references to the fabled sources of pearls, such as this one from Sir Edwin Arnold:

Dear as the wet diver to the eyes
Of his pale wife, who waits and weeps on shore,
By sand of Bahrein in the Persian Gulf;
Plunging all day in the blue waves; at night,
Having made up his toll of precious pearls,
Rejoins her in their hut upon the shore.

Middle Eastern poets, many of whom were admired in Europe and the United States, also delighted in pearl allegory. Shabl Abdullah, for one, wrote in an elegy to a dead woman:

Nazomi's gone, our fairest pearl is lost.
From purest dew, kind Heaven had given her birth,
And then fashioned her the pearl supreme.
She softly shone, but hidden from mankind,
So God has now restored her to her shell.

Just as pearls had traveled from East to West throughout history, so did pearl symbolism. The exchange of Eastern and Western ideas, whether couched in terms of pearls or not, prompted the American poet James Russell Lowell to remark in his 1888 poem "In a Copy of Omar Khayyam,"

These pearls of thought in Persian gulfs were bred,
Each softly lucent as a rounded moon;
The diver Omar plucked them from their bed,
Fitzgerald strung them on an English thread.

The world's entrance into the industrial age brought literary romanticism to an end, at least temporarily, and cast pearls in a new light. The gems retained their metaphorical and monetary value, but the more cynical writers of the 20th century handled them differently, with less reverence. Instead of conveying gentle, ethereal notions such as innocence and blessedness, pearls now stood for more concrete, and often harsh, modern ideas. One humorous example comes from Dorothy Parker, the

American writer famous for her caustic witticisms. Parker maintained a running feud with the playwright, journalist, and politician Clare Booth Luce. When the two women met one day in a doorway, Luce deferred to Parker with the remark, "Age before beauty." Sweeping past Luce, Parker retorted, "Pearls before swine," giving new, and distinctly contemporary, meaning to the biblical phrase.

John Steinbeck, an American novelist of the West, portrayed the grim realities of life during the Great Depression in such works as *The Grapes of Wrath* and *Of Mice and Men*. In *The Pearl* (1947), he focused on the cruel existence of pearl divers in the Gulf of California. Kino, the protagonist, learns that finding a valuable pearl will not, as he had hoped, solve his problems or bring him happiness:

> All manner of people became interested in Kino—people with things to sell and people with favors to ask. Kino had found the Pearl of the World. The essence of pearl mixed with essence of men and a curious dark residue was precipitated. Every man suddenly became related to Kino's pearl, and Kino's pearl went into the dreams, the speculations, the schemes, the plans, the futures, the wishes, the needs, the lusts, the hungers, of everyone, and only one person stood in the way and that was Kino, so that he became curiously every man's enemy.

The American writer Madeleine L'Engle also used pearl imagery to convey suffering, in her 1988 memoir *Two-Part Invention: The Story of a Marriage*. The book chronicles the lingering death of L'Engle's husband and contains her sometimes bitter reflections on the difficulties of life:

> We are one planet, a single organism. What happens on this floor makes a difference everywhere. For the entire universe with its countless galaxies is the setting for this pearl of pain.

Another form of misery, that of being jailed as a political prisoner, serves as the focus of "A Pearl," by the Chinese poet Zhou Liangpei:

> *Like grains of sand grinding inside the oyster,*
> *Like pearls being formed from the grains;*
> *Still waiting, though in unbearable patience,*
> *Still believing, though almost in disbelief.*

The emotional confusion of life in postindustrial America permeates Amy Wallace's 1990 novel *Desire* (Houghton Mifflin Company). The book tells the story of Lily van Velsen, heir to a jewelry empire, whose family's expertise in pearls reaches back to the Renaissance. Troubled by her romance with an unworthy fiancé—who views all gems, including pearls, as mere products—the protagonist takes solace in her work as a pearl doctor. "It's the idea of a natural pearl that's exciting," she says, continuing:

> To think of the odds against its growing in a hostile sea, the odds against its survival. . . . They're called true pearls, or wild pearls. And we pearl doctors—that's what I'm called, a pearl doctor—know, from experience, that an extraordinary jewel may exist beneath a flawed surface. To find it, you have to take a risk by destroying the exterior. If you judge wrongly, of course, you've lost everything.

In Wallace's novel, the pearl serves as a symbol for that which really matters in life. Amid the crassness and superficiality of modern existence, it is a melancholy metaphor indeed.

Poets and novelists from antiquity to the present have thus found a literary use for the pearl that resembles the gem's role in ancient legend and belief. Much as the milky jewel appeared as a powerful totem in the mythology of the world's early cultures, so it has emerged again and again as a compelling symbol in poetry and fiction. The pearl's spiritual and social significance is further mirrored in other arts, such as painting, sculpture, music, theater, and film. Like all of humanity's most potent icons, the pearl bridges religion and the arts, linking the two pursuits and highlighting their similarities in form and function. Nature's iridescent gem defines and decorates each of humankind's loftiest endeavors, from the celebration of the earthly to the worship of the divine.

The pearl's special hold on people, whether on their spirits, their emotions, or their intellects, has taken many forms during the five millennia in which humanity has known the lustrous gemstone. Priests and shamans, scientists and philosophers, princesses and sheikhs; merchants and entrepreneurs, designers and inventors, artists and writers: Each has found something uniquely enchanting in the pearl. Its luminous splendor, precious rarity, and radiant power have made the natural ornament an object of unquenchable obsession. Brought to the edge of extinction by human rapacity and rescued from extinction by human ingenuity, the pearl reflects the ever-turning cycle

*Five different
16th-century designs
for pearl pendants, by
Hans Collaert.*

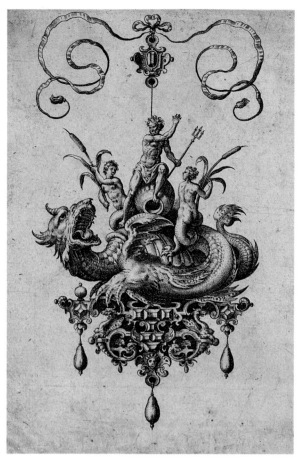

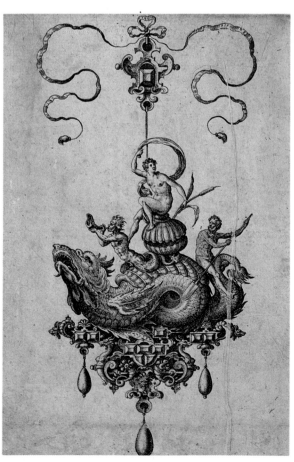

of human existence. Just as it derives its iridescent beauty from many nacreous layers built up over time, so human history derives its richness from the multiple strata of empire, exploit, and enlightenment that have characterized human existence through the ages. And, though its enigma has been deciphered, the pearl remains a wondrous mystery. Likewise, even after centuries of effort devoted to unlocking the secrets of the universe and the puzzles of the human soul, life itself remains just such a wonder. The pearl's origins, form, and uses thus make it the consummate metaphor for humankind's past, present, and future.

Glossary

ABALONE See HALIOTIS.

ABRAIAMAN A fish charmer who was paid to conduct rituals and prayers on behalf of pearl divers at the old pearl fisheries in order to protect the divers from attack by sharks and other predators.

ADDUCTOR The muscle that opens and closes a bivalve's shell.

AKOYA The type of oyster used in Japanese pearl culturing, whose species name is *Pinctada fucata* (martensii).

AMA A specially trained Japanese woman who dives for oysters, abalone, and pearls using ancient, traditional techniques.

ARAGONITE Crystallized calcium carbonate that forms the translucent, microscopic platelets of which nacre is composed.

BANK See PAAR.

BAROQUE An irregularly shaped pearl, sometimes hollow.

BDELLIUM Biblical term for pearls.

BIVALVE A mollusk with a hinged, two-part shell, such as a clam or a scallop.

BLACK PEARL A pearl with a dusky, rather than white, body color. Black pearl shades range from silver-gray to aubergine to black.

BLISTER PEARL A pearl, sometimes hollow, affixed to the mother-of-pearl lining of a mollusk's shell.

BOUTON A flat, round button-shaped pearl.

BOUTRE See LUGGER.

BRAIL See DREDGE.

BUNNIA An Arab or Indian entrepreneur who financed pearl-fishing expeditions at the old pearl fisheries of Asia and the Middle East.

BUTTON PEARL See *BOUTON*.

CALCIUM CARBONATE The compound from which the nacreous shell lining and crystalline calcite layer of an oyster's shell are made.

CALCOSPHERULE A natural, detached accumulation of shell material inside a mollusk, around which a pearl can form.

CHICOT A hollow blister pearl.

CHROMATOPHORE "Cells" of pigment found in certain pearl strata; they lend body color to some pearls.

CONCH See *STROMBUS GIGA*.

CONCHIOLIN The protein that cements together the calcium crystals from which an oyster's outer shell, or periostracum, is formed. Conchiolin also serves as the adhesive for aragonite platelets joining into layers of nacre.

CRYSTALLINE CALCITE The substance that makes up the middle layer of an oyster's shell.

CULTCH The rocky anchorage favored by oysters as footing.

Cultured Pearl A pearl produced by periculture.

Culturing See PERICULTURE.

Dredge A device dragged along the sea floor or a riverbed to harvest oysters in quantity. In the United States, dredges are known as brails.

Dust Pearl A very tiny pearl weighing a slight fraction of a grain.

Epithelium See MANTLE.

Essence d'Orient A pearly lacquer composed of varnish and guanine from fish scales.

Faux Pearl A pearl-like bead manufactured by coating the inside of a hollow glass sphere or the outside of a solid glass or plastic sphere with a pearlescent coating.

Fine Pearl A pearl formed in the wild by the random intrusion of a natural irritant into a mollusk's shell. Also called wild pearl, natural pearl, oriental pearl.

Foot The muscle that provides a mollusk with locomotion; in many varieties the foot contains glands that secrete an adhesive substance by which the mollusk attaches itself to stationary objects.

Foval Pearlescent glass manufactured in the United States from 1901 to 1933 by the H. C. Fry Glass Company. Also known as Pearl Art Glass.

French Deco Linoleum See RHODOID.

Gastropod See UNIVALVE.

Grain A unit of weight measurement equal to 0.002083 ounces, or 0.0648 grams. There are 480 grains in an ounce, 15.43 grains in a gram. A grain is equivalent to one-quarter of a carat.

Great Conch See *STROMBUS GIGA*.

Guanine Organic waste matter, similar to uric acid, that coats the scales of certain types of fish. Used to make essence d'orient.

Haliotis The gastropod known commonly as the abalone. Yields very colorful, lustrous baroque pearls and mother-of-pearl, as well as edible flesh.

Hollow Pearl See *SOUFFLURE*.

Imitation Pearl See FAUX PEARL.

Inlay A decorative pattern of materials such as mother-of-pearl set into wood, lacquer, or another surface.

Iridescence The characteristic play of light on the surface of pearls and mother-of-pearl, in which the reflection and interference of light waves produce a rainbow of changing color. See also ORIENT.

Krisana Term for pearls used in some ancient Hindu texts (Vedas).

Lugger A large, single-masted sailing vessel, capable of carrying fifteen to twenty people, used around the old pearl fisheries. Also called a *boutre*.

Luster The glowing appearance of a pearl. See also ORIENT.

Mabe A hemispherical pearl.

Majorica Pearl A high-quality faux pearl manufactured in Spain by Majorica, S.A.

Mantle The thick skin, also known as the epithelium, that encases a mollusk's soft body and secretes the materials from which its shell is formed.

Mollusk A member of the zoological phylum Mollusca, a category of soft-bodied invertebrates that live in shells. Also called shellfish.

Mother-of-Pearl The smooth inner lining of a mollusk's shell, composed of nacre. Also called pearl shell.

Murawa, Murwari, Mirwareed The Persian word for pearl, which translates as "child of light." Source of the name Margaret.

Mussel A freshwater bivalve mollusk, usually with a dark, elongated shell. Unionides, the general term for mussels that yield especially fine mother-of-pearl, derives from the genus name, *Unio*.

Nacre The material of which pearls and mother-of-pearl are made. Composed of platelets of aragonite cemented together by conchiolin to form a microscopically ridged, iridescent surface.

Nacreous Composed of nacre.

Nautilus A univalve mollusk with a chambered, spiral shell.

Nucleate To implant a nucleus in an oyster in order to stimulate the generation of a cultured pearl. Also seed.

Nucleus The intruding irritant that forms the core of a pearl. In a cultured pearl, the nucleus is a mother-of-pearl bead.

Orient The iridescent sheen of a pearl. See also IRIDESCENCE and LUSTER.

Orientalism A fashion trend of the 1910s and 1920s, launched by the Paris designer Paul Poiret, which interpreted the clothing styles of Asia for European and American use. Orientalism made abundant use of pearls and faux pearls as decorative accents.

Oyster A marine bivalve mollusk with a rough, irregular exterior shell and a smooth, mother-of-pearl shell lining.

Oyster Bank See PAAR.

Paar An oyster bank, the habitat where large numbers of oysters live close together. Also called pearl bed.

Paragon A large spherical or nearly spherical pearl weighing 100 grains or more.

Parure A matched set of jewelry, which might include earrings, a necklace, brooches, rings, and other pieces.

Pavé A type of jewelry in which the setting is completely covered, literally "paved," with gems such as pearls.

PEARL A nacreous growth inside a mollusk's shell, which forms around intruding irritants to protect the creature's delicate body. See BLACK PEARL, WHITE PEARL.

PEARL AGE The period during the Renaissance, roughly 1450–1650, when the immense popularity of pearls in Europe produced extravagant pearl fashions and fueled the pearl rush in Central America.

PEARL ART GLASS See FOVAL.

PEARL BED See PAAR.

PEARL CULTIVATION See PERICULTURE.

PEARL DIVER A person who dives for pearl-bearing mollusks.

PEARL DOCTOR An artisan who peels layers of nacre from blemished pearls in order to uncover a more perfect surface.

PEARL FARM An operation where oysters are bred and grown in captivity for the production of cultured pearls, and then nucleated and tended until cultured pearls are ready to be harvested.

PEARL FISHERY A site where mollusks are harvested in the wild for the purpose of finding pearls or mother-of-pearl.

PEARL SAC A cyst of epithelium tissue that surrounds an irritant inside a mollusk's shell and secretes nacre around it to form a pearl.

PEARL SHELL See MOTHER-OF-PEARL.

PEARLESCENT Resembling pearls or mother-of-pearl in iridescence and luster.

PEARLING The art and craft of pearl fishing.

PEARLING CAMP A makeshift settlement erected near a pearl fishery to house those engaged in pearl fishing.

PEARLIZED Having an artificially produced pearly appearance.

PERICULTURE Pearl culturing or pearl farming; the practice of inducing pearl formation in oysters by inserting artificial stimuli, most often small mother-of-pearl beads. Also called pearl cultivation.

PERICULTURIST A pearl farmer; one who engages in periculture.

PERIOSTRACUM The hard outer shell of an oyster.

PIG-TOE A variety of mussel found in certain rivers of the United States. The pig-toe's mother-of-pearl is used throughout the world to manufacture nuclei for cultured pearls.

PINCTADA The genus of oysters that produces the high-quality pearls prized as jewels. The best pearl producers are *Pinctada mazatlantica*, *Pinctada margaritifera*, *Pinctada maxima*, *Pinctada fucata* (martensii), and *Pinctada radiata*.

PINK PEARL The porcelaneous, non-nacreous gem produced by *Strombus giga*. Specimens range in color from whitish-yellow to pink to brown.

PINNA A Mediterranean bivalve that makes lustrous pearls that deteriorate rapidly because of their unusual crystalline structure and high water content. Also sought for its edible flesh.

RHODOID A pearlized laminate used for tabletops and other objects. Also known as French Deco Linoleum.

SEED See NUCLEATE.

SEED PEARL A small pearl weighing up to half a grain.

SHELL CARVING The practice of carving mother-of-pearl and other types of shell into figurines, trinkets, and objets d'art.

SHINJU Japanese term for pearl.

SOUFFLURE A hollow pearl, formed when an organic irritant decomposes inside its pearly coating before the nacre hardens. Gases released by the rotting object inflate the nacreous buildup like a bubble.

SPAT An oyster larva before it forms its shell.

STROMBUS GIGA A large, horny univalve of the Caribbean, which has a smooth, pink interior. Produces porcelaneous, pearl-like gems and edible flesh. Commonly known as conch or great conch.

TRIDACNA The giant clam of the South Pacific. Produces large but not particularly lustrous pearls.

UNIO A genus of freshwater mussel that makes small, irregular pearls with good luster.

UNIONIDES General term for mussels, derived from the genus name *unio*.

UNIVALVE A mollusk with a one-part shell, such as a snail.

VALVE The shell of a mollusk. Univalves have one valve, bivalves have two.

WHITE PEARL A pearl with basically white body color. Can range in tint from white, cream, yellow, and golden to pink, green, blue, and silver.

WILD PEARL See NATURAL PEARL.

Selected Bibliography

Arnold, Janet, *Queen Elizabeth's Wardrobe Unlock'd*. (Leeds, England, W. S. Maney, 1988.)

Arunachalam, S., *The History of the Pearl Fishery of the Tamil Coast*, Annamalai University Historical Series, no. 8 (Annamalai Nagar, 1952).

Batterberry, Michael and Ariane, *Fashion: The Mirror of History* (New York: Holt, Rinehart and Winston, 1977).

Birmingham, Nan, "The Peerless Pearl," *Town & Country*, June 1981.

Campbell, Joseph, *Transformations of Myth Through Time* (New York: Harper & Row, 1990).

Charles-Roux, Edmonde, *Chanel and Her World* (New York: The Vendome Press, 1981).

D'Alpuget, Blanche, "Australia's Remote Pearl Coast," *The New York Times Magazine*, May 19, 1991.

De Boot, Anselmus, *Gemmarum et lapidum historia* (Leiden: Adrianus Tollius, 1647).

De Jongh, E., "Pearls of Virtue and Pearls of Vice."

Dirlam, Dona M., et al., "Pearl Fashion Through the Ages," *Gems & Gemology*, Summer 1985.

Ebin, Victoria, *The Body Decorated* (London: Thames and Hudson, 1979).

Eunson, Robert, *The Pearl King: The Story of the Fabulous Mikimoto* (Rutland, Vt.: Charles E. Tuttle Company, 1955).

Farn, Alexander E., *Pearls: Natural, Cultured and Imitation* (London: Butterworth, 1986).

Federman, David, "Biotechnology: A New Dawn for Pearl Farming," *Modern Jeweler*, September 1990.

Green, Marilyn, "Humphalflatrin, Gabber and Back Rig: The History of Scotland's Freshwater Pearls," *British Heritage*, December/January 1985–86.

Gunston, David, "Master of the Pearl: The Story of Kokichi Mikimoto," *Modern Jeweler*, May 1984.

Kunz, George Frederick, and Charles Hugh Stevenson, *The Book of the Pearl* (London: MacMillan, 1908).

McCormick, Jo Mary, *Pearls in Pictures* (New York: Sterling Publishing Co., 1966).

Mosk, Sanford Alexander, "Spanish Voyages and Pearl Fisheries in the Gulf of California: A Study in Economic History," Ph.D. Dissertation, University of California, Berkeley, 1927.

Nadelhoffer, Hans, *Cartier, Jeweler Extraordinaire* (London: Thames and Hudson, 1984).

Nardo, Anna K., "Here's to Thy Health: The Pearl in Hamlet's Wine," *English Language Notes*, December 1985.

Needham, Joseph, *Science and Civilization in China*, vol. 4: *Physics and Physical Technology*, Part III: "Civil Engineering and Nautics" (Cambridge: Cambridge University Press, 1971).

Newman, Harold, *An Illustrated Dictionary of Jewelry* (London: Thames and Hudson, 1981).

Pandey, Dr. Indu Prabha, *Dress and Ornaments in Ancient India* (Delhi: Bharatiya Vidya Prakashan, 1988).

Plinius Secundus, Gaius, *Historia naturalis*, translated by Philemon Holland (London, 1601).

Polo, Marco, *The Book of Marco Polo*, translated by H. Yule (London, 1871).

Porter, Bruce, "The Black-Pearl Connection," *Connoisseur*, April 1991.

Prakashan, Avani, *Rasa-Jala-Nidhi, or Ocean of Indian Chemistry and Alchemy*, Parimal Publishing, Ahmedab, India, 1984.

Ritchie, Carson I. A., *Shell Carving: History and Techniques* (Cranbury, N.J.: A. S. Barnes, 1974).

Shakespeare: A New Companion to Shakespeare Studies (Cambridge: Cambridge University Press, 1971).

Steinbeck, John, *The Pearl* (New York: Viking, 1947).

Streeter, Edwin W., *Pearls and Pearling Life* (London: George Bell & Sons, 1886).

Sweaney, James L., and John R. Latendresse, "Freshwater Pearls of North America," *Gems & Gemology*, Fall 1984.

Taburiaux, Jean, *Pearls: Their Origin, Treatment and Identification* (Radnor, Pa.: Chilton Book Company, 1986).

Vollmer, John E., et al., *Silk Roads, China Ships*, exhibition catalog, Royal Ontario Museum, Toronto, 1983.

Wallace, Amy, *Desire* (Boston: Houghton Mifflin Company, 1990).

Ward, Fred, "The Pearl," *National Geographic*, August 1985.

Picture Credits

ART RESOURCE:
Borromeo/New Dehli National Museum, 32;
Galleria Palatina, 6 bottom right, 74;
Giraudon/Louvre, 102–3, 172;
Giraudon/Musée Condé, Chantilly, 2;
Giraudon/Musée Crozatier, Le Puy en Velay, 99;
Musée de Cluny, 155 left detail;
Museo Cristiano, Brescia, 86 right;
Museum of Indian Art, Staatliche Museum, Berlin,
 23;
Residenz Museum, Munich, 49;
SCALA, 20, 28, 152, 167 top left;
SCALA/Antwerp Museum of Fine Arts, 31;
SCALA/Duomo, Palermo, 109;
SCALA/Gallery Uffizi, Firenze, 175;
SCALA/Ghent, S. Bavone, 196 detail and 197 both;
SCALA/Milan Castello Sforzesco, Milano, 167 top
 left;
SCALA/New Delhi Museum, 24–5;
SCALA/Palazzo Vecchio, Firenze, 112;
SCALA/St. Bavone, Ghent, 89 and details on 90, 91.

Reproduced with permission from the Bakst Estate,
Artist Rights Society, 209

Photographs by David Behl, Courtesy of James Arpad
Designer, New York, 182 top; Courtesy of Showroom
Seven, New York, 73; Courtesy of Private Collection,
177 left; Courtesy of Private Collection, Tender
Buttons, New York, 126, 127, 151, 158

Courtesy of Gary Knox Bennet, 148 top left

The Bettmann Archive, 106 top, 107, 117 bottom left
and right, 122, 177 right, 178, 179, 184 right, 208

The Bettmann Archive/Hulton, 111 right, 128, 129

Biblioteca Nazionale Centrale, Firenze Photograph by
Donato Pineider, 207

Black Star/Fred Ward, 44, 50, 66, 144–5

The Bodleian Library, Oxford, (Ms. Bodley 264, fol.
265R), 6 left and 61

Courtesy of Cartier, 106 bottom

Courtesy of Buster Cleveland, 7 bottom left, 204

Photographs by David Doubilet, 67, 138 bottom, 147

Courtesy of John Dunnigan, 149

Courtesy of the Fashion Institute of Technology, 185,
210, 213 right

Courtesy of The Forbes Magazine Collection, New
York, Photograph by Larry Stein, 164 left

Courtesy of Franklin Parrasch Gallery, Photograph by
Marco Prozzo, 206

Photographs by Michael Freeman, 140 bottom; 141

Freer Gallery of Art, 83 bottom right

Courtesy Gibson Custom Division, Gibson Guitar
Corporation, Designed by Greg Rich and Phil Jones;
166 and 167 (except top left)

Gruppo Alma, Photograph by Peter Lindberg,
Modeled by Ludmillal, Art Direction by Art Work
Alas, 180–1

Photograph by Michael Holford, 168

Photographs by Matthew Klein, copyright 1990, 159

Kunsthistorisches Museum, Wien, Photograph by
Marianne Haller, 170 both

Kunz and Stevenson, "The Book of the Pearl," 46,
70 top, 78 left, 80 left, 108, 188

Photograph by Peter Lindberg, Modeled by Naomi
Campbell. Photograph originally published in Vogue.
Reproduced with permission from Mr. Lindberg and
Ms. Campbell, 182 right

Courtesy of Lotus, 148 top right

The Louvre, Copyright photo R.M.N., 34 detail and
35, 163

Manchester City Art Galleries, 52

Index

About
the Authors

PEARLS: ORNAMENT AND OBSESSION is the product of a remarkable partnership that came about quite by accident. At the age of thirty-seven, Kristin Joyce had retired from a career in fashion to write, and to develop her own business as a book packager collaborating with writers and artists. Soon, offers came her way in response to a number of book proposals she developed, including a fashion project entitled "Pregnant with Style." It was because of this project that we met. At the time, Shellei Addison was a new mother with a six-month-old son named Addison Wilde Rex, working in the United States and abroad as a stylist and costume designer. Personifying elegance while pregnant and later taking her baby with her everywhere, she had proven that women could look stunning in any "condition," no matter how delicate.

We hit it off immediately: we both appreciated quirky style, quirky people, all children, most art, travel, beaches, Japanese food, Italian design, philosophy, film, and of course, books. Kristin had studied theater arts, journalism, and education and had worked as a journalist and as a writer for children's network television. Shellei had mastered several languages, discovered an affinity for the physical sciences, and developed a special visual perception project for the San Francisco Exploratorium. From these varied backgrounds, both of us were drawn eventually to careers in fashion and the decorative arts, and both of us had become accredited costume designers.

While working on this project, we have discovered the special rapport between two working mothers, who can compare notes on periculture in one breath and parenting in the next. We have discovered a unique visual and artistic affinity and delighted in the ease with which a gesture or glance can communicate an idea between partners. We have found that passion, persistence, resilience, and good humor can inspire a friendship, solidify a business relationship, and create a book.

Today, one new business, three books, and, in Kristin's case, two babies after we started this project, we relish the joyous discovery that the process of writing a book can be as enlightening and pleasurable as the subject itself. Through our faith in each other, this project became an adventure in creative partnership and a tribute to brilliant friendship. For all this, we thank each other.

WITHDRAWN

Joyce, Kristin.

Pearls.

$65.00

2/23/93

DATE		

LONGWOOD PUBLIC LIBRARY

BAKER & TAYLOR BOOKS